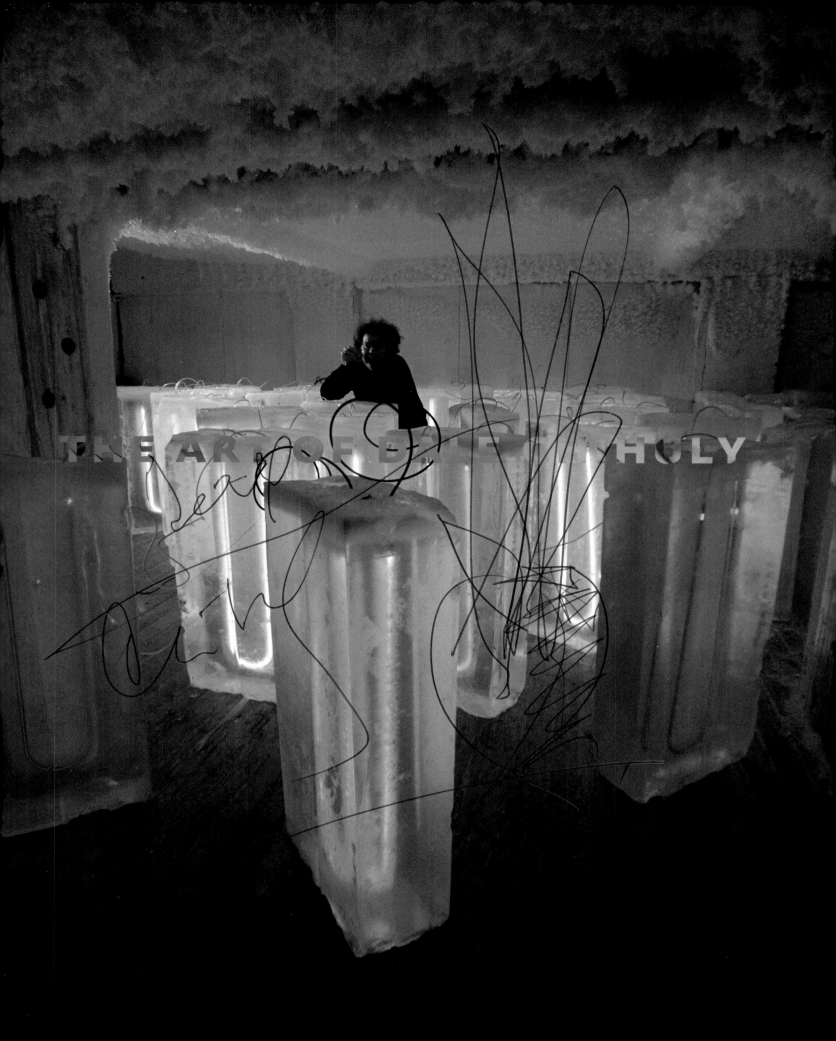

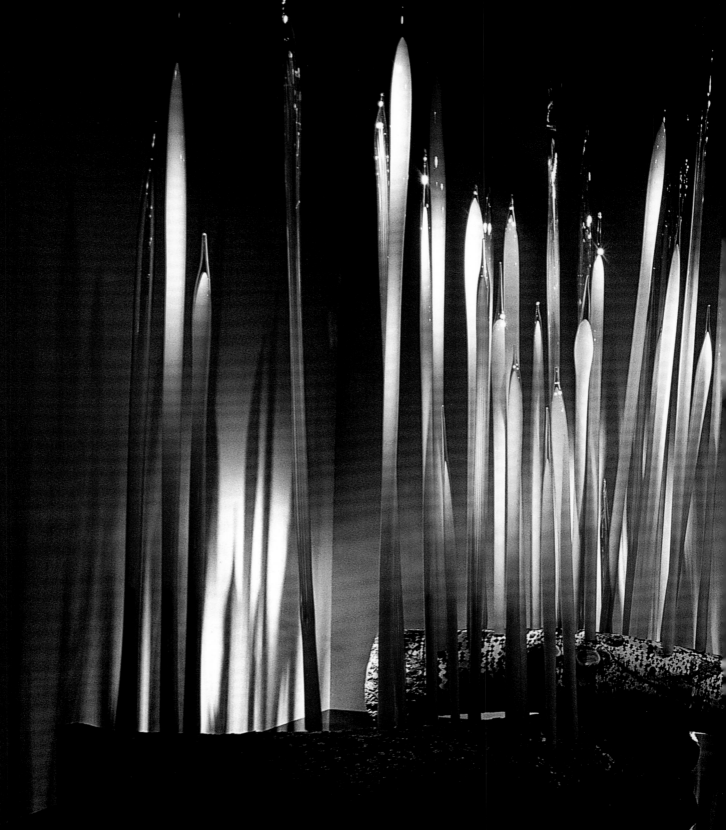

THE ART OF DALE CHIHULY

Timothy Anglin Burgard

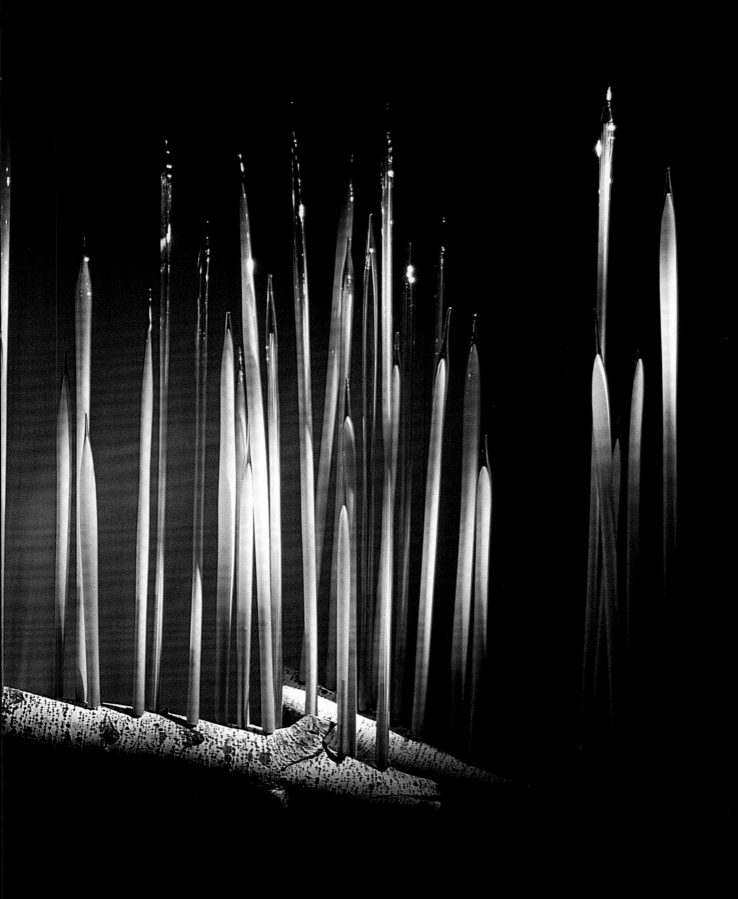

CHRONICLE BOOKS
SAN FRANCISCO

Fine Arts
Museums of
San Francisco

The Art of Dale Chihuly is published by Chronicle
Books and the Fine Arts Museums of San Francisco
upon the occasion of the exhibition

Chihuly at the de Young
June 14–September 28, 2008

This exhibition is organized by the Fine Arts Museums
of San Francisco in cooperation with Dale Chihuly.

Major Patron, Koret Foundation

Sponsor support is provided by Dorothy and George
Saxe, Target, the Winifred Johnson Clive Foundation,
and the Ednah Root Foundation.

Additional support is provided by Bombardier
Aerospace Flexjet, The Barkley Fund, Imago Galleries,
LIULI, the Walla Walla Valley Wine Alliance, and
Hilton San Francisco.

Library of Congress Cataloging-in-Publication
Data available.
ISBN: 978-0-8118-6608-8 (hardcover)
ISBN: 978-0-8118-6626-2 (softcover)

Manufactured in China

Fine Arts Museums of San Francisco
Ann Heath Karlstrom
Director of Publications and Graphic Design
de Young, Golden Gate Park
50 Hagiwara Tea Garden Drive
San Francisco, CA 04118-4502

Edited by Elisa Urbanelli
Designed by Zach Hooker
Produced by Marquand Books, Inc.
www.marquandbooks.com

10 9 8 7 6 5 4 3 2 1

Chronicle Books LLC
680 Second Street
San Francisco, CA 94107
www.chroniclebooks.com

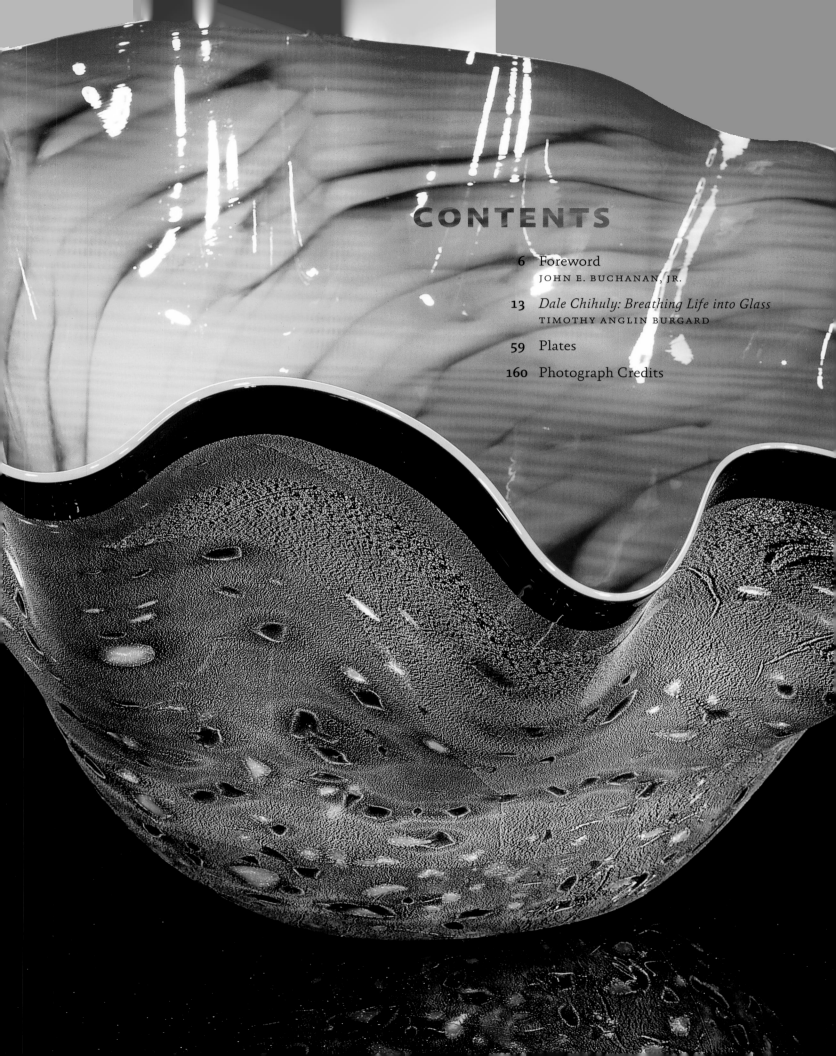

CONTENTS

FOREWORD

FEW ARTISTS CAN LEGITIMATELY CLAIM to have transformed an entire medium through their work. Dale Chihuly is one of these rare artists. His extraordinary glass sculptures challenged a functional vessel tradition that had existed for thousands of years and helped to demolish the critical and curatorial barriers that had previously prevented glass objects from being viewed as a serious art form. In retrospect, his longstanding interest in a communal model of art-making, and in exporting it to global venues, seems remarkably prescient.

It is with great pleasure that the Fine Arts Museums of San Francisco host the exhibition *Chihuly at the de Young*, Dale Chihuly's largest to date, and his first in our city. Historically, the Bay Area has provided a fertile ground for the creation of objects in all media, spanning from the Native American traditions admired and emulated by the artist, through the Arts and Crafts movement that provided a precedent for the studio, or team, model of producing handmade objects, to the studio crafts renaissance of the last half-century in which Chihuly has played a preeminent role.

It is especially appropriate that the de Young serves as the venue for this exhibition, as two dozen of Chihuly's works are included in the Dorothy and George Saxe Collection and were featured in *The Art of Craft: Contemporary Works from the Saxe Collection* (1999), a major exhibition and catalogue celebrating the gift of this extraordinary collection to the Fine Arts Museums. Appropriately, we asked the curator of that exhibition, Timothy Anglin Burgard, our Ednah Root Curator of American Art, to serve as the curator of this exhibition. His catalogue essay reflects an interdisciplinary vision of art history and a belief that Chihuly's work merits scholarly consideration within a broader cultural context.

As with any project of this magnitude, we are indebted to many individuals for bringing this superlative exhibition and book to fruition. Our publications director, Ann Karlstrom, oversaw the completion of this book; Elisa Urbanelli, editor and project manager, edited the manuscript with her usual skill; and Suzy Peterson researched and obtained the sometimes elusive photographs for the essay. This handsome volume was designed by Zach Hooker of Marquand Books in Seattle. We are very pleased to be copublishing this catalogue with Chronicle Books of San Francisco, an arrangement shepherded by Alan Rapp, Senior Editor of Art and Design at Chronicle, with Assistant Editor Bridget Watson Payne.

The stunning *Chihuly at the de Young* installation was designed by the artist and the Museums' exhibition designer, Bill White; Juliana Pennington created the elegant exhibition graphics. Exhibitions director Krista Brugnara worked with head registrar

Therese Chen, project manager Elizabeth Scott, and conservator Elisabeth Cornu to coordinate the complicated exhibition logistics and care within the Museums.

Special funding from various sources has made this exhibition possible. It is a great pleasure to recognize our major patron, Koret Foundation. We also thank our sponsors Dorothy and George Saxe, Target, the Winifred Johnson Clive Foundation, and the Ednah Root Foundation. Additional support comes from Bombardier Aerospace Flexjet, The Barkley Fund, Imago Galleries, the Walla Walla Valley Wine Alliance, and Hilton San Francisco. We are grateful to all for their generosity in helping bring the exhibition and its programs and events to our audience.

We are especially indebted to the expertise and skill of the many professionals who make up Team Chihuly. They were involved at every stage of this enormously complex project, from the first discussions to the remarkable installation here in San Francisco. However, our greatest debt is to Dale Chihuly, not only for creating glass works of such extraordinary beauty, but also for sharing these works so generously with the public, thus bringing joy to millions of viewers.

John E. Buchanan, Jr.
Director of Museums
Fine Arts Museums of San Francisco

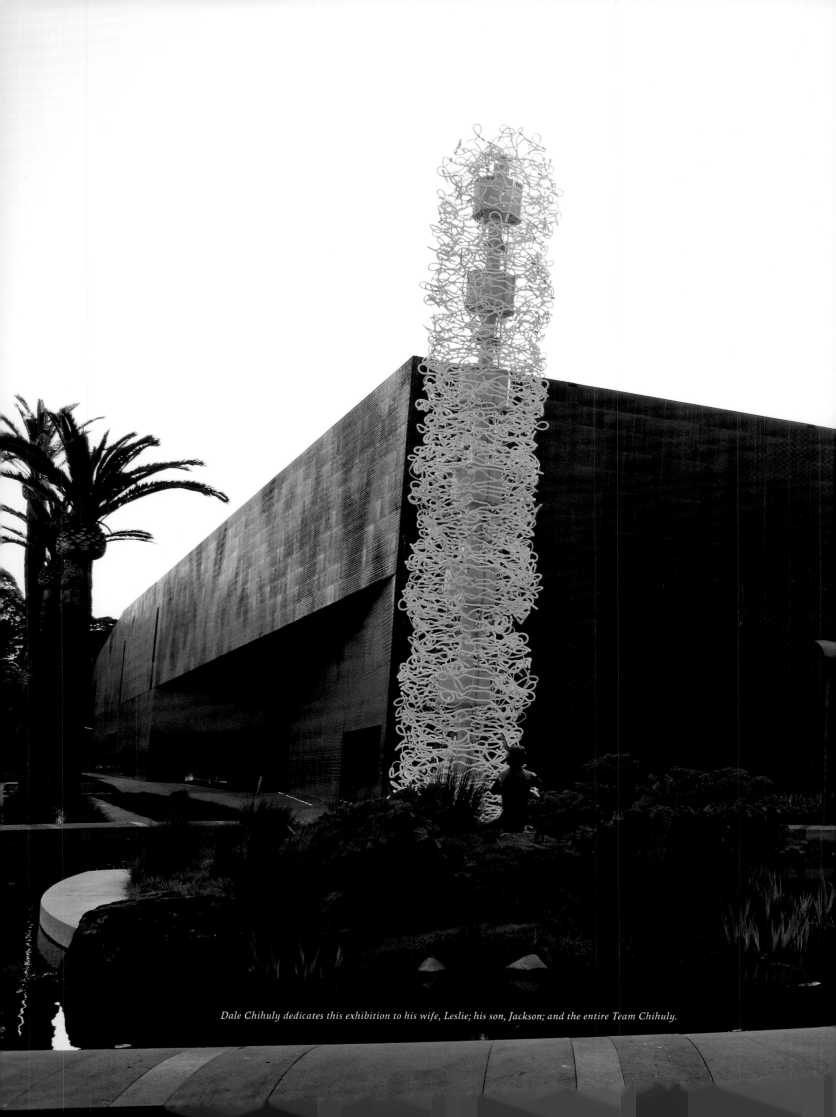

Dale Chihuly dedicates this exhibition to his wife, Leslie; his son, Jackson; and the entire Team Chihuly.

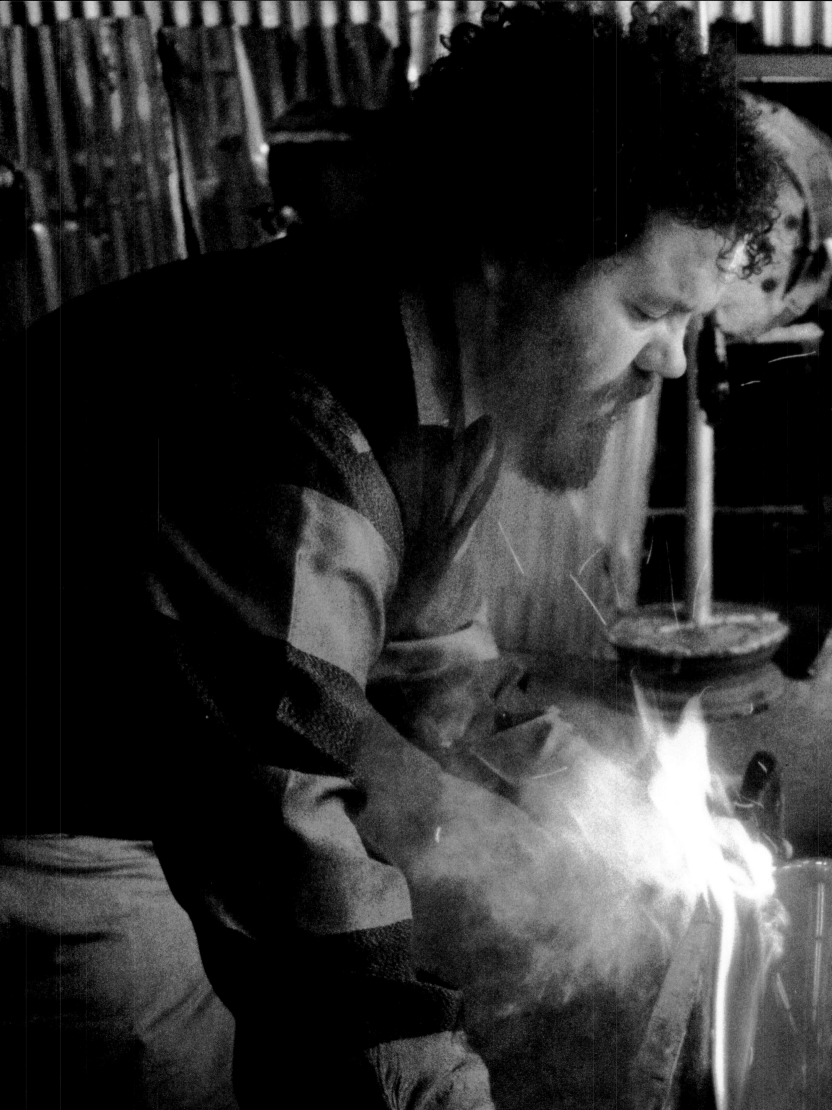

DALE CHIHULY | BREATHING LIFE INTO GLASS

Timothy Anglin Burgard

One can only wonder what kind of genius thought of blowing human breath down a metal tube, forming a bubble inside a molten blob of glass. And to think that this molten blob of glass is made only of silica or sand, the most common material in the world, that can be transformed from a solid to a liquid to a solid just from fire. For me it's the most mysterious and magical of all the inventions or materials that mankind has invented or discovered. Since I was a little boy I always loved glass. And 34 years ago I put a pipe into some stained glass that melted in my basement, and blew a bubble. Since that moment I have spent my life as an explorer searching for new ways to use glass and glassblowing to make forms and colors and installations that no one has ever created before—that's what I love to do.[1] —Dale Chihuly, 2000

DALE CHIHULY (b. 1941) is perhaps the best-known artist associated with the post–World War II studio crafts movement. He is widely credited by both advocates and detractors with transforming or transcending the traditional forms and functions of glass, playing a major role in dissolving the barriers that separated craft from art, introducing contemporary craft into fine art galleries and museums, raising the price structure for all craft objects, pioneering new modes of marketing art, cultivating a broad collector base for contemporary craft objects, reviving the European model of the large-scale studio master and apprentice system, and making the Pacific Northwest a modern Mecca for glass.[2]

It has been more than four decades since Dale Chihuly first blew glass, yet the critical interpretation of his work has evolved little beyond the original and increasingly unproductive debate over the definitions and significance of art and craft. Similarly, the critical reception of Chihuly's work during this period has focused almost exclusively on the means by which the artist's glass objects are created rather than on their meaning. However, Chihuly's contributions cannot be evaluated properly without expanding the context for his work from the postwar American studio glass movement to larger art historical and cultural contexts. In the process, common critical and popular assumptions regarding Chihuly's art and career are challenged, and the necessity for a reevaluation of his proper place in art history is revealed.

Chihuly was born and raised in Tacoma, Washington, a working-class city whose major industries included shipping, railroads, and logging. He spent a fairly typical postwar childhood playing marbles, building model airplanes, collecting *National Geographic* magazines, mowing lawns, washing cars, and delivering newspapers. Chihuly later recalled growing up with his father, George, and mother, Viola:

Neither one of my parents went to college. My dad was in the coal mines up on Mount Rainier with the rest of his brothers, and he was the only one to get out of the mines and get a job, initially as a butcher, and then eventually he became an international union organizer for the AFL-CIO and traveled around the country. When I was young I didn't really see my dad all that much. I remember my childhood as being a perfectly normal childhood—there was a mother who didn't work, who took very

loving care of myself and my brother. My father was a guy about town who was in the Eagles Club and kind of a big shot. He was one of those guys who was kind of up and down—he could be the nicest guy or could have a hell of a temper.[3]

Chihuly's "normal" youth was shattered by the deaths of his older brother, George, Jr., in a Navy flight-training accident in Florida in 1957, and of his father from a heart attack the following year. Burdened with debt, Viola Chihuly went to work as a barmaid, while her son helped out by working at a meatpacking plant. Chihuly reacted to these deaths by breaking street lamps and a police car window—incidents that led to his arrest.[4] Chihuly's reluctance to revisit the trauma of his early life is manifested in his prodigious work ethic and in a personal credo: "I don't think much about the past. I think more about the future. I prefer to be thinking about what I want to be doing tomorrow."[5]

With his mother's urging and financial support, Chihuly enrolled for the 1959–1960 academic year at the College of Puget Sound.[6] A weaving course and a term paper on Vincent van Gogh were rare highlights of an otherwise lackluster academic experience.[7] More significant, given his later interest in installation projects, Chihuly remodeled the basement of his mother's house in the style of Frank Lloyd Wright, one of his heroes.[8] This first experience working with a complete design environment prompted the budding artist to transfer in 1960 to the University of Washington, Seattle, where he studied interior design and architecture.

After two years at the University of Washington, Chihuly traveled in 1962 to Europe, where he was especially drawn to the stained-glass windows of cathedrals and churches.[9] It did not escape Chihuly's notice that these large-scale religious art projects, from the twelfth-century Chartres Cathedral to Matisse's 1951 Chapel of the Rosary in Vence, were visited by millions of tourists who revered these glass works, not for their theological content, but as timeless works of art.[10] Escaping an unusually cold winter, Chihuly traveled south through Greece and Turkey, and then to Israel, where he worked (1962–1963) at Kibbutz Lahav in the Negev Desert.[11] Although he is not Jewish, like other Americans who participated in the kibbutz movement during the 1960s, Chihuly developed a new sense of purpose from this experience in collective living:

> I remember arriving at the kibbutz as a boy of 21 and leaving a man, just a few short months later. Before Lahav my life was more about having fun, and after Lahav, I wanted to make some sort of contribution to society—I discovered there was more to life than having a good time. It's difficult to explain how this change came about, but it had a lot to do with going out on border patrol during the night with guys my own age who had more responsibility and maturity than adults twice their age in the States. After the kibbutz experience my life would never be the same.[12]

Chihuly returned in 1963 with renewed dedication to his studies at the University of Washington, where he earned a B.A. in interior design in 1965. His first artistic insight occurred during this period, when he was given an assignment to incorporate a non-fiber material into a weaving. Chihuly's choice of glass as the material most unlike

fiber—rigid instead of flexible, transparent instead of opaque—endowed several otherwise conventional window hangings with the luminosity of a stained-glass window (fig. 1). His incorporation of glass techniques into a fiber context also provided a cross-media precedent for the later incorporation of fiber techniques into his glass *Navajo Blanket Cylinders* of 1975–1976.

Chihuly's greatest discovery during this period was the blowing of his first glass bubble in 1965, an experience that set him on his career path as a glass artist.[13] Chihuly has revealed that this pivotal event, typically described as a fortuitous accident that occurred while he was melting stained glass for use in his woven window hangings, was somewhat more predetermined:

I don't know why I did it. I'd never seen it done. I didn't know anybody who knew how to blow glass. After trying to research the subject, I very systematically made a pipe and melted a piece of stained glass between five bricks that constituted a ceramics kiln. I put some of the melted glass on the end of the pipe, blew air into it, and the glass bubble sort of accidentally blew up. It probably shouldn't have. It didn't break either.[14]

Fig. 1 Dale Chihuly, *Early Fused Glass Weaving*, 1965. Linen and glass, 35 × 24 × 4 in. Collection of the artist

Recognizing that he had found his calling, Chihuly worked after graduation in 1965 as a designer for John Graham Architects in Seattle and as a commercial fisherman in Alaska, earning money for graduate school. In 1966, he enrolled at the University of Wisconsin in Madison, where he studied with Harvey Littleton, the most famous pioneer of the studio glass movement. It was here that Chihuly broke with the studio craft tradition of solitary glassblowing and first worked with a partner—Fritz Dreisbach—thus establishing the collaborative model he has used throughout his career.[15]

After receiving his M.S. in sculpture in 1967, Chihuly spent the first of several summers teaching glassblowing at the Haystack Mountain School of Crafts on Deer Isle, Maine. If his kibbutz experience had demonstrated the power of collective living to achieve social and economic goals, Haystack revealed the synergy of a communal experience for artists and provided a model for the Pilchuck Glass School, which Chihuly later cofounded.[16]

In 1968, Chihuly received Fulbright funding to study at the Venini glass factory on the island of Murano in Venice, the Mecca of European glass since the thirteenth century.[17] While he admired the Venini factory's team method of commercial glassblowing, his subsequent visits to the studios of independent glass artists such as

Erwin Eisch in Frauenau, Germany, and Stanislav Libensky and Jaroslava Brychtova in Prague convinced him of the need to develop a new model of glass creation in the United States.

THE COUNTERCULTURE ARTIST

Chihuly's glass sculptures typically are discussed primarily in technical and aesthetic terms, as if they are largely lacking in significant cultural content.[18] As early as 1975, Chihuly encouraged this perception of his collaborative work with James Carpenter, stating, "We are less concerned with being narrative or figurative, but we are involved in the glass and the light that passes through it—the phenomenon of light being transmitted through colored glass. The designs are to bring out the light and the quality of the glass—if the piece gets too complex or narrative, you begin to compete with this."[19] However, Chihuly also said of his work during this early period, "I don't care what people call them—containers, sculpture, craft, fine art—as long as they're given as much consideration as other objects that represent the maker's feelings and ideas."[20]

When viewed in historical context, the roots of Chihuly's convention-shattering techniques and aesthetics, as well as the philosophy underlying his works, may be traced in part to his involvement with some of the prominent political, social, and cultural issues of the late 1960s and early 1970s, while he was both a student (1967–1968) and faculty member (1969–1980) at the Rhode Island School of Design (R.I.S.D.), where he established the school's first glass program.

This turbulent period was characterized by numerous traumatic events, including the assassinations of Martin Luther King, Jr., and Robert F. Kennedy in 1968, and was dominated by civil conflicts over the Vietnam War. Soon after President Richard Nixon announced the invasion of Cambodia on April 30, 1970, student protests spread to college campuses nationwide, most famously at Kent State in Ohio, where on May 4 National Guard troops opened fire on antiwar protestors, killing four students.

At R.I.S.D., Chihuly helped organize a student strike that shut down the campus.[21] He and John Landon also organized the erection of a large antiwar billboard in Providence.[22] In keeping with Chihuly's growing preference for collaborative projects, Landon recalled that he and Chihuly "literally would drive down the street, collecting people off the street to work on this project."[23] The completed billboard bore a printed statement, chosen by Chihuly, that many readers assumed had been made by Richard Nixon or another administration official. Only at the end of this nationalistic, law-and-order quote did readers have their assumptions about its authorship jarringly contradicted:

> The streets of our country are in turmoil. The universities are full of students rebelling and rioting. Communists are seeking to destroy our country. Russia is threatening us with her might and the republic is in danger. Elect us and we shall restore law and order. We will be respected by the nations of the world for law and order. Without law and order, our republic will fall. —Adolf Hitler, 1932

The attribution of this previously published quote to Adolf Hitler was subsequently challenged. Nonetheless, the billboard installation documents Chihuly's strong anti-war position.[24] Soon after, Chihuly, Landon, and other members of the R.I.S.D. community joined the May 9 march on Washington, D.C., where they protested the invasion of Cambodia, the Kent State killings, and the Vietnam War.

In April 1971, Chihuly collaborated with the artists James Carpenter and Italo Scanga to create an explicit antiwar statement in glass (fig. 2), which he documented photographically. As Chihuly recalled, "Jamie and I blew glass into a mold Italo had made out of bamboo. Needless to say, it burned up instantly, but I guess we succeeded in making some sort of anti-Vietnam War statement."[25] While this less public and largely symbolic act of protest in the R.I.S.D. hot shop may have been of limited political efficacy, it reflected the widespread belief that artists with a social conscience should not remain disengaged from contemporary events.[26]

Determining whether any of Chihuly's other works from this period contain a comparable political component—public or private—is problematic. *Glass Environment #3* (fig. 3) of 1968 was installed in the unfinished basement of a former funeral parlor in Providence, Rhode Island, where the artist worked and lived.[27] Chihuly's description of these pendant glass objects, some spray-painted red, as "slabs of meat from a butcher," recalls both his father's work as a butcher and his own experience working

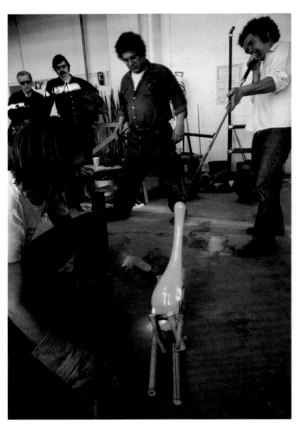

Fig. 2 Italo Scanga, Dale Chihuly, and James Carpenter blowing glass into a bamboo mold at the Rhode Island School of Design, 1971

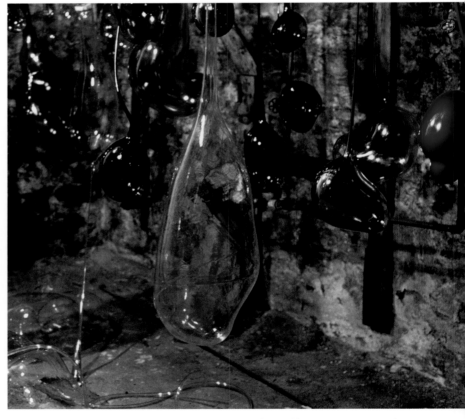

Fig. 3 Dale Chihuly, *Glass Environment #3*, 1968. Blown glass and lacquer paint, 200 sq. ft. No longer extant

in a meatpacking plant following his father's death.[28] The visceral forms may have served as a private memorial to the deaths of his father and brother.

For contemporary viewers unaware of Chihuly's personal history, this installation may have evoked associations with the graphic violence inflicted on human bodies during the Vietnam War era, which the media brought into the homes of American readers and viewers. Like Rembrandt van Rijn's famous painting *The Flayed Ox* (fig. 4) of 1655, Chihuly's installation explicitly confronted the materiality of the flesh and implicitly questioned the existence and locus of the immaterial spirit.

Chihuly's interest in themes of mortality and immortality was more subtly explored in a collaboration with James Carpenter, *20,000 Pounds of Ice and Neon* of 1971. This work, composed of neon tubes encased in approximately sixty, three-hundred-pound blocks of ice, debuted in the controlled environment of a commercial icehouse (see page 1), whose darkened interior heightened the subtle variations in the translucency of the ice medium.[29] A second version (fig. 5) was installed outdoors adjacent to the entrance of R.I.S.D.'s Woods-Gerry Gallery, which housed the annual faculty art exhibition.

As the ephemeral *20,000 Pounds of Ice and Neon* slowly melted and disappeared over a ten-day period, it pointedly highlighted the hubris of museums dedicated to preserving artworks for posterity, long after the deaths of their creators. Like other artists of the period who introduced time as an element through the creation of ephemeral installations, Chihuly and Carpenter subverted Hippocrates' famous aphorism *ars longa, vita brevis* ("art is long, life is short") by suggesting that both art and life are equally ephemeral.

Chihuly and Carpenter's *Glass Forest #1* and *Glass Forest #2*, of 1971–1972, fused glass and technology to give permanence to the ephemeral effects of nature. Both installations were composed of approximately five dozen white milk-glass stalks created by blowing molten glass from the top of a stepladder to the floor below, where the deflated bubble pooled like congealed candy. These glass stalks or stems were arranged in enclosed spaces of approximately five hundred square feet and were illuminated by electrically charged argon and mercury. With their globular collapsed bases and gracefully ascending stalks, the individual elements appear to be shaped by, and yet to defy, the forces of gravity.

Glass Forest #1 was first installed in an all-black Plexiglas and vinyl-covered space at the Museum of Contemporary Crafts (now the Museum of Arts & Design) in New York. (See the re-creation, *Glass Forest #3*, in the plate section.) *Glass Forest #2* (fig. 6)

Fig. 4 Rembrandt van Rijn (1606–1669), *The Flayed Ox,* 1655. Oil on wood, 37 × 27⅛ in. Musée du Louvre, Paris

Fig. 5 Dale Chihuly and James Carpenter (b. 1949), *20,000 Pounds of Ice and Neon*, 1971. Ice, neon tubes. Installation view in front of the Woods-Gerry Gallery, Rhode Island School of Design, Providence. No longer extant

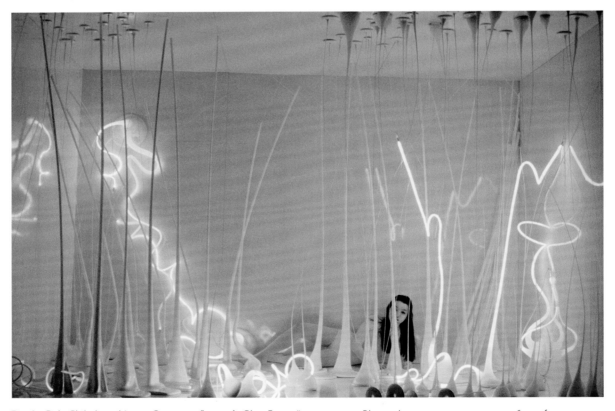

Fig. 6 Dale Chihuly and James Carpenter (b. 1949), *Glass Forest #2*, 1971–1972. Blown glass, neon, argon, approx. 160 sq. ft. Installation view at the Rhode Island School of Design, Providence. Now owned by Museum Bellerive, Zurich, Switzerland

was installed first in an all-white space at the annual faculty art exhibition in the R.I.S.D. Museum of Art.[30] On opening night, Chihuly and Carpenter positioned a young Asian American art student named Eva Kwong, who was dressed entirely in white, within the installation.[31] For Chihuly, who had spent the previous summer at the newly formed Pilchuck Glass School near rural Stanwood, Washington, these ethereal terrariums may have re-created his experiences in the Northwest forest.

In Providence, at the height of the Vietnam War, the appearance of an Asian American woman in the midst of this forest must have seemed evocative—if not provocative.[32] However, any possible political interpretation was defused by the luminous purity of the white installation, which captured the pacific power of nature. The two interpretations were not necessarily mutually exclusive, as the Vietnam War generation often sought solace for the ills of civilization amid nature's transcendent beauty.

THE GLASS COMMUNE

Chihuly's experience organizing the student strike and antiwar protests at R.I.S.D. reinforced his belief in the enormous potential of collective action and dovetailed with his desire to further the evolution of glass in the United States. Chihuly later recalled that these two goals were explicitly linked: "During the downtime that resulted from this strike, a graduate student named John Landon and I began to talk seriously about starting a glass school."[33] This vision was realized in 1971, when Chihuly cofounded the Pilchuck Glass School on land donated by John and Anne Gould Hauberg.

Chihuly observed that this western endeavor symbolized a conscious rejection of the eastern establishment: "It was non-institution time. Non-establishment. The whole idea of being in an established university or art school like R.I.S.D. just didn't seem to be the right thing. It was a time for experimentation. I wanted to teach in a different way, without the confines of the traditional institution."[34] Chihuly noted that his choice of an unimproved site that lacked buildings, electricity, and telephones "was all part of this 'back to the earth' movement."[35] He lived in a van the first summer and, embracing the environmental movement's principle of recycling, built a cabin out of old windows the second year.

Reflecting the divisive tenor of the times, one group of artists lobbied to transform Pilchuck from a glass school into a multimedia art commune, while others lobbied for the production of commercially viable glass.[36] However, both groups perceived handmade objects as providing a humanist alternative to the mass-produced objects that pervaded postwar life. As technology and modernism increasingly were critiqued during the 1960s, handcrafted objects were perceived as signifying alternative lifestyle choices with populist, communal, and even countercultural associations. These larger trends dovetailed with Chihuly's own aspirations and experiences, and distinguished him as both an innovator and a man of his time.

According to his friend and fellow Pilchuck instructor Italo Scanga, Chihuly rejected the "decadent" commercial traditions he had observed in Venice and focused on reinventing glass in an American idiom:

We got up early in the morning and we went to the hot shop. I would do drawings and show them to Dale and Jamie and say, "Is this possible to do?" Or I would come in with garlic and onions and manure and put it on the glass. This stuff they learned from Venice—we were trying to break it. It became so decadent. . . . But at Pilchuck they tried to start afresh. Brand new. It was very primitive. . . . Rough. Very American, very Northwestern. I thought it was very, very original.[37]

Many of Chihuly's early Pilchuck works were not only emphatically noncommercial, they were not even single objects in the Venetian vessel tradition.[38] His *Pilchuck Pond* installation of 1971 consisted of irregular, clear glass bubbles that were placed in a pond near the hot shop, where they floated until the water evaporated in the summer heat. In a second work, *Glass Environment* (fig. 7), Chihuly embedded small, tendril-like glass tubes in the forest floor. In both installations, Chihuly sought not to copy nature but to emulate natural processes—to find the common ground between the nature of glass and nature itself.[39]

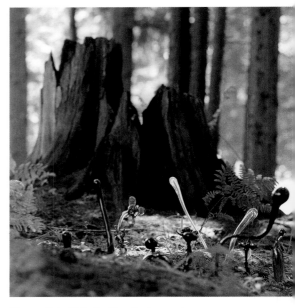

Fig. 7 Dale Chihuly, *Glass Environment*, 1971. Blown glass. Installation at Pilchuck Glass School, Stanwood, Washington. No longer extant

THE COMMUNAL STUDIO

Chihuly's communal, or team, model of glassblowing, forged during the Pilchuck experience and refined during his subsequent career, is one of his most important contributions to the American studio glass movement.[40] Contrary to popular perception, Chihuly's loss of his left eye in a car crash in 1976 and the dislocation of his right shoulder in a bodysurfing accident in 1979 were not the impetus for his working method. Rather, these events reinforced a preexisting desire to work in a collaborative and communal manner. As early as 1966, two years before his first trip to Venice, five years before he cofounded Pilchuck, and a decade before he lost his eye, Chihuly relied upon a partner—Fritz Dreisbach—to implement his vision.[41]

Perhaps in compensation for the early loss of his brother and father, throughout his adult career Chihuly has sought out and bonded with male artists who either became like fathers (e.g., Stanislav Libensky), like brothers (e.g., Italo Scanga), or like sons (e.g., William Morris).[42] Over time, his partnerships have expanded to encompass an extended surrogate family of glassblowers, either working daily in his studio or on call for periodic special projects. Chihuly has speculated, "My Dad was a union organizer and worked with a team. Maybe my knack for teamwork came from him?"[43]

Chihuly's communal practice of making glass is mirrored by the habits of many of his patrons, for whom glass collecting is less a part-time hobby than a lifestyle choice. These collectors are nearly tribal in their loyalty to their shared passion, which

is expressed not only through professional forums such as museums, galleries, societies, publications, and conferences, but also through an informal network of friendships that are formed at annual craft fairs throughout the country. It is a rare serious collector of contemporary glass who does not know most of his colleagues—and competitors—even if they meet only once or twice a year.

Chihuly's periodic series of sculptures are heralded by these collectors upon their arrival and can be repeated, chronologically, like a litany: *Navajo Blanket Cylinders, Baskets, Macchia, Seaforms, Persians, Venetians, Ikebanas, Floats, Chandeliers,* etc. Chihuly's series offer collectors the dual pleasures of owning a unique object and knowing that it belongs to a larger family of objects that are conceptually bound together. Chihuly has inspired patrons of his work to invest, not just in individual objects, but also in his collective vision for contemporary glass. The active participation of these collectors in the glass community suggests that they seek a meaningful communal experience otherwise lacking in contemporary society.

The strong communal and countercultural components of the Pilchuck Glass School also were expressed through a shared fascination with Native American cultures. The name *Pilchuck* was derived from the Chinook Indian words for *red* and *water*, a reference to the iron-rich and rust-tinted waters of the nearby Pilchuck River.[44] One of the first structures erected on the site was John Landon's Sioux-style tepee, a communal gathering spot where the painter Robert Hendrikson, who called himself "White Eagle," introduced the Pilchuck community to Native American spiritualism and ecological responsibility.[45] The information packet sent to students who registered for the second summer in 1972 included reproductions of Edward S. Curtis's photographs from the *North American Indian* folio (1907–1930).[46] That summer John Landon built an Indian-style sweat lodge next to a pond on the site, while John Hauberg gave slide lectures on Native American art.[47]

These interests mirrored a broader cultural context in which Native American culture and politics gradually entered the consciousness—and conscience—of Euro-American society. Influential events that coincided with the early years of Pilchuck included the occupation (1969–1971) of San Francisco's Alcatraz Island by Native American activists, which Marlon Brando supported by declining his Best Actor Oscar for *The Godfather* (1972); the publication of Dee Brown's *Bury My Heart at Wounded Knee* (1970); and the occupation of Wounded Knee, South Dakota, by the American Indian Movement (1973). These serious political issues were paralleled in popular culture by the proliferation of a market for Native American crafts, especially Zuni turquoise jewelry, Pueblo pottery, and Navajo blankets. Given this cultural context, it is not surprising that two of Chihuly's earliest series of works—the *Navajo Blanket Cylinders* (1975–1976) and the *Baskets* (1977)—were inspired by Native American craft traditions.

NAVAJO BLANKET CYLINDERS

Chihuly's first major series of glass objects, the *Cylinders* of 1974, morphed into the *Navajo Blanket Cylinders* of 1975–1976. Chihuly, who could not afford to collect Navajo blankets because of their renewed popularity and higher prices, instead collected blankets manufactured by Pendleton and other companies, and some of the early *Cylinders* were inspired by these trade blankets.[48] However, the *Navajo Blanket Cylinders* (fig. 8) replicated and improvised on the patterns of Navajo blankets by fusing glass-thread "drawings" by Kate Elliott and Flora C. Mace to the surface of the cylinders.[49] The forms of these early cylinders bear a remarkable resemblance to Native American ceramic vessels created by the Maya (fig. 9), which Chihuly would have known from his visits with James Carpenter to ancient American sites and museums in Mexico and the Yucatan peninsula in 1972–1973.[50]

The Navajo blanket motifs that Chihuly applied to his cylinders were inspired by the fiber-and-glass window hangings (fig. 1) that he created at the University of Washington (1960–1962, 1963–1965); Andy Warhol's R.I.S.D. Museum of Art installation entitled *Raid the Icebox I: With Andy Warhol* (1970), which incorporated Navajo blankets (fig. 35); Chihuly's teaching experience at the Institute of American Indian Arts, Santa Fe (1974); and an exhibition at the Museum of Fine Arts, Boston (1975), which included Navajo blankets.[51] Chihuly exhibited the *Navajo Blanket Cylinders* at

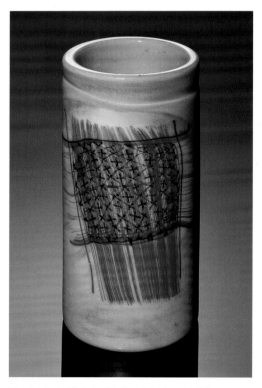

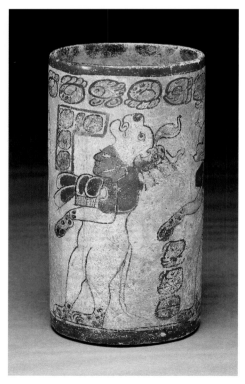

Fig. 8 Dale Chihuly, *Blanket Cylinder with White Threads*, 1975. Blown glass, 11½ × 6 × 6 in. Collection of Malcolm and Clarice Grear

Fig. 9 Unidentified artist, Central Maya Area (Maya Culture). Processional vase of animal companions, ca. A.D. 600–800. Earthenware and paint, 8¾ × 4½ in. Fine Arts Museums of San Francisco, promised gift of Gail and Alec Merriam, L06.144.11

the Institute of American Indian Arts in 1975 and at Brown University's Bell Gallery in 1976, where they were displayed with a selection of Navajo blankets.[52]

BASKETS

Chihuly's second major series, the *Baskets*, was inspired by a 1977 visit with James Carpenter and Italo Scanga to the History Museum at the Washington State Historical Society in his hometown of Tacoma. Viewing the museum's collection of Northwest Coast Indian baskets, Chihuly was struck by their pliable yet strong structures, and by the way in which their symmetrical forms had been distorted while stacked together for storage.[53] Chihuly had acquired his first Native American basket in 1970, and Carpenter had started collecting Northwest Coast Indian baskets during the summer of Pilchuck's founding in 1971.[54] As a native of the Northwest and a former textile artist, Chihuly was exceptionally receptive to the history and aesthetics of these traditional fiber containers.

Chihuly's *First Baskets* installation of 1977 (fig. 10) at the Seattle Art Museum Pavilion paid tribute to his magical first encounter with the basket collection at the History Museum. These baskets of folded glass replicated the effects of weight, gravity, and time on their prototypes, while simultaneously transcending these forces by being rendered in a permanent medium. Chihuly's *Black Set* (fig. 11) of 1980 recalls the luminous blackware pottery (fig. 12) created by Maria Martinez of San Ildefonso Pueblo in New Mexico. Modeling her work on archaeological prototypes, Martinez transformed modern blackware into a marketable commodity whose renewed popularity in the 1960s and 1970s made her the most famous Native American artist and a cultural icon.[55]

Fig. 10 Dale Chihuly, *First Baskets*, 1977. Blown glass, approx. 3 × 24 ft. Installation at the Seattle Art Museum

Chihuly's artistic embrace of Navajo blankets, Northwest Coast baskets, and Pueblo pottery can be viewed within a broader cultural context. These objects were among the first Native American crafts to be appreciated and collected for their aesthetic qualities in the late nineteenth century. Louis Comfort Tiffany's *American Indian*

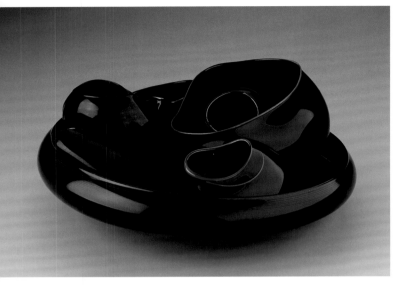

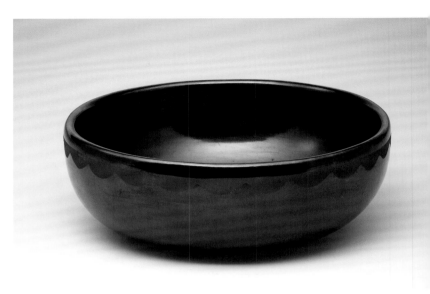

Fig. 11 Dale Chihuly, *Black Set*, 1980. Blown glass, 6¾ × 16 × 15 in. Fine Arts Museums of San Francisco, partial and promised gift of Dorothy and George Saxe, 2002.148.9

Fig. 12 Maria Montoya Martinez (1887–1980) and Santana Martinez (1909–2002). Bowl, ca. 1950–1960. Ceramic, 3½ × 9¼ in. Fine Arts Museums of San Francisco, bequest of George Frederic Ward, 1987.21.5

Basket Lampshade (fig. 13), like Chihuly's later *Navajo Blanket Cylinders*, fused fiber motifs and the glass medium to capitalize on this interest. These cultures appeared to preserve unbroken traditions of mythology, spirituality, communal responsibility, environmental sensitivity, and artistic creation, and thus they seemed to provide modern Euro-American viewers—and artists—with access to the roots of a collective past.

Maturing as an artist during this peak period of interest in Native American cultures, Chihuly embraced their objects both as an artist and as a collector. He later enshrined the sources of his inspiration and the resulting creations in the Indian Room installation (fig. 14) of his Seattle Boathouse studio, which houses four hundred trade blankets by Pendleton and other makers, seventeen *Navajo Blanket Cylinders*, eighty-three Native American baskets, nineteen glass *Baskets*, forty-four framed photogravures of Indian women from Edward S. Curtis's *North American Indian* folio, an Algonquin birchbark canoe, and a 1915 Indian Twin motorcycle.[56] Fittingly, given the communal philosophy that Chihuly implemented both at Pilchuck and in his studio, the wood post-and-plank architecture of the Indian Room recalls another type of communal gathering place—the Native American longhouse.[57]

Ironically, while many Navajo blankets, Northwest Coast baskets, and Pueblo pots were modeled on historical antecedents, their forms, colors, and content often were influenced by Euro-American patronage and by their marketing as commodities within the context of the tourist industry. Chihuly's Pendleton blankets, Curtis photogravures, and Indian motorcycle reveal that he values not only original Native American objects but also objects that have been inspired by these cultures—like his own *Navajo Blanket Cylinders* and *Baskets*.[58] Chihuly's defining aesthetic of cultural appropriation,

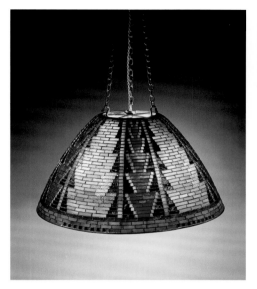

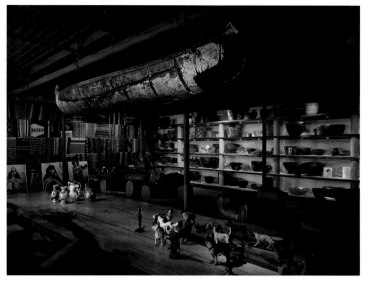

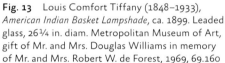

Fig. 13 Louis Comfort Tiffany (1848–1933), *American Indian Basket Lampshade*, ca. 1899. Leaded glass, 26¼ in. diam. Metropolitan Museum of Art, gift of Mr. and Mrs. Douglas Williams in memory of Mr. and Mrs. Robert W. de Forest, 1969, 69.160

Fig. 14 Dale Chihuly, The Indian Room at the Boathouse, Seattle, 1990–present

fusion, and hybridity is epitomized by the Indian Room, which reveals his ability to knit together culturally diverse objects and ideas into a unified whole.

Chihuly, who became internationally known for his later engagement with Persian, Italian, and Japanese cultural traditions, founded his mature career on the appropriation and assimilation of indigenous Native American craft traditions. Rejecting traditional Euro-American artistic conventions and embracing alternative Native American models, he created a new paradigm for the field of American glass art, one that retained an aura of the counterculture through its associations with indigenous cultures that had been marginalized by the political establishment.

SEAFORMS

Chihuly's *Seaform* series evolved in 1980 from the Native American *Basket* series, a link revealed not only by their irregular, organic forms but also by a comparison with Edward S. Curtis's *Washo Baskets* (fig. 15), a photogravure owned by Chihuly. The *Seaforms* epitomize both Chihuly's negotiation with his unpredictable medium and the fine line that separates nature and culture: "We are using gravity, centrifugal force, the heat, the fire, all of these different elements, and in many ways we are not totally in control. It's letting the glass also make the form. Going with it, I want the pieces to be very often as if they are from nature. And so you are not sure, is it man-made? Is it made by nature?"[59]

The *Seaforms* represent a subtle shift from the culturally derived *Baskets* back to nature, the artist's deepest and perennial source of inspiration: "Then the *Baskets* started looking like sea forms, so I changed the name of the series to *Seaforms*, which suited me just fine in that I love to walk along the beach and go to the ocean. And glass

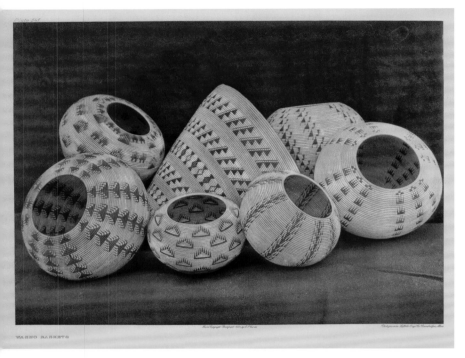

Fig. 15 Edward S. Curtis (1868–1952), *Washo Baskets*, ca. 1924. Photogravure, 13¾ × 17⅜ in. Published in *The North American Indian* (Norwood, Mass., Plimpton Press, 1924), vol. 15, plate 541. Collection of Dale Chihuly

itself, of course, is so much like water. If you let it go on its own, it almost ends up looking like something that came from the sea."[60]

The *Seaforms* are permeated with the aqueous atmosphere that is the defining element of the Pacific Northwest. Chihuly has spent most of his life on or near Puget Sound, which is not unlike an enormous aquarium teeming with life, surrounded by a humid rainforest terrarium filled with abundant flora and fauna. Chihuly's deep ties to water in all its forms span from childhood walks along the beaches of Puget Sound to his mature career, in which he situated the two versions of his Boathouse studio on the water—the first (1980–1983) on Pawtuxet Cove, Rhode Island, and the second (1990–present) on Lake Union in Seattle.[61]

Chihuly has linked the origins of glass to a water environment through the myth of shipwrecked Mediterranean sailors accidentally creating glass from a beach bonfire some four thousand years ago.[62] He also perceives water as a major source of his own creativity, noting, "One of the great attractions of being in the Northwest is the rain. I find the rain very creative. Water is the one thing that I can assure you is a major influence on my work and my life and everything I do. . . . If I don't feel good or I don't feel creative, if I can get near the water something will start to happen."[63]

Pale Green Seaform Set with Green Lip Wraps (fig. 16) of 1980 appears to be suspended in water. The symmetrical spheres with radial patterns recall sea urchin shells, while the undulating rims of the larger forms are reminiscent of the translucent jellyfish that float in Puget Sound, morphing rhythmically through their own swimming motion and through the wave action that distorts their symmetry. Despite the resemblance of the *Seaforms* to marine life, Chihuly has observed that he is not trying to copy nature but to replicate its processes and sensory effects:

> But I don't bother to study shells, it's mostly a feeling of underwater. Real shells don't look so great out of context. If you take them out of the water and sand and put them in your house they don't hold up so well. And similarly if my glass pieces are taken to the water and the beach, they don't look so great either. They are really meant to be in a room.[64]

The organic morphologies of the *Seaforms*, which appear to be pulsing and beating, opening and closing, prompted one of Chihuly's greatest revelations—the transformation of supposedly inert materials into equivalents for living, breathing beings: "One

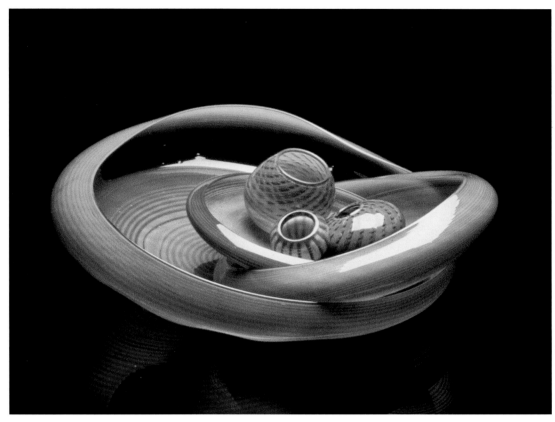

Fig. 16　Dale Chihuly, *Pale Green Seaform Set with Green Lip Wraps*, 1980. Blown glass, 4 × 12 × 12 in. Collection of the artist

thing I like about the association with sea creatures is the importance that gives to an opening or orifice. The process of blowing wants to leave a hole to account for the original entry, where the air first came in."[65]

MACCHIA

If the *Seaforms* emulated the element of water to achieve a new understanding of form, the *Macchia* series, begun in 1981, embraced the element of fire to achieve a break-through in Chihuly's use of an expanded color palette.

> The *Macchia* series began with my waking up one day wanting to use all three hun-
> dred of the colors in the hot shop. I started by making up a color chart with one color
> for the interior, another color for the exterior, and a contrasting color for the lip
> wrap, along with various jimmies and dusts of pigment between the layers of glass.
> Throughout the blowing process, colors were added, layer upon layer. Each piece
> was another experiment. When we unloaded the ovens in the morning, there was
> the rush of seeing something I had never seen before. Like much of my work, the
> series inspired itself. The unbelievable combinations of color—that was the driving
> force.[66]

As Chihuly acknowledges, the rippling forms of the *Macchia* series (fig. 17) were derived from the "Fazzoletto" or "Handkerchief" vases (fig. 18) created by Fulvio Bianconi for

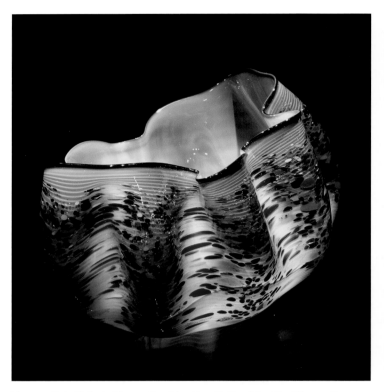

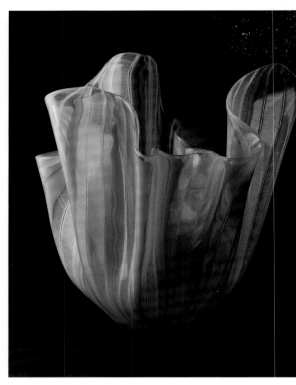

Fig. 17 Dale Chihuly, *Thames Gray Macchia with Kingfisher Blue Wrap*, 1982. Blown glass, 6 × 9 × 7 in. The George R. Stroemple Collection

Fig. 18 Fulvio Bianconi (1915–1996) and Paolo Venini (1895–1959), Fazzoletto ("Handkerchief") Vase, ca. 1950. Blown glass, 11½ × 12 in. Los Angeles County Museum of Art, gift of Mr. and Mrs. Glenn W. Tripp, M.84.203

Paolo Venini in the late 1940s.[67] Their Italian ancestry is acknowledged in the series title, which was proposed as "Spotted" by Chihuly and translated as *Macchia* by his friend Italo Scanga.[68] These large-scale works seemed to cross an invisible boundary separating so-called craft objects from sculpture, prompting Chihuly to observe, "I felt for the first time that a single piece of my glass could hold its own in a room."[69]

The *Macchia* also owe an historical debt to the dazzling juxtapositions of colors contained in the stained-glass windows of European cathedrals, although Chihuly deployed the colors in the service of organic form rather than figurative narration. He explicitly linked his experience of these stained-glass windows with a major technical innovation in the *Macchia*—the creation of an interlayer of "clouds" or white glass that allows the overlaid colors on both the interior and exterior to retain their brilliance and integrity.[70] Chihuly also experimented to achieve compatibility between the various glass colors, which can be highly reactive when combined.[71]

The artist's fascination with color can be traced to vivid childhood memories of his mother's abundant flower gardens and the spectacular sunsets he and his brother viewed with her. As Viola Chihuly later recalled in a newspaper interview, "I'd be right in the middle of peeling potatoes or something, and I knew just when the sun was about to set because I could see it from our kitchen window. I'd clap my hands, which meant, 'Come on, we're going to run up the hill.' And we'd tear up to the top, one on

each side, me holding on to their little hands as they flew up there. All my life I've been crazy for sunsets." The reporter concluded, "She is not alone. Chihuly says that, for him, color is always an outgrowth of nature—sunsets, to be sure, the treasures of the sea, the vibrant flower gardens he was always warned not to step on as a youth."[72] A photograph of *Macchia* arrayed like giant flower blossoms on the grass at the Pilchuck Glass School (fig. 19), evoking Viola Chihuly's flower gardens, suggests the objects' deep roots in nature.

However, the *Macchia* relate most directly not to flowers but to molten glass. Often balanced slightly off-center, they attempt to capture the essence of glass in its most volatile state—simultaneously hot and flowing, but also cool and congealing. The blurred edges of the color striations and "spots" suggest that they are being dissolved by heat or have coalesced into opal-like mineral deposits. Chihuly's "lip wraps," thin ribbons of colored glass that run along the vessel's lip, suggest the presence of a superheated inner core and recall the leading edge of a lava flow, breaking through the perimeter of a magma mass. Like the interior of Washington's active volcano Mount Rainier, whose inverted form appears to have inspired the shape of a related series created in 1992, Chihuly's *Macchia* are permanently aglow with the fires of their creation.[73]

Fig. 19 *Macchia* on the grass at the Pilchuck Glass School, Stanwood, Washington, 1983

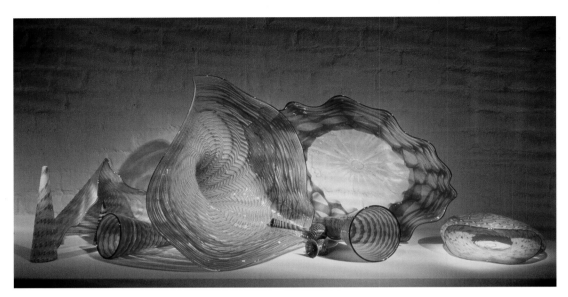

Fig. 20 Dale Chihuly, *Rose Madder and Green Persian Shelf*, 1988. Blown glass, 18½ × 46 × 20 in. Private collection

PERSIANS

The works in Chihuly's *Persian* series, begun in 1986, like the earlier *Navajo Blanket Cylinders* and *Baskets*, mine history and culture for their content, but on a global stage. As Robert Hobbs has noted, "'Persia' connotes a special and distant realm of refinement and luxury, a place where mathematics, calligraphy, walled gardens, rich carpets, mystical love poetry, and elaborately decorated, finely blown glass vessels were created and respected. Persia was located on the ancient silk route along which caravans traveled to and from China with spices, porcelain, silk, and new ideas. It was a crossroads between East and West, a seat of culture, as well as a transmitter of concepts."[74]

The *Persian* series resonates with romanticized notions of Orientalism, an historical construction that was challenged by Edward Said's influential book, *Orientalism* (1978). The definition of Persia itself had been recently redefined by the overthrow of the Iranian monarchy and the institution of an Islamic state. However, as Chihuly observed, his source of inspiration lay not in the present but in the past: "I don't know why I call these pieces *Persians*. I didn't do any research on the arts of ancient Persia. But the forms make me think of mystical, enchanted gardens and minarets."[75] He later recalled, "I just liked the name *Persian*. It conjured up 'Near Eastern,' 'Byzantine,' 'Far East,' 'Venice,' all the trades, smells, scents. It was an exotic name to me, so I just called them *Persians*."[76]

Chihuly has suggested that the *Persians* are meant to evoke the sense of wonder experienced by early European explorers such as Marco Polo (1254–1324/25), who traveled to distant lands and encountered new experiences—and new objects.[77] At first glance, many of Chihuly's *Persians* resemble an archaeological cache of treasured objects. Among the defining components of the *Persians* (fig. 20) are accumulations of flared beakers and long-necked vessels that suggest scientific, alchemical, or even magical usages, but whose exact purpose remains indecipherable. Chihuly no doubt identifies with the concept of a cultural explorer, as this is a key component of his

artistic identity. He continually explores and reinterprets the history and culture of glass, developing new forms for contemporary viewers so that they may experience a sense of wonder comparable to that of Marco Polo's audiences.

Chihuly's flared beakers recall the glass vessels that served as emblems of sensory pleasure and mortality in seventeenth-century Dutch and Flemish *vanitas* still-life paintings. These memento mori, or mortality-themed works, encouraged meditations on the fragility of both earthly possessions and existence, as well as on the inevitability and finality of death. Chihuly's conjunction of flared geometric beakers with curvilinear biomorphic forms serves as a reminder that human bodies are merely physical vessels for the metaphysical spirit, another common *vanitas* conceit. Chihuly also has explicitly identified biological imagery in his *Persians*, observing:

> I've tried hundreds of color combinations in the *Persians*. Lately I've been making very brightly colored little ones that go inside or alongside a large stemmed form. The stem was first developed to hold the bottom piece into a wall, but then I found that it also held the piece upright on a shelf in a nice way. The stem is the pontil and like an umbilical cord. Traditionally, that part of the piece was ground off, but I like to leave it on.[78]

Chihuly's large tazza forms, with "little ones" nestled within their folds, evoke a mother sheltering her young. This family analogy also may extend to the larger "family" groupings that constitute the artist's glass series and installations, as well as his numerous

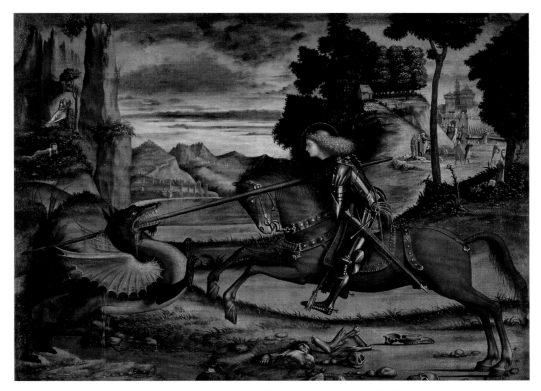

Fig. 21 Vittore Carpaccio (1460–1525), *Saint George and the Dragon*, ca. 1502–1506. Oil on canvas, 37 × 27 in. San Giorgio Maggiore, Venice

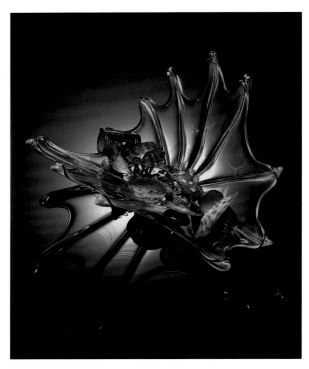

Fig. 22 Dale Chihuly, *Opaline Spined Sea Form with Cadmium Yellow Persians*, 1986. Blown glass, 14 × 25 × 19 in. Collection of the artist

collections of antiques and collectibles, which he prefers to purchase in groups (fig. 36) rather than one object at a time.

Chihuly has disclosed that one source for the *Persians* was Vittore Carpaccio's Renaissance painting *Saint George and the Dragon* (fig. 21), which he knows well from his numerous trips to Venice.[79] In the legend of the same title, a plague-bearing dragon terrorizes the inhabitants of a town, who appease the beast with animal and human sacrifices. On the day when the king's daughter is to be sacrificed, Saint George comes upon the scene and confronts the dragon. He wounds the dragon with his lance, ensnares the beast with the princess's girdle, and later kills it.

Chihuly's *Opaline Spined Sea Form with Cadmium Yellow Persians* (fig. 22) explicitly appropriates the spiny form of the dragon's wings in Carpaccio's painting to cradle a seemingly random assemblage of glass objects. The implicit association of these glass pieces with the dismembered body fragments scattered across Carpaccio's landscape dramatically confirms the artist's correlation of glass vessels with living entities. This conception also recalls the fragmentary nature of Chihuly's early *Glass Environment #3* (fig. 3), a work that may evoke the artist's deceased father and brother, George, Sr., and George, Jr. The symbolism of their namesake saint—George—slaying the deadly dragon and rescuing the female figure is particularly resonant given their premature deaths, which devastated the family and left Chihuly as his mother's sole protector.

VENETIANS

The *Venetian* series, begun in 1988, marked a symbolic return to Venice, Chihuly's true birthplace as a glass artist. He has described his residency at the Venini factory in 1968 as a formative experience that "changed my attitude and ideas about glassblowing forever."[80] Venice, a glass capital famously defined by two of his favorite elements—water and light—remains the artist's favorite city and a constant source of glass history and new inspiration.[81] The genesis of the *Venetian* series was an invitation to Lino Tagliapietra, the great Italian master, to blow glass at Chihuly's studio in Seattle. In the interim, Chihuly traveled to Venice, where he viewed a private collection of Venetian Art Deco glass by artists such as Napoleone Martinuzzi, Alfredo Barbini, Dino Martens, and Vittorio Zecchin.[82]

> I was fortunate enough to be invited to this palazzo and saw this extraordinary collection of Venetian glass from the twenties and thirties. I had never seen any of this sort of Art Deco Venetian glass. It really isn't in any museums that I know of. It's not

in any books. It's quite different from the French Art Deco work. It is a little more garish, the colors bolder: green and gold leaf, green and red. I'm a bit of a collector myself and I was thinking I would try to collect some of this glass. I talked to different Venetian glass dealers to see what was around, and it just was not available. This one guy would snap up just about anything for sale. So, I said to myself, "Well, I'll just have Lino make the damn things."[83]

The *Venetians*, which represent the full flowering of Chihuly's organic and chromatic conception of glass, are defined by a baroque aesthetic of exuberance—or even excess—that is deeply rooted in the Venetian tradition. This is especially true of the colors, which owe as much, if not more, to the extraordinary color combinations in the Renaissance paintings of Titian, Veronese, and other Venetian masters as to the glass produced in the factories of Murano. Chihuly's neo-expressionist use of form and color for their own sake, so foreign to American sensibilities, is one of the liberating characteristics of the *Venetians*.[84]

At the core of the *Venetians* is a vessel or vase form of the type that was perfected in the traditional glass shops of Venice and that epitomized glass as "craft" in much of the Western world. However, the central vessel is overwhelmed by a profusion of exotic flora and fauna; handles become sinuous vines, slugs, or serpents, and vases sprout flowers, ferns, and flames. Some of these organic elements appear in historical examples of Venetian glass, in which they typically are decorative and subservient to the object's dominant identity as a vase.

In Chihuly's *Venetians*, the surface ornament extends outward, animating the surrounding environment and reducing the vessel to a mere supporting role. In *Gold Over Cobalt Venetian* (fig. 23) of 1989, the columnar vessel is not only subsumed within a swirl of flamelike leaves but actually bent out of shape by this whirlwind. Chihuly, who had circumvented the functional-vessel tradition with his early glass installations, undermined it with the *Navajo Blanket Cylinders*, and discarded it completely with the *Seaforms*, revived and embraced it for the *Venetians*. Here the vessel form serves as a foil for his true subject, the triumph of creativity over convention, of nature over culture, and of art over craft.

Fig. 23 Dale Chihuly, *Gold Over Cobalt Venetian*, 1989. Blown glass, 22 × 12 × 11 in. Private collection

36

IKEBANA

Chihuly's *Ikebana* series, begun in 1989, represents an inversion of the dynamic that characterized the *Venetians*, returning the unruly blossoms and foliage to the vases that they had previously outgrown in order to explore the possibility of revitalizing the vessel tradition. The series title, *Ikebana* ("arranged flower"), also known in Japan as *kado* ("the way of flowers"), refers to the traditional Japanese art of flower arrangement. In contrast to a Western aesthetic of abundance, ikebana is grounded in a simplified and stylized aesthetic in which twigs, leaves, blossoms, and even the container are all important elements of the composition, which must create a harmonious whole. Many ikebana arrangements are composed with the silhouette of a scalene triangle, whose three points are symbolic of heaven, earth, and man.

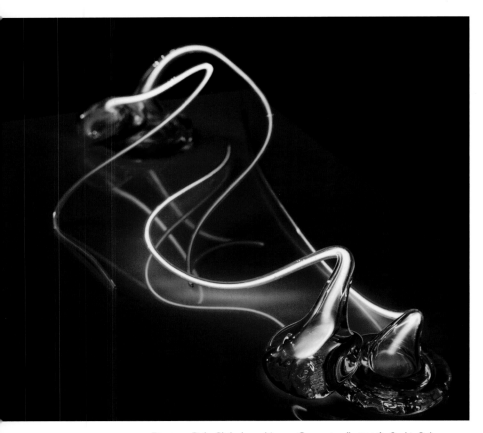

Fig. 24 Dale Chihuly and James Carpenter (b. 1949), *Orchis Pubescence,* 1970. Glass, neon, argon, 30 in. long. Location unknown

The *Ikebana* were prefigured two decades earlier by a series of sculptures based on imaginary floral forms that Chihuly and James Carpenter created in 1970 at the Haystack Mountain School of Crafts and by neon and argon variants that they exhibited at the Toledo Glass National III later the same year.[85] The latter sculptures, their first publicly exhibited works, were titled with exotic and erotic Latin names such as *Orchis Pubescence* (fig. 24), *Physalia Deluxeus, Medusae Superioris,* and *Monotropa Uniflora*.[86] Frequently fusing botany and zoology, Chihuly's mature *Ikebana* flowers appear to oscillate between soft, snail-like creatures ready to retreat into their protective, shell-like vases and carnivorous, snakelike creatures that aggressively seek out prey.

Carpenter, a R.I.S.D. illustration major specializing in botanical drawings, had originally approached Chihuly as a collaborator in 1970 because he wanted to blow botanical forms inspired by the famous Leopold and Rudolf Blaschka Collection of glass flowers (fig. 25) at Harvard University's Museum of Natural History.[87] During a visit to the Blaschka Collection with Carpenter soon after, Chihuly recognized that the works' extraordinary appeal comes not just from replicating real flowers so perfectly but from doing it so miraculously in glass, suggesting the infinite potential of the medium.

The flowers, leaves, and vines of the *Ikebana* may serve partly as a tribute to the artist's mother and her abundant flower gardens, which she kept in bloom all year.[88] However, animated as some of the *Ikebana* blossoms may appear as they struggle and

stretch to escape confinement, they represent cut flowers that wilt and fade, and as such they are traditional *vanitas* symbols of mortality and the fleeting nature of beauty. The origins of ikebana may be traced to the Buddhist practice of offering flowers to the spirits of the deceased, and Chihuly's series was partly inspired by the gilt, carved wood lotus blossoms that he had admired in Japanese Buddhist temples.[89]

Chihuly's selection of sunflower blossoms for several of his *Ikebana* hints at their artistic ancestry in the paintings of the most famous artist to depict the flower— Vincent van Gogh. The subject of Chihuly's first serious art history paper in college, Van Gogh is one of the artist's heroes.[90] Chihuly vividly recalls the Metropolitan Museum of Art's 1984 *Van Gogh in Arles* exhibition, which included several of the Dutch artist's iconic sunflower paintings (fig. 26). Van Gogh's works were in the news again in 1987, when a Japanese insurance corporation purchased *Sunflowers* (1888), attributed to Van Gogh, for $39.9 million, a record price for a painting. As suggested by Paul Gauguin's portrait *Van Gogh Painting Sunflowers* (1888), sunflowers were an emblem or surrogate for the Dutch artist.[91]

Van Gogh's several paintings of sunflowers in a vase allude to the cycles of life and death by including blossoms both at the peak of their beauty and in desiccated decline, a conceit codified in seventeenth-century Dutch *vanitas* still lifes of flowers. Several of Chihuly's *Ikebana* vases (fig. 27) contain single sunflowers, with blood-red centers that glow as if either pulsing with the dawn of a new day or cooling like a setting sun.[92] These singular buds serve as poignant and poetic offerings to a solitary

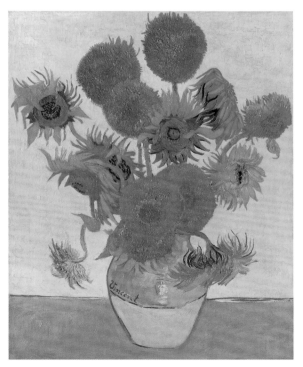

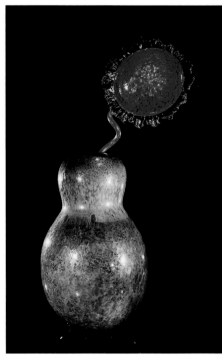

Fig. 25 Leopold Blaschka (1822–1895) and/or Rudolf Blaschka (1857–1939), *Panicum Boreale (Panic Grass)*, ca. 1887–1936. Blown glass. Harvard University Museum of Natural History

Fig. 26 Vincent van Gogh (1853–1890), *Sunflowers*, 1888. Oil on canvas, 36¼ × 28¾ in. National Gallery, London, bought by the Trustees of the Courtauld Fund, 1924, NG3863

Fig. 27 Dale Chihuly, *Metallic Silver Ikebana with Cadmium Red Flower*, 1992. Blown glass, 45 × 24 × 16 in. Private collection

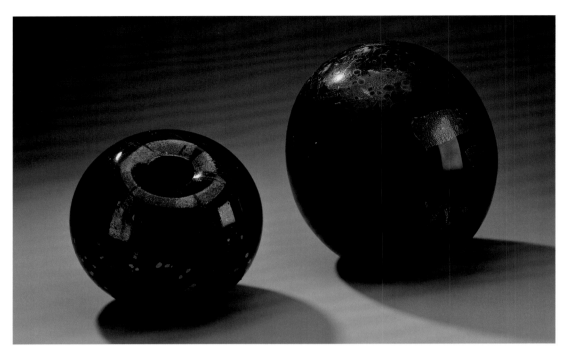

Fig. 28 Dale Chihuly, *Mottled Black Float*, 1992. Blown glass, 16 × 17 × 17 in.; *Gilded Silver Black Float*, 1992. Blown glass, 22 × 19½ × 19½ in. Fine Arts Museums of San Francisco, partial and promised gift of Dorothy and George Saxe, 2002.148.12, 2002.148.13

and manic-depressive artist who toiled in obscurity during his brief career, supported professionally and personally only by his loyal brother. While Chihuly has not worked in obscurity, he identifies with Van Gogh's perennial creative struggle, and he certainly shares a lasting bond with his own deceased brother, who was cut down in the prime of life.[93]

NIIJIMA FLOATS

Chihuly's *Niijima Floats*, begun in 1991, were inspired by a 1989 trip with his glassblowing team to the glass school on the island of Niijima, Japan, in the Bay of Tokyo.[94] The trip rekindled memories of childhood walks along the beaches of Puget Sound, where he collected Japanese floats and their fragments that had washed ashore.[95] Reminiscing about the origins of his lifelong fascination with glass, Chihuly remarked:

> It started, I'm sure, back when I was a little kid. Walking on a beach somewhere, I found a little bit of glass. It could've been a bottle like this that had broken on a rock into a hundred pieces, which was then dispersed on the beach for a hundred kids to find. And then you take thousands and millions of bottles that this happened to, and millions of Japanese fishing floats, and millions of other objects of glass . . .[96]

Unlike their functional counterparts, which typically measure less than twelve inches, the *Niijima Floats* range in size from one to nearly four feet in diameter, truly stretching the technical limits of glassblowing.[97] Their relatively restricted physical vocabulary includes spherical, ovoid, or dimpled mushroom-cap forms, with or without a small

circular opening. Their kaleidoscopic colors, often high-lighted by gold and silver leaf, are reminiscent of both Japanese lacquerware and Chihuly's childhood marbles, which he also linked to his early love of glass.[98]

The *Niijima Floats* epitomize the most basic form in glassblowing—the bubble—a shape whose natural associations are accentuated by the objects' placement on the ground, as if they had grown there, rather than on a platform or pedestal, which would signify their status as art objects. Installed on a bed of glass shards at the American Craft Museum in New York in 1992, the *Floats* resembled fishing floats that had been cast upon a beach. Scattered across a grass courtyard at the Honolulu Academy of Arts in 1992, they evoked a field of giant fungi or a game of enormous marbles.

The *Niijima Floats* most resemble lava bubbles or igneous rocks that have cooled from molten magma and retain sparkling inclusions of colorful minerals. The colored *Floats* recall magnified aquatic or terrestrial cells, spores, embryos, or eggs, and seem pregnant with unseen potential for life, while the black *Floats* call to mind celestial spheres encompassing the cosmos. The variegated and mottled surfaces of Chihuly's *Floats* (fig.

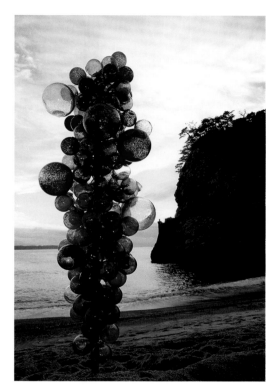

Fig. 29 Dale Chihuly, *Niijima Tower*, Niijima, Japan, 1997. Blown glass and steel, 8 × 3 ft. diam. No longer extant

28) appear to incorporate fragments of beach glass that have been gathered and fused to the spheres, as if in an attempt to reconstruct glass vessels that had been shattered, tumbled in the ocean, and washed up on a beach.

By its very nature, the glass fishing float—a breath or air bubble rendered permanent and carried by ocean currents around the world—is a symbol of passage and transition.[99] As Chihuly observed, "There are literally millions of fishing floats still in the Pacific, caught in the trade currents, going round and round."[100] In 1997, on the beach of Niijima, Chihuly symbolically reconstructed the glass fragments of his childhood into a triumphant *Niijima Tower* (fig. 29), thus bringing full circle the voyage that had commenced on the shores of Puget Sound five decades earlier with a bit of beach glass.

CHANDELIERS

If Chihuly's *Venetians* marked a symbolic return to Venice through his work, the *Chandeliers* installed in the *Chihuly Over Venice* project of 1996 represented a reciprocal gift to the city that signified his birth as a glass artist. This logistically complex project, which entailed the installation of fourteen large-scale *Chandeliers* at public sites around the city, coincided with the *Venezia Aperto Vetro*, the city's first contemporary glass biennal.[101] Chihuly's project, which incorporated glass fabricated by collaborative teams at factories in Nuutajärvi, Finland; Waterford, Ireland; and Monterrey, Mexico,

represented the most ambitious expression of his communal model of working and his populist philosophy of display:

> Working with a team is good for me—new people, new ideas, new places. *Chihuly Over Venice* started out with the end in sight—which was the *Chandeliers* hanging over the canals. But the people became more important. All the glassblowers and artisans from different countries working hand in hand with all the Americans. The hanging of the *Chandeliers* became secondary to the people interaction.[102]

Chihuly's first *Chandelier*, created for an exhibition at the Seattle Art Museum in 1992, reflected his longstanding interest in the integration of architecture and glass.[103] His revival of the form originated in his observation that the chandelier, which historically had played a major role in defining interior architectural space, had been deemed obsolete by International Style architects.[104] In a gesture that embraced both continuity and change, Chihuly installed his contemporary *Palazzo Ducale Chandelier* (fig. 30) directly beneath a traditional eighteenth-century Venetian chandelier in one of Venice's most historic buildings.[105]

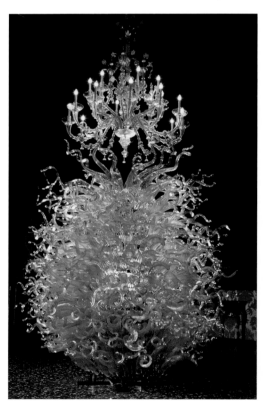

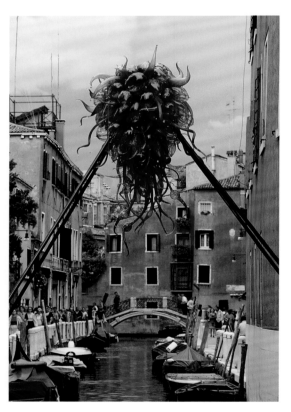

Fig. 30 Dale Chihuly, *Palazzo Ducale Chandelier*, 1996. Blown glass, steel, 9 × 8 ft. diam. Installed in the Palazzo Ducale, Venice, beneath an 18th-century chandelier by the firm of Galliano Ferro, Murano, Venice. Collection of the artist

Fig. 31 Dale Chihuly, *Rio delle Torreselle Chandelier*, 1996. Blown glass, steel, 6 ft. 9 in. × 8 ft. 2 in. diam. Installation view, Venice. Now owned by the Cincinnati Art Museum, museum purchase, with funds provided by Mrs. Richard Thayer, Geraldine B. Warner, Robert and Fay Boeh, Martha and David Wolf, Mary Lynn and Thomas M. Cooney Fund, Dick and Peggy Andre, Cincinnati Art Museum Womens' Committee, Dr. Stanley and Mickey Kaplan/Kaplan Foundation, 2001.37

Breaking with this architectural tradition, the other thirteen *Chandeliers*, many of them appropriately incorporating aquatic-themed forms, were installed in public spaces near the canals of Venice (fig. 31). Chihuly's selection of these public sites reminded viewers that he is an installation and performance artist, a maestro who orchestrates the creation and exhibition of glass for new audiences.[106] As Barbara Rose has observed, "Chihuly is the only artist, outside of Robert Rauschenberg perhaps, who manages actually to live out the sixties' dream of making environmental art for the people and of connecting groups in communal situations."[107] Chihuly has cited the influence of the installation artists Christo and Jean-Claude, whose most famous project, the wrapping of the Reichstag building in Berlin, was completed in 1995, the year before he mounted his own ambitious installation in Venice:

> Christo and Jean-Claude are among the artists that inspired me the most. I really connect with their projects and the way they do them. Some time ago, I saw one of the documentary films about one of their first big projects, called Rifle Gap in Colorado. The concepts seemed like such a unique undertaking. We went to Berlin when they wrapped the Reichstag. They had 1,200 people working on it. . . . In many ways what I do is a smaller version of what they do.[108]

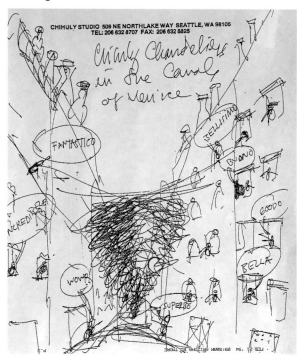

As Chihuly's early installation works at R.I.S.D. demonstrate, his performance persona was an essential element of his artistic identity from the beginning of his career. Although the loss of his eye in 1976 compelled him to largely relinquish the physical act of glassblowing, it allowed him to expand the performance possibilities of glass creation and viewing. He projected this new, magnified vision into the public realm through installations such as *Chihuly Over Venice*, as well as the films and publications documenting these performances. Chihuly has often observed that the communal process of creation, along with the audiences who participate in his projects, are as important as the glass objects, which constitute only the physical record of the installation experience.

Fig. 32 Dale Chihuly, *Chihuly Chandeliers in the Canals of Venice*, 1994. Pen on paper, 11 × 8½ in. Collection of the artist

Chihuly's complex installations are not just set pieces but sets—theatrical stages upon which he, his works, and their audience are all protagonists. As Chihuly observes, "I'm as interested in the way my art works in a public space as in the art itself."[109] His theatrical conception is apparent in *Chihuly Chandeliers in the Canals of Venice* (fig. 32) of 1994, a preparatory study for the *Chihuly Over Venice* project. The city of Venice is replicated in flanking stage-flat format, while a colossal, suspended Chihuly *Chandelier* occupies center stage. From their front-row windows, the resident spectators shout out superlatives ("Fantastico," "Incredibele," "Wowo," "Superbo," "Bella," "Goodo," "Buono," "Bellisimo") like an appreciative audience at

La Scala in Milan. Chihuly's set designs (1992–1993) for the Seattle Opera's performance of Claude Debussy's *Pélleas and Mélisande* only made more explicit the theatrical tenor of his glass installations.[110]

CRITIQUE AND CONTEXT

Chihuly's public visibility and popularity reached new heights with the *Chihuly Over Venice* installation and the televised PBS documentary (1998) of the same title. However, criticism of his works also appears to have peaked at this moment, when the artist and his works seemed to have reached a saturation point in the public consciousness.[111]

A review of the earlier literature reveals that Chihuly received nearly universal praise as a pioneer of the studio craft movement during the first two decades of his career. Substantial criticism of the artist's works began to appear only in 1986, the year his *Objets de Verre* exhibition was held at the Musée des Arts Décoratifs at the Louvre. It is tempting to speculate that this hallowed venue, with its implicit claim that Chihuly's "glass objects" should be perceived as fine art (and could hold their own on a global stage), earned Chihuly the enmity of both "craft" and "fine art" artists, dealers, and critics who believed that their territorial prerogatives were threatened. Art world politics aside, the major criticisms of Chihuly's works are worth examining, as their underlying assumptions are as revealing as their overt content.

The most common criticism is that Chihuly has not blown glass since the loss of his eye (and attendant depth perception) in 1976, instead relying on his communal, or team, method of glassblowing. Like his predecessor Louis Comfort Tiffany, Chihuly

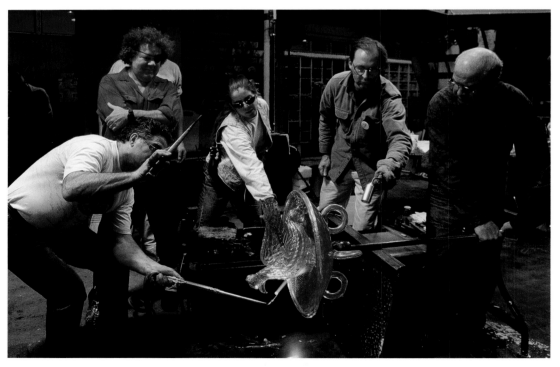

Fig. 33 Pino Signoretto, Dale Chihuly, Patricia Davidson, Charles Parriott, and Lino Tagliapietra at Chihuly's Boathouse studio, Seattle, 1994

is known for using works fabricated by other artists, not only from his own studio (fig. 33) but also from other glass shops.[112] Most notably, *Chihuly Over Venice* (1996) incorporated glass fabricated by collaborative teams in Finland, Ireland, and Mexico.[113] The *Chihuly in the Light of Jerusalem* (2000) project utilized glass made by not only local Arab glassblowers but also a Japanese maker of traditional fishing floats.[114]

Chihuly choreographs and deploys his glassblowers and crews like actors on a stage. These surrogates are expected to subsume their creative personae within his own, prompting Flora C. Mace to observe, "When I work for Dale, I almost become him."[115] Chihuly's favorite analogy for this process is film—of which he is an avid aficionado:

> I feel like I move around my studio team during a blowing session as a director might tour a set while shooting a film. Let's say my master blower is the head cameraman and my color person is similar to the lighting or makeup person on a soundstage. Film is so clearly a collaborative team effort that I use it as an obvious comparison. I'm also fond of drawing parallels between the way I work and the way an architect relates to his group.[116]

While neither critique of Chihuly's creative process is completely true (he does occasionally blow glass and his team approach predates the loss of his eye by a decade), why either of these issues should pose a problem for critics is an interesting question. Partial blame may be traced to the romantic ideal of artists as the sole creators of their unique works. This trope dates back at least as far as Giorgio Vasari's mythologizing of Michelangelo (despite that artist's use of assistants), and still attaches itself to contemporary artists, thanks in part to Hans Namuth's photographic canonization of Jackson Pollock (fig. 37) as the epitome of the force-of-nature creator.

Glassblowers are especially susceptible to the criticism of not creating their own work, as associations with the primordial element of fire and the magical qualities of the molten-glass medium raise viewers' expectations that glass can be created only by a Promethean artist capable of harnessing these dangerous elements (fig. 34). However, an arbitrary double standard applies to glassblowers, since it is a common and widely accepted art-world practice for contemporary painters, sculptors, and printmakers to have assistants who help fabricate—or even create—their works.

At his Factory studio, where the commercial means of production were inseparable from the meaning of the work, Pop artist Andy Warhol collaborated with, and authorized, assistants to make silkscreen paintings that left the studio with his signature. Similarly, artists aligned with minimal, performance, installation, and conceptual

Fig. 34 Dale Chihuly, *Untitled*, 1995. Acrylic on paper, 60 × 40 in. Collection of the artist

art, in which the idea is perceived to take primacy over the execution, are allowed exceptional latitude for the outside fabrication of works. If Chihuly were recognized not only as a sculptor who works primarily with glass, but also as the performance and installation artist that he has been since the beginning of his career, criticisms of the means of his glass production would seem largely irrelevant.[117]

Criticism of Chihuly's studio as an overly commercial enterprise may be attributed in part to the persistence of the romantic ideal of artists who live solely for their art, oblivious to crass material concerns. Professional jealousy also may be a contributing factor, despite the fact that Chihuly has played a major role in elevating the price structure for all so-called craft objects, thus breaking through the glass ceiling that had confined them to the category of secondary decorative arts. Chihuly considers himself one of the first artists to "charge what I wanted for the work," commencing with his *Navajo Blanket Cylinders*, for which he asked the unprecedented sum of $1,000 in 1975.[118]

While Chihuly is by any estimation a marketing genius, he has neither dissolved the boundaries between art and commerce nor sold out (however one might define such a subjective standard) any more or any less than one of his heroes, Andy Warhol, against whom similar charges frequently were leveled.[119] Like Warhol, Chihuly has embraced a commercial studio model of production; marketed the resulting works through gallery sales, commissions, and limited editions; and pushed the boundaries of conventional taste. Chihuly himself acknowledges that it would be difficult to underestimate the impact of Warhol's life and work on his own:

> Andy Warhol was a big influence on me. He was alive when I was younger and I once traded with him. He wanted one of the pieces in my gallery and I was glad to do it. He has done so many things and influenced a lot of creative people. He did a lot of movies that people haven't seen. Many of them are pretty boring, but I still think they had a huge influence on filmmakers. And then he did *Interview* magazine. It was very avant-garde at the time it came out. It influenced magazines a great deal. He also had a band [*Velvet Underground*], a really hip band before there were very many like it. He wrote a couple of books, designed shoes, and even did store windows. I just find his work very interesting and it has made a lasting impression on me.[120]

Chihuly's first significant encounter with Warhol's work occurred during the exhibition *Raid the Icebox I: With Andy Warhol*, which was on view at the R.I.S.D. Museum of Art in 1970, during Chihuly's first year as head of the new glass department. Given free rein to create an exhibition drawn from the museum's permanent collection of forty-five thousand objects, Warhol created an audacious installation (fig. 35) that challenged and subverted museological conventions of history, connoisseurship, cataloging, and display.[121]

Warhol randomly installed groupings of chairs and an entire collection of shoes, in their storage cabinets, with hatboxes stacked on top. Paintings were installed on their storage racks, and several Old Master paintings of dubious quality were stacked together on the floor, braced by sandbags.[122] Sharing Chihuly's taste for Native American art, he chose Northwest baskets, Mound Builder ceramics, and Navajo blankets

Fig. 35 Andy Warhol (1928–1987), *Raid the Icebox I: With Andy Warhol*, 1970. Installation view, Museum of Art, Rhode Island School of Design, April 23–June 30, 1970

Fig. 36 Chalkware figurines, Dale Chihuly's Tacoma Studio I, Tacoma, Washington

over the European highlights of the museum's collection.[123] Warhol's ability to conceive a total environment that would challenge viewers, to create meaning from seemingly disparate individual elements, and to have this vision serve as a signature or surrogate for the artist's identity must have had an enormous impact on Chihuly, the nascent installation artist.[124]

Chihuly's Seattle studio, the Boathouse, recalls Warhol's New York studio, the Factory, which also revived the European studio system of art making and promoted a 1960s communal aesthetic. While Chihuly's current studio (which employs more than one hundred people) appears to have little in common with his original communal conception for the Pilchuck Glass School, they share a rejection of convention and a desire for absolute creative freedom. As Chihuly has observed, the size of his studio has less to do with money than with what money can buy:

> I never really intended for my studio to be this big. On the other hand, I let it get this
> big. In order to do what you want to do, you often have to have freedom. And so I
> have the freedom to use the resources to make whatever I want to do.[125]

Like Warhol's Factory, Chihuly's studio is enormously productive—even prolific—prompting charges that quality has been sacrificed for quantity. Acknowledging his own fallibility as an artist, Chihuly has reflected, "It's tough because I fail a lot. I question my own aesthetics much of the time. I'll make something and really like it, and then a couple of months later not like it."[126] However, like Warhol, who included entire collections in *Raid the Icebox I*, and who also was an obsessive collector of Americana and objects of popular culture, Chihuly has made quantity an aesthetic choice, creating and collecting in volume (fig. 36).[127] For critics who equate prolific with profligate,

Chihuly's fecundity is a weakness, but the artist sees this quality not only as a conscious choice but as a creative necessity:

> Picasso didn't have a lot of employees, people working for him, probably. But Picasso made more work than any artist ever did, in any time, in any century, throughout civilization. I don't even know how many pieces Picasso made, but probably hundreds of thousands of ceramics, tens of thousands of paintings, hundreds of thousands of drawings and prints. By working, you are able to learn and expand. And out of that comes ideas, refinement, more work, more ideas. Other artists work in a different way. They work more quietly and more slowly or more conceptually. But it's not the way I work.[128]

The inherent beauty of Chihuly's chosen medium has led many critics to assume that the works do not lend themselves to serious critical evaluation. This has not stopped reviewers from critiquing his work as beautifully crafted and aesthetically pleasing, but otherwise devoid of meaningful content or lasting significance.[129] Chihuly, an iconoclast who is also a populist, is sanguine about the critical response to his work: "At the end of the day, the public makes their choice as to whether or not the work is important. I'm less concerned with those who write about it, than I am about the public and how they feel about it."[130]

Henry Geldzahler, an early supporter who acquired Chihuly's work for the permanent collection of the Metropolitan Museum of Art, has noted that criticism of the artist on aesthetic grounds may be largely irrelevant: "Chihuly challenges taste by not being concerned with it. He never asks himself whether his work is in good taste. I don't think he knows the difference between good and bad taste. His sole concerns are color, drawing, and form. He does go over the top at times, with pieces about which people say, 'This is really too much,' but perhaps it's not. Five or ten years later it's no longer too much."[131] Chihuly's immunity to both convention and criticism derives in part from the instinctual need to create that is shared by most artists.

> I could dissolve Chihuly, Inc., and Chihuly Land, or Team Chihuly, whatever you want to call it. I could stop the train if I wanted to. I know this: that my life would not be fulfilling now without continuing to work on trying to make new things. There's too much unknown out there not to continue to experiment. There are so many things that I could make that the world has never seen that I have to continue. *Obsessed* isn't the right word. I don't know what the right word is, but it's not obsessed. It's what I am.[132]

THE BREATH OF LIFE

Chihuly's self-identification as an instinctual creator is partially expressed through his conscious emulation of the creative persona and painterly abstraction of Jackson Pollock, an important source of inspiration.[133] Like Pollock, Chihuly has emphasized artistic innovation over convention, process over completion, and intuitive actions over rational thought. Chihuly's perceived affinity with Pollock derives in part from the belief that they both harness natural forces in their works, walking a fine line between conscious intention and chance occurrences, and ultimately aspiring to become like

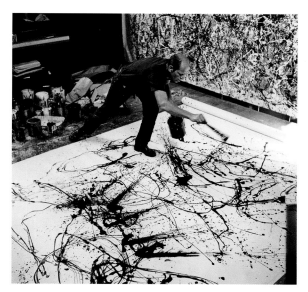

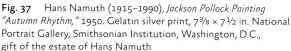

Fig. 37 Hans Namuth (1915–1990), *Jackson Pollock Painting "Autumn Rhythm,"* 1950. Gelatin silver print, 7⅜ × 7½ in. National Portrait Gallery, Smithsonian Institution, Washington, D.C., gift of the estate of Hans Namuth

Fig. 38 Dale Chihuly painting at the Boathouse, Seattle, 1992

nature itself. Glass is uniquely suited to capturing and preserving the evidence of its own creation, of motion and gravity arrested in time. As Chihuly has noted:

> The technology hasn't really changed.... We use the same tools they used 2,000 years ago. The difference is that when I started, everyone wanted to control the blowing process. I just went with it. The natural elements of fire, movement, gravity, and centrifugal force were always there, and are always with us. The difference was that I worked in this abstract way and could let the forces of nature have a bigger role in the ultimate shape.[134]

This aesthetic is also apparent in Chihuly's drawings and paintings, which serve both as an independent means of expression and as a form of communication that enables his glassblowers to implement—and to improvise on—his designs while working in the hot shop.[135] Chihuly's early drawings were emphatically physical, with the skin of the paper impressed and impregnated with the prosaic materials of everyday life: "I would often draw on the steel marvering table with bits of glass under the paper to give it texture. For color, I used whatever I could find around the shop—tea, fruit juices, wine, coffee (my friend Italo [Scanga]'s influence)."[136]

More recently, Chihuly has recognized and embraced the intrinsic connections between the liquid medium of molten glass and his use of liquid acrylic paints: "If you think about my paintings, I work almost entirely now with liquid paint. So the paint itself is a lot like the glass. Everything has to be fluid for me, it seems."[137] Emulating Pollock's famous drip and pour techniques (fig. 37), Chihuly squirts, pours, and drips these paints onto a paper or canvas support laid on the ground (fig. 38), and then spreads them with brushes, brooms, and his own hands, thus giving physical form to his stream-of-consciousness aesthetic.[138]

Chihuly also identifies with Pollock for his perceived ability to tap into the unconscious imagination, thus unleashing instinctual or even archetypal forms of creation.[139] Discussing the series of *Spears* he created with a team in Nuutajärvi, Finland, Chihuly described a visceral rather than a rational creative process, and the power of the artist creator to give form to an idea:

> I don't know where these ideas come from. I really don't think that very many of my ideas come from up here [*gestures to his head*]. They probably don't even come from here [*gestures to his heart*]. I think they come from down here [*gestures to abdomen*]. Somebody told me Picasso once said that the ideas come from the gut.[140]

Chihuly owns one of Warhol's *Oxidation*, or piss, paintings, which were created by having studio assistants urinate on canvases primed with copper-based pigment that then oxidized. Warhol's ironic commentary on Pollock's seminal drip paintings explicitly draws an analogy between bodily fluids and paints.

A similar conception informs Chihuly's drawings such as *Untitled* (fig. 39) of 2000, in which a centralized circular form resonates with associations spanning from the microcosm to the macrocosm—from seeds, to embryos, to celestial orbs. The vertical blood-red shaft is evocative of penetration, fertilization, and growth. This fusion of male and female forces conveys processes of internal creation and external growth, reaffirming the artist's perception of a deep connection between the acts of artistic and biological creation. Chihuly's desire to create or to replicate physical objects that serve as an implicit affirmation of life may have originated in his defining confrontation with mortality and death as a teenager.

Beginning with his childhood discovery of beach glass by the waters of Puget Sound, Chihuly has been fascinated with the transformative powers of nature, as epitomized by glass and water. Chihuly's favorite element—water—can assume the form of ice, snow, rain, fog, and mist, or can evaporate entirely. The duality of water, which can appear solid and permanent, liquid and changeable, and vaporous and ephemeral, exemplifies the concept of transience. Chihuly's instinctual pull to water is reflected in his comment, "Water is the one thing that I can assure you is a major influence on my work and my life and everything I do."[141]

Chihuly's preferred medium—glass—is a super-cooled liquid, and thus is ideally suited to give some semblance of permanence to many of water's defining but ephemeral qualities: light transmission, transparency and translucency, and refraction and reflection. More important, the artist perceives glass, along with water, ice, and plastic, as a physical material that serves as a transformative medium for immaterial light, which in turn can reveal the metaphysical:

Fig. 39 Dale Chihuly, *Untitled*, 2000. Acrylic on paper, 42 × 30 in. Collection of the artist

And so when you're working with transparent materials, when you're looking at glass, plastic, ice, or water, you're looking at light itself. The light is coming through, and you see that cobalt blue, that ruby red, whatever the color might be—you're looking at the light and the color mix together. Something magical and mystical, something we don't understand, nor should we care to understand. Sort of like trying to understand the moon.[142]

Chihuly has embraced photography, another light-based medium, to reveal the spiritual dimension of his work: "I don't feel the work is really finished until it is photographed. It dematerializes the object until I feel I'm looking at its real spirit, its other dimension. That's why I don't collect my own art, only photographs of my work."[143]

Chihuly is intensely aware of the complexities and contradictions of his glass medium, which is both fragile and ephemeral, but also resilient and eternal. His career reflects his ongoing fascination with the fundamental nature of glass as beginning with an inhalation, emanating from the body in the form of an exhalation, and then being transformed by the forces of gravity. In essence, the art of glassblowing is an exaggerated form of breathing.

Regarding his own glass works, Chihuly was struck by a realization: "I thought it was the hot glass that was mysterious, but then I realized it was the air that went into it that was miraculous."[144] The glass bubble that magically embodies human breath may be seen as a metaphor for humankind's desire to transcend earthly existence, but also for the inevitability of mortality. No doubt drawing upon his own painful family experience, Chihuly views glass as a *vanitas* symbol whose fragility might be applied to the frailty of human life:

> There's something about owning something that's vulnerable, in a way. It's the difference between drinking out of the world's most beautiful goblet and knowing that it couldn't break or knowing that it could break; which would give you more pleasure? So I think there's something about the fact that you own this precious thing that may go away.[145]

Although a glass bubble resembles a water bubble in its transparency, the viewer might assume that it differs fundamentally in being bound to the earth by weight and gravity. Yet, over time, Chihuly's glass has evolved from vessel-like objects to increasingly open forms that—like exhalations of breath—have defied gravity, floating onto the walls and up to the ceiling. In a very real sense, Chihuly's vessels, like the human vessel, are vehicles for human breath, or at least the expression of that breath: the ephemeral rendered permanent, and perhaps immortal.

> Why do people want to collect glass? Why do they love glass? For the same reason, I suppose, that many of us want to work with it. It is this magical material that's made with human breath, that light goes through, and that has incredible color. And I think the fact that it breaks is one of the reasons that people want to own it. Isn't it unbelievable that the most fragile material, glass, is also the most permanent material?[146]

NOTES

Extracts from unpublished interviews have been edited for publication.

1. Dale Chihuly, "Chihuly in the Light of Jerusalem," in *Chihuly: Jerusalem 2000* (Seattle: Portland Press, 2000), 29–30.

2. The Pacific Northwest is home to more glass studios (more than one hundred) and artists (more than five hundred) than the Venetian island of Murano. See Margery Aronson, "Seismic Shifts: Chihuly in the Northwest," in Dale Chihuly and Margery Aronson, *Fire: Dale Chihuly* (Seattle: Portland Press, 2006), 9.

3. Dale Chihuly, "Kitchen Sessions," typescript of interview by Mark McDonnell, 15 Mar. 1998, Chihuly Studio Archives, Seattle.

4. See William Warmus, *The Essential Dale Chihuly* (New York: Harry N. Abrams, 2000), 13–14. Chihuly recalled, "I got in trouble, too, in high school, for doing stuff I shouldn't have. But, fortunately and largely, I think because of my mother's influence, I managed to never get in very much trouble. I ran around with guys who ultimately did get in trouble. I would never—you know, sometimes we put out a streetlight, my first work in glass!—but I wouldn't steal a car. I never got to that point." See Susan Resneck Pierce, "Chihuly," *Arches* (Autumn 2000): 18.

5. Dale Chihuly, Barbara Rose, Lisa C. Roberts, and Mark McDonnell, *Chihuly: Gardens & Glass* (Seattle: Portland Press, 2002), 132. Decades later, when he had achieved success as a glass artist, Chihuly donated a retrospective survey collection of his work to the Tacoma Art Museum in memory of his father and brother.

6. Chihuly, who protested that he couldn't afford college, was admonished by his mother, Viola: "When his father died, I did tell Dale, 'There's one thing you're going to do. You're going to college. I don't know how we're going to make it, but we are—so just get over there and register.'" Joan Brown, "Molten Magic: Dale Chihuly's Mystical Artist Sensitivity Flows and Glows in Scintillating Glass," *[Tacoma] Morning News Tribune,* 8 Sept. 1991, 12.

7. Barbara Rose, "The Earthly Delights of the Garden of Glass," in Chihuly et al., *Chihuly: Gardens & Glass*, 48.

8. Chihuly later recalled, "I went to college up the street, and did take a weaving course that first year. And that year I also remodeled my mother's basement, the rec room, and I did a lot of fifties modern and Frank Lloyd Wright drapes and I made my own furniture. And so, I thought I was this cool designer. I'm sure that the weaving class had a lot to do with my wanting to be an interior designer. Because now that I think about it, the drapery in my mother's rec room was this Frank Lloyd Wright weaving. Frank Lloyd Wright's wife was a weaver. Fabric was always important to Wright, and Wright was always a big hero of mine and still is." Chihuly, "Kitchen Sessions," 15 Mar. 1998.

9. Chihuly recalled, "My strongest memory from the cathedrals were the windows. And I think that would probably be true for a lot of people. It's not just because I had a big fascination for glass. I mean, how do you walk into a cathedral with that rose window in there and not have that be your focal point?" Ibid., 5 Mar. 1998.

10. Early in his career, Chihuly observed, "After experiencing places like Matisse's Chapel and Chartres, it's very simple to realize the importance of glass. We specialize in glass I guess, and that's not much of a limitation when you're aware of its potential." Seaver W. Leslie, "Glass in Architecture: An Interview with Dale Chihuly and James Carpenter," *Bulletin of the Rhode Island School of Design* (Mar. 1975): 22. Although they are abstract rather than figurative, Chihuly's stained-glass windows (1980) for the Shaare Emeth Synagogue in Saint Louis, Missouri, were almost certainly inspired by Matisse's famous Chapel of the Rosary (1951) in Vence, France. See Patterson Sims, *Dale Chihuly: Installations, 1964–1992* (Seattle: Seattle Art Museum, 1992), 54–55.

11. See Chihuly, "Kitchen Sessions," 15 Mar. 1998.

12. Chihuly, *Chihuly: Jerusalem 2000*, 28.

13. Thirty-three years later, describing his revelation about the magical properties and power of glass, Chihuly pointed to a cheap, mass-produced, cobalt blue bottle in his studio and observed that even if it were juxtaposed with his priceless Native American basket collection viewers still would be instinctively and inexorably drawn to the luminous glass bottle: "It wasn't a conscious decision, probably, to work with glass. It was just another one of those things that happened in my life that I came upon. It started, I'm sure, back when I was a little kid. Walking on the beach somewhere, I found a little bit of glass." Chihuly, "Kitchen Sessions," 5 Mar. 1998. In another version of his early interest in glass, Chihuly recounted, "Why glass? Suppose a child comes upon some beach glass with sun on it. The little kid will drop everything to get that. Maybe I'm that little kid." "Chihuly in Tacoma" brochure (Tacoma: Museum of Glass, William Traver Gallery, Tacoma Art Museum, 2006).

14. Barbara Perlman, "Dale Chihuly: Master of Glorious Glass," *Arizona Arts & Lifestyle* 4, no. 1 (1982): 49. A more typical account has Chihuly recalling, "One night I melted a few pounds of stained glass in one of my kilns and dipped a steel pipe from the basement into it. I blew into the pipe and a bubble of glass appeared. I had never seen glassblowing before. My fascination for it probably comes in part from discovering the process that night by accident. From that moment I became obsessed with learning all that I could about glass." Chihuly et al., *Chihuly: Gardens & Glass*, 150.

15. According to Chihuly, "When I enrolled in Harvey Littleton's graduate glassblowing program at the University of Wisconsin in 1966, everyone in the department blew glass by themselves. Fritz Dreisbach was the first glass blower I asked for assistance, so Fritz and I made

up my first 'team.' I hardly ever blew glass alone after that." Dale Chihuly, Linda Norden, and Murray Morgan, *Chihuly: Baskets* (Seattle: Portland Press, 1994), 45.

16. Chihuly later recalled of his summers at Haystack, "I had an extraordinary life-changing experience there and was so overwhelmed by everything—the architecture, the site, the people, the social structure, and, more than anything, [director] Fran Merritt. I taught four years in a row and really got to know Fran and Priscilla. I idolized Fran and wanted to be just like him. I started to think about a glass center that would be patterned after Haystack. In 1971, the Pilchuck Glass School did get started on the opposite coast and to this day is very similar in size and structure to Haystack. Pilchuck would not exist if it weren't for Haystack and Fran and Priscilla Merritt." Chihuly et al., *Chihuly: Gardens & Glass*, 130, 132.

17. While working at the Venini Fabrica on Murano, Chihuly designed a never-realized project for an architectural competition sponsored by the city of Ferrara. See Sims, *Dale Chihuly: Installations*, 28–29.

18. Chihuly's political engagement in his work is apparent in the *Chihuly in the Light of Jerusalem* project, which was installed in the historic Tower of David Citadel in 2000. The completed project incorporated stacked *Red Spears* and *en garde Yellow Spears* that recalled primitive weapons —and thus the ancient roots of the Israeli/Palestinian conflict. Chihuly also pointedly incorporated glass objects that he commissioned from Arab glassblowers in Hebron. See Chihuly, *Chihuly: Jerusalem 2000*, 134. Most dramatically, the "Jerusalem Wall of Ice," built with twenty-four massive blocks of Alaskan ice, inevitably recalled not only the historic Western Wall fragment of the First Temple, but also the symbolism of walls as divisive elements in the political geography of the Middle East. The melting of the ice wall over a period of three days functioned metaphorically as "a kind of melting of the tension between Arabs and Jews." See Herb Myers and Richard Gerstman, eds., *Creativity: Unconventional Wisdom from 20 Accomplished Minds* (New York: Palgrave Macmillan, 2007), 42. However, in his public statements Chihuly consistently avoided overt political interpretations: "At one point I was going to make three towers—one for Judaism, one for Christianity, and one for Islam—but in the end I decided not to do that. Obviously people are going to look at them and see things they want to see in them. I prefer that than if I told them what it is they should be seeing." Avi Machlis, "Artist Transforms Part of Jerusalem into City of Glass," *St. Louis Jewish Light,* 13 Oct. 1999, quoted in Chihuly, *Chihuly: Jerusalem 2000*, 90.

19. Leslie, "Glass in Architecture," 21.

20. Rose Slivka, "A Touch of Glass," *Quest* (Sept. 1979): 86.

21. A Providence newspaper headline announced, "At RISD 'Strike Central' Artists Fight 'Kentbodia.'" See Tina Oldknow, *Pilchuck: A Glass School* (Seattle: Pilchuck Glass School in association with University of Washington Press, 1996), 45.

22. Ibid., 46.

23. Ibid.

24. Ibid., 45–46.

25. Dale Chihuly, "Introduction," in Lloyd E. Herman and Dale Chihuly, *Clearly Art: Pilchuck's Glass Legacy* (Bellingham, Wash.: Whatcom Museum of History and Art, 1992), 13.

26. See, for example, the Art Workers' Coalition (1969–1971), which organized the "Moratorium of Art to End the War in Vietnam" in 1969, and disseminated the famous antiwar poster with a photograph of the My Lai massacre and the text "Q. And babies? A. And babies." (1970). See *http://en.wikipedia.org/wiki/Art_Workers'_Coalition.* Jasper Johns, an artist who rarely made overt statements in or about his work, contributed the lithograph *Moratorium* (1969), comprising a distorted American flag with black and green stripes and black stars on an orange field, in support of the national moratorium and march against the Vietnam War. See Universal Limited Art Editions, *The Prints of Jasper Johns/1960–1993/A Catalogue Raisonné* (West Islip, N.Y.: Universal Limited Art Editions, 1994), supplement, cat. S5.

27. See Chihuly, "Kitchen Sessions," 15 Mar. 1998.

28. Sims, *Dale Chihuly: Installations,* 26.

29. For the two versions of *20,000 Pounds of Ice and Neon* (1971), see ibid., 38–39.

30. See ibid., 42–43.

31. In a second version of *Glass Forest #2,* the color of the stalks modulated when they were touched by the several women performers who moved in their midst. In 1972, *Glass Forest #2* was installed in the *Glas Heute* ("Glass Today") exhibition at the Museum Bellerive in Zurich, Switzerland, where the piece remains today. Ibid.

32. In New York, the artists had described the sharp spikes of their *Glass Forest #1* installation enigmatically as a "barricade." See Rita Reif, "Blown Glass 'Trees' That Create a Forest of Light," *New York Times,* 29 Sept. 1971, 29.

33. See Chihuly, "Introduction," in Herman and Chihuly, *Clearly Art,* 10.

34. Koji Matano, "Dale Chihuly," *Glasswork* 5 (May 1990): 10. Pilchuck pioneer Toots Zynsky recalled: "The philosophy behind it [Pilchuck] was that we were going West. . . . We went West with the idea that we might not come back. . . . It was the time of alternative education, when institutions were being questioned and analyzed." See Oldknow, *Pilchuck,* 52.

35. Oldknow, *Pilchuck,* 20. John Landon described Pilchuck as "the Woodstock of Glass!" and Toots Zynsky reminisced, "No one had a watch. We didn't even know what time we were getting up. We were hippies, okay? No watches, no underwear, no nothing." See Herman and Chihuly, *Clearly Art,* 20, and Oldknow, *Pilchuck,* 59.

36. For the attempts to transform Pilchuck into a multimedia art commune, see Oldknow, *Pilchuck*, 23, 106–109, 122–125. Describing the tension between the proponents of art glass and functional glass, Peet Robinson recalled, "I'm oriented toward functional glass and pottery. And I could see the conceptual direction . . . Pilchuck was going in and I didn't understand it. . . . It was, 'We are not blowing glass just to make vessels, we are blowing glass to create art.' That's where I got lost! . . . What I like is making functional glass and having people buy it for a modest amount of money and use it every day. And it wasn't that that was being put down, but it wasn't explored." Ibid., 90. Chihuly observed, "We were antiproduction, no doubt about it. Between Buster [Simpson] and me and people like Erwin Eisch, we were not the place for production." Ibid., 90–91.

37. Ibid., 120.

38. Toots Zynsky recalled that there was a strong anticommercial streak among many of the early Pilchuck artists: "No one was thinking about money then. We wanted to make these things, and we were practically giving them away." Ibid., 70.

39. James Carpenter recalled, "The environment was the primary emphasis. To be in an environment of nature and to respond to [it]." Ibid., 83.

40. This team model has been documented in Dale Chihuly, *Team Chihuly* (Seattle: Portland Press, 2007). Chihuly's apprentices and gaffers include Flora C. Mace (1974), William Morris (1978), Joey Kirkpatrick (1979), Benjamin Moore (1979), Richard Royal (1979), Dante Marioni (1982), and Martin Blank (1986). Chihuly modeled Pilchuck on the European master/apprentice system: "Pilchuck started on the grounds that artists could get together and work and that students would learn from the way artists worked." Lutz Haufschild, "The Pilchuck Glass School—Teaching What Cannot Be Taught," *Stained Glass* 78 (Spring 1983): 35.

41. Chihuly included the following dedication with a photograph of one of his glassblowing teams: "I am forever grateful to all of you that have put so much time and energy into my glass year after year. My teamwork started with Fritz Dreisbach helping me blow a couple of sculptures back at Madison [Wisconsin] in 1966. I knew right away that I'd never blow glass alone again. I'd like to thank all of you for making my life and work so much more enjoyable than if I'd decided to work alone." See Henry Geldzahler and Robert Hobbs, *Dale Chihuly: Objets de Verre* (Paris: Musée des Arts Décoratifs, 1986), 3. In his first major monographic publication, Chihuly wrote, "I would like to thank all my friends from the cooks to the gaffers who made the glasswork in this catalogue possible." Linda Norden, *Chihuly: Glass* (Pawtuxet Cove, R.I.: Dale Chihuly, 1982), 6.

42. Chihuly has described the Czech glass artist Stanislav Libensky as a father figure. E-mail from Joanna Sikes, Chihuly Studio, to the author, 14 Dec. 2007. Chihuly dedicated one of his books, "for my brother Italo." See

William Darby Bannard and Henry Geldzahler, *Chihuly: Form from Fire* (Daytona Beach, Fla., and Seattle: The Museum of Arts and Sciences and University of Washington Press, 1993), 5.

43. Dale Chihuly, manuscript, 9 June 2007, reproduced in Chihuly, *Team Chihuly.*

44. Oldknow, *Pilchuck,* 27.

45. Ibid., 51–52, 57, 66.

46. Ibid., 83.

47. Ibid., 88, 90.

48. Chihuly recalled, "After studying weaving and textiles, I wound up falling in love with both Navajo blankets and Pendleton trade blankets. As a student, I couldn't afford the Navajo blankets, but I began to collect Pendletons." See Dale Chihuly, "The Indian Influences upon My Work," in Dale Chihuly and Charles J. Lohrmann, *Chihuly's Pendletons and Their Influence on His Work* (Seattle: Portland Press, 2000), 177.

49. The imagery on Chihuly's *Blanket Cylinder with White Threads* (fig. 8) was inspired by a *Late Serape Style Navajo Blanket* (ca. 1870–1880), illustrated in Mary Hunt Kahlenberg and Anthony Berlant, *The Navajo Blanket* (New York: Praeger Publishers, in association with the Los Angeles County Museum of Art, 1972), 67, plate 42. Chihuly's *Five Cross Cylinder* (1976), illustrated in Chihuly and Lohrmann, *Chihuly's Pendletons*, 220–221, was based on a *Third-Phase Chief Pattern Blanket* (ca. 1890–1895), illustrated in Kahlenberg and Berlant, 96, plate 70. For a photograph of Kate Elliott making a glass-thread "drawing" of a *Serape Style Blanket* (1850–1865) illustrated in ibid., 38, plate 16, see Chihuly and Lohrmann, *Chihuly's Pendletons*, 188–189. As Chihuly later observed, "Looking back, I think it is possible to say that in both series, the *Navajo Blanket Cylinders* and the *Baskets*, the pieces were wearing their drawings just as the Indians were wearing their blankets." Chihuly, "The Indian Influences upon My Work," in ibid., 177.

50. In homage to his travels in Central America, Chihuly created a plate-glass pyramid installation entitled *Mitla* (1973), whose title refers to an ancient Zapotec/Mixtec site that they had visited near Oaxaca, Mexico. In collaboration with Carpenter, Chihuly also created a *Cast Glass Door* of 1973, whose surface was inspired by the geometric patterns of the high-relief stonework at Mitla. See Sims, *Dale Chihuly: Installations*, 46–49. Prior to the founding of Pilchuck Glass School, Pilchuck patrons John and Anne Gould Hauberg had considered building museums devoted to Mark Tobey and ancient American art on the site. See Herman and Chihuly, *Clearly Art*, 20.

51. The exhibition that Chihuly recalls may be one that was on view at the Museum of Fine Arts, Boston, 23 Jan.–16 Mar. 1975. See Jonathan L. Fairbanks, *Frontier America: The Far West* (Boston: Museum of Fine Arts, 1975), 219, nos. 133–134.

52. See the exhibition brochure "Blankets/Cylinders: Glass Cylinders by Dale Chihuly; Navajo Blankets from the Haffenreffer Museum of Anthropology," Bell Gallery, List Art Building, Brown University, 1976.

53. Chihuly recalled, "In the summer of 1977, I was visiting the Tacoma historical society with Italo Scanga, and I remember being struck by a pile of Northwest Coast Indian baskets that were stacked one inside another. They were dented and misshapen, wonderful forms. I don't really know what made me want to reproduce them in glass, but that was my mission for the summer." Henry Geldzahler, *Dale Chihuly: Japan 1990* (Tokyo: Japan Institute of Arts and Crafts, 1990).

54. E-mail from Joanna Sikes, Chihuly Studio, to the author, 14 Dec. 2007, and in Norden and Morgan, *Chihuly: Baskets*, 7.

55. For Maria Martinez's life and work, see Richard L. Spivey and Herbert Lotz, *The Legacy of Maria Poveka Martinez* (Santa Fe: Museum of New Mexico Press, 2003).

56. Chihuly created the first, less elaborate version of this Indian Room in his studio/residence at the Buffalo Shoe Company building on the east side of Lake Union in Seattle. Chihuly's gender-based selection of Curtis's photogravures may reflect the traditional role of women as creators of most Indian blankets and baskets.

57. Commensurate with the Northwest Coast aesthetic of the Indian Room, the centerpiece is a twenty-foot-long table fabricated from a single piece of a one-thousand-year-old Douglas fir found decaying on the Olympic Peninsula.

58. Chihuly writes: "The blankets are called trade blankets because they were originally made especially for the Indian market. The Indians would go to trading posts near or on the reservations and trade their own woven blankets, baskets, furs, and other goods for the machine-made blankets provided by non-Indian manufacturers. The Indians were willing to trade their extraordinary handwoven blankets for the trade blankets because they found these commercially produced pieces to be more colorful and warmer than their own blankets. They also valued the beauty of the trade blankets. From an economic point of view, one of the Indian handwoven blankets was worth several machine-made Pendletons. . . . What's truly fascinating to me and other collectors is how incredibly beautiful, aesthetically successful, and varied the designs and colors of these blankets are. There's considerably more variety in the trade blankets than in the Indian-made blankets, and that's another reason Indians wanted to wear and collect them." Dale Chihuly, "Collecting Trade Blankets," in Chihuly and Lohrmann, *Chihuly's Pendletons,* 9–10.

59. Dale Chihuly, fax letter reproduced in *Chihuly: Jerusalem 2000*, 112.

60. Bannard and Geldzahler, *Chihuly: Form from Fire,* 27.

61. Chihuly has referenced the sea not only in his *Seaforms* but also for the placement of these objects in his installations: "I'm a little less particular about the placement of things. One of the reasons being that I like things to feel that they sort of happened by nature and not been put there by man. If it gets too organized then it's too uptight for me. I get a kick out of having other people do things, because they might do them differently—even if they're a little awkward I like it. I strive for, as if the wave from the ocean scattered it out and obviously it would happen differently every time the wave came in, but in a way that was natural and felt right." Chihuly and Aronson, *Fire: Dale Chihuly,* 138.

62. According to Chihuly, "Legend has it that there was a shipwreck, and the sailors who got to the beach built a bonfire and used some blocks of soda that had been part of the cargo for seating around the fire. During the night a block of soda fell into the fire, which acted like a flux, which lowers the melting point of sand. When they awoke in the morning they discovered they had made a batch of glass." Chihuly, "Chihuly in the Light of Jerusalem," in *Chihuly: Jerusalem 2000,* 29.

63. Chihuly and Aronson, *Fire: Dale Chihuly,* 148.

64. Martha Sherrill Dailey, "Movement in Glass," *Washington Post,* 5 Feb. 1987, 21.

65. Lorelei Heller McDevitt, "3 Under Glass," *Designers West* (June 1982): 233.

66. Robert Hobbs, *Chihuly alla Macchia: From the George R. Stroemple Collection* (Beaumont, Tex.: Art Museum of Southeast Texas; Seattle: Portland Press, 1993). Regarding his use of all the glass colors in his studio, Chihuly speculated: "Maybe I thought of using all the colors from remembering back to a trip that I made in 1962 on the Trans-Canadian train from Vancouver to Montreal. I had dropped out of college for a year and was making my way across the country en route to Florence to study art (I ended up working on a kibbutz in the Negev Desert instead). During the sixty-hour train ride, I decided I would mix as many colors as I possibly could from a complete set of Windsor Newton watercolor tubes I was carrying for sketch purposes. . . . Three thousand miles later I had an album filled with two thousand color samples coded with the tubes involved." Dale Chihuly, "Macchias," typescript, Chihuly Studio Archives, Seattle.

67. Chihuly cited "The *Handkerchief Vase* that was made at Venini in the 1940s, which I would imagine inspired my *Macchia* pieces, because my *Macchia* look a lot like the *Handkerchief Vase.*" Chihuly, "Kitchen Sessions," 1 Mar. 1998.

68. Ironically, Scanga had spent so much time in the United States that he had to look up the Italian word for *spotted* in a dictionary. See Hobbs, *Chihuly alla Macchia,* opposite plate 13.

69. Ibid., 32.

54

70. "I remember studying a beautiful stained-glass window. Part of the window was in front of a white building, the other half was backed by the blue sky. The blue sky really killed the delicate tints in the window. It had the same effect as if one were wearing blue glasses. That's when I learned the importance of white. While blowing the early *Macchia* I added a layer of 'clouds' between the inside and outside colors. It was the white that allowed the colors to pop. I could now have one color on the interior and one on the exterior without any blending of the colors." Ibid., opposite plate 22.

71. "Most people don't realize it, but blowing a piece with a range of colors is extremely difficult because each color attracts and retains the heat differently. Over time we figured out these technical complexities and the *Macchia* began to increase in size." Ibid., 32.

72. Joan Brown, "Molten Magic," 12.

73. For *Macchia* that resemble the silhouette of the Mount Rainier volcano, see Hobbs, *Chihuly alla Macchia*, plates 31–35, 38, 39.

74. Robert Hobbs, "Dale Chihuly's Persians: Acts of Survival," in Henry Geldzahler and Robert Hobbs, *Chihuly: Persians* (New York: Dia Art Foundation, 1988), 8–9.

75. Joy Hakanson Colby, "Who Needs Paris? Dale Chihuly Has His Own Habatat," *Detroit News,* 17 June 1988, 5D.

76. Chihuly, "Kitchen Sessions," 1 Mar. 1998.

77. "This is a very complicated series to explain. The pieces started out as experimental forms but as the series grew the title, 'Persians,' seemed to fit. Many of the things that Marco Polo brought back from his travels had probably never been seen before." Ron Ronck, "Glass Act," *Honolulu Advertiser,* 30 May 1990, E1.

78. Geldzahler and Hobbs, *Chihuly: Persians*, 20.

79. Robert Hobbs, "Dale Chihuly's Persians: Acts of Survival," in ibid., 10. Chihuly has identified the larger version of Carpaccio's *Saint George and the Dragon*, in the Scuola degli Schiavoni, Venice, as the original source of inspiration for the *Persian* series.

80. Ron Glowen, *Dale Chihuly: Venetians* (Altadena, Calif.: Twin Palms Publishers, 1989).

81. In keeping with his romantic vision of the city's glass history, Chihuly enjoys recounting that in 1292 the Venetian doges moved all the glassblowers to the island of Murano to protect the trade secrets of this valuable commodity. The city executed unsuccessful escapees and the families of those who were successful. See Lois Tarlow, "Alternative Space: Dale Chihuly," *Art New England* (July/Aug. 1982): 16–17.

82. Matthew Kangas, "Dale Chihuly: A Return to Origins," *Glass* 39 (1990): 22.

83. Dale Chihuly, "Dale Chihuly," *The Glass Art Society Journal* (1990): 36.

84. In 1962, Chihuly already was experimenting with an expanded color palette (see note 66). He has admitted, "I'm obsessed with color—never saw one I didn't like." Hobbs, *Chihuly alla Macchia,* opposite plate 4. He has also complained, "I can't understand it when people say they don't like a particular color. . . . How on earth can you not like a color?" Chihuly et al., *Chihuly: Gardens & Glass*, 110.

85. See, for example, the black and red bulbs and tendrils of *Haystack Installation #5* (1970) in Sims, *Dale Chihuly: Installations*, 32–33.

86. Ibid., 34–35.

87. See ibid., 30. For the Blaschka Collection, see Richard Evans Schultes, William A. Davis, and Hillel Burger, *The Glass Flowers at Harvard* (Cambridge, Mass.: Botanical Museum of Harvard University; New York: E. P. Dutton, 1982).

88. Sims, *Dale Chihuly: Installations, 69.*

89. Ibid.

90. For Chihuly's term paper on Van Gogh, see Barbara Rose, "The Earthly Delights of the Garden of Glass," 48. Chihuly later observed, "A few artists have influenced my work, but it is hard to name them. I mentioned one to you already, Van Gogh." Myers and Gerstman, *Creativity,* 39.

91. Drawing an analogy between his own creative ups and downs, Chihuly observed, "Take Van Gogh, for instance. He was depressed on and off. He only worked for ten years, and the last two or three were his most productive. I remember a Van Gogh show a few years ago at the Metropolitan Museum in New York. I think it was called *Van Gogh in Arles* and it showed every painting he made while living in Arles, all in the right order. The show included some of the letters that he sent to his brother, discussing his paintings. And when I looked at them, I tried to figure out at what point he felt great about what he was painting and what point he was brooding. I'll tell you, I couldn't tell by looking at the paintings. They *all* looked great to me. I am sure he worked whether he felt well, and also when he felt depressed, which was often. In either state, he didn't stop working." Ibid.

92. Van Gogh wrote to his brother, Theo van Gogh, on 23 Jan. 1889, comparing himself to other flower painters: "You know that the peony is Jeannin's, the hollyhock belongs to Quost, but the sunflower is mine in a way." See *http://www3.vangoghmuseum.nl/vgm/index.jsp?page947&article=979&showImage=&lang=en.* Van Gogh painted several of his sunflower paintings to decorate Paul Gauguin's room in Arles, in conjunction with his unsuccessful attempt to establish an artists' colony.

93. See Chihuly's *Gilded Ikebana with Ochre Flower and Red Leaf* (1992), in which the sunflower appears to burst forth from the vase, which resembles a cracked eggshell, illustrated in Chihuly and Aronson, *Fire: Dale Chihuly*, 92–93.

94. Inspired by the fishing floats he had seen in Japan, Chihuly recalled, "I started the *Floats* in an odd way, as many series begin. I told Rich Royal and the team to blow as big a ball as they could and to put a dimple in the end so that we could stick a smaller ball on top of it that would have flowers attached. The idea was to make the largest *Venetian* that I could—hopefully six to eight feet tall. Looking at these balls after they came out of the oven, I decided that they looked pretty good on their own." Sims, *Dale Chihuly: Installations*, 66.

95. See Dale Chihuly, "Niijima," at *http://www.chihuly.com/installations/niijima/statement.html*.

96. Chihuly, "Kitchen Sessions," 5 Mar. 1998.

97. Chihuly: "I've never done anything like the *Niijima Floats*. They are probably the most monumental-looking since there's no reminiscence of a container shape. Just because they are so goddamn big, the *Floats* are technically, or say, physically, the most difficult things we have ever done. Even though a sphere or a ball is about the easiest form you can make in glass, when you get to this scale, up to 40 inches in diameter, it becomes extremely difficult." Bannard and Geldzahler, *Form from Fire*, 101.

98. Following his recollection of finding beach glass as a child, Chihuly added, "And then I used to play marbles when I was a kid, you know, and you'd get these marbles, these beautiful 'shooters.' Everybody loved those marbles." Chihuly, "Kitchen Sessions," 5 Mar. 1998.

99. The universal qualities of floats, which transcend national boundaries, made them an apt choice for inclusion in Chihuly's *Jerusalem 2000* project, which was situated amid some of the most disputed lands in the world. "When I was blowing glass in Japan a few years ago, I started making large floats, those big colored balls. But I also heard about this Japanese glassblower—the last one to make the real fishing floats. So I found out that he lived up in Hokkaido, he was seventy-eight years old, and we went up and visited him. Then I ordered one thousand fishing floats from him. I had no idea what the hell I was going to do with them, so they sat around, one thousand, mostly in boxes, sat around my studio for a couple of years. I decided to take them to Israel and put them down into one of these pits, one of these digs." Chihuly, *Chihuly: Jerusalem 2000*, 106.

100. Barbara Rose and Dale Lanzone, *Chihuly Projects* (Seattle: Portland Press; New York: Harry N. Abrams, Inc., 2000), project no. 29.

101. Chihuly conceived of the *Chihuly Over Venice* project as follows: "I felt that the chandelier was a very overlooked art form in the 20th century and that chandeliers were and are very important in defining space in architecture and without, or outside. One day I started dreaming about Venetian chandeliers and I started imagining my *Chandeliers* hanging in the canals of Venice. *Chandeliers* 10 to 20 feet high and wide hung near the bridges so people could get close to them. They would be lit internally with neon and reflect in the watery canals,

especially at night. I then imagined making five *Chandeliers* in 5 countries with great glassblowing traditions and I chose Finland, Ireland, France, Czech[oslovakia], and Italy. We would travel to each factory and utilize their glassblowers working with the Americans—a collaboration and exchange of techniques that would revitalize both sides. When the five projects are finished they will be sent by containers to be hung in the little canals with PBS following the story in HDTV." Dale Chihuly, fax letter, 2 June 1995, 7–9, Chihuly Studio Archives.

102. Chihuly et al., *Chihuly: Gardens & Glass*, 104.

103. See Rose and Lanzone, *Chihuly Projects*, project no. 5.

104. Chihuly observed, "Probably the most important interior element of a building was the chandelier. If you look at a Venetian palazzo or a palace in France or an Irish castle, or no matter where you go in history, the chandelier plays a dominant role in the building. And yet, along comes the twentieth century and what happens? We quit making chandeliers because Gropius, Corbusier, those European architects that got everything going in this country wanted the sterility of the box, and they didn't want any decorative element, as they saw it, I suppose. But [the chandelier] can play such a central, pivotal role in a room or in a space. The chandelier anchors the space and allows the eye to expand around it." Chihuly, "Kitchen Sessions," 1 Mar. 1998.

105. According to Tina Oldknow, the *Palazzo Ducale Chandelier*, "an immense, colorless *Chandelier* planted, rather than hung, on a metal structure beneath a capacious, 18th-century-style chandelier made by the Muranese firm of Galliano Ferro, was Chihuly's contribution to the Aperto's feature of international works by 26 acknowledged glass 'masters.' Of all the *Chandeliers*, the Palazzo Ducale installation was the artist's most pointed salute to Venice as the grand city of glass. Curling into, and intertwined with, the hanging glass crystals of the Ferro fixture, Chihuly's *Chandelier* paid a deeply felt tribute to the past of glass and to the leading role played by Venice, Murano, and its glassmakers in the American studio glass movement. At the same time, the irrepressible exuberance of the *Chandelier* affirmed the energy and creative power of the present." See Tina Oldknow, "Chihuly Over Venice: Dale Chihuly's Shining Legacy," at *http://www.chihuly.com/essays/oldknow_shining.html*.

106. Asked whom he felt the closest to in sensibility, Chihuly once replied, "One of my favorite artists is Harry Houdini. Maybe that's what I'm trying to be—a magician." Warmus, *The Essential Dale Chihuly*, 5.

107. Barbara Rose, "Dale Chihuly's Paradise Regained," in Rose and Lanzone, *Chihuly Projects*.

108. Myers and Gerstman, *Creativity*, 39.

109. Carol Soucek King, "Public Works: Dale Chihuly's Glass Sculptures Showcased at the New Seattle Art Museum," *Designers West* (Nov. 1992): 43.

110. See *Pélleas and Mélisande + Chihuly* (Seattle: Seattle Opera, in association with University of Washington Press, 1993).

111. William Darby Bannard identified a common conundrum in writing about Chihuly's work during this period: "As a 'formalist' critic, one who takes the work as it is, as an unconditional aesthetic object, I usually write about the object itself. Here I find myself writing about Chihuly as much as about his glass." William Darby Bannard, "Introduction," in Bannard and Geldzahler, *Chihuly: Form from Fire,* 11.

112. Recent scholarship on Louis Comfort Tiffany's practice has revealed that some of his studio's most famous works—including the "Dragonfly," "Wisteria," and "Peony" lamps—were designed by Clara Driscoll (1861–1944). See Martin Eidelberg, Nina Gray, and Margaret K. Hofer, *A New Light on Tiffany* (New York and London: The New-York Historical Society in association with D. Giles Limited, 2007).

113. See William Warmus and Dana Self, *Chihuly Over Venice* (Seattle: Portland Press, 1998).

114. See Chihuly, *Chihuly: Jerusalem 2000*, 106, 134.

115. Karen Chambers, "Dale Chihuly: Portrait of an Artist," *Rhode Island Times* (June 1984): 10.

116. Elsa B. Parry, "Dale Chihuly: Teamwork and Spontaneity," *American Art Glass Quarterly* 3, no. 1 (1985): 57.

117. Defining the act of glassblowing as a means to an end, and not an end in itself, Chihuly noted, "I never got completely absorbed into the blowing process. Even though my work comes out of the miraculous process of glassblowing, and often develops from it, my real love was never the glassblowing, but the object itself. And really I've always been interested in space. Even when I made the *Cylinders*, the single object *Cylinders*, or the *Macchia*, my interest remained in space. I was thinking not of the object but how the object would look in a room." Chihuly et al., *Chihuly: Gardens & Glass*, 162, 164.

118. As Chihuly recalled, "I decided to sell them for a lot more money than people would have thought they were worth. That was twice as much as [ceramicist] Peter Voulkos was selling one of his plates for. I didn't want to sell a lot of them. I thought that was a fair price. Slowly they started to sell." Perlman, "Dale Chihuly: Master of Glorious Glass," 49.

119. Warhol actively courted famous and wealthy clients, such as Liza Minelli and Truman Capote, whom he termed "victims," to commission a portrait. See Victor Bockris, *The Life and Death of Andy Warhol* (New York: Bantam Books, 1989), 302.

120. Myers and Gerstman, *Creativity*, 39. After Andy Warhol viewed the *Seaforms* at Charles Cowles Gallery in New York in 1981, he selected a red *Seaform* (1981) and proposed a trade. To his eternal regret, Chihuly was unable to visit Warhol's studio and sent Kate Elliott with Charles Cowles to deliver the *Seaform*. Elliott selected a dollar-sign painting because she thought Chihuly's close friend Italo Scanga would have picked it, in part because it was predominantly red and green, Italy's national colors. Joanna Sikes, Chihuly Studio, e-mail to the author, 10 Dec. 2007.

121. Warhol insisted that the catalogue entry for each work, drawn from the museum's archives, include the minutiae of the individual object's donor history, as well as its museum identification, classification, etc., thus juxtaposing personal narratives with professional standards. See Daniel Robbins, "Confessions of a Museum Director," in Daniel Robbins and David Bourdon, *Raid the Icebox I: With Andy Warhol* (Providence: Museum of Art, Rhode Island School of Design, 1970), 14.

122. See David Bourdon, "Andy's Dish," in ibid., 18.

123. Ostensible highlights of the collection, including European and American period dresses, and Chinese and European porcelains, were completely omitted. See Robbins, "Confessions of a Museum Director," in ibid., 14.

124. As Daniel Robbins, then director of the R.I.S.D. museum, observed: "There were exasperating moments when we felt that Andy Warhol was exhibiting 'storage' rather than works of art, that a series of labels could mean as much to him as the paintings to which they refer. And perhaps they do, for in his vision, all things become part of the whole and we know what is being exhibited is Andy Warhol. In the end, having selected whatever he did, it is Andy Warhol who will become part of the work." Ibid., 15.

125. Chihuly, "Kitchen Sessions," 5 Mar. 1998. Chihuly et al., *Chihuly: Gardens & Glass*, 168.

126. Chihuly et al., *Chihuly: Gardens & Glass*, 146.

127. "I've got collections everywhere. And I don't know what it is about collecting, but I love to collect things. But I don't like to collect them individually. My preference is to buy things already collected." Chihuly, "Kitchen Sessions," 1 Mar. 1998.

128. Ibid.

129. These criticisms of Chihuly's works are epitomized in the following review: "A thing of beauty is a joy forever, except when it's shallow. No artist represents both beauty's allure and its limitations as Dale Chihuly does. . . . Only those with a puritanical distaste for the decorative could dismiss him out of hand on first acquaintance. But familiarity can breed a certain amount of distance, even boredom. . . . A few Chihuly bowls, with their fluted, fragile edges and translucent, lovely color, are striking. A roomful tends to diminish each one, laying Chihuly open to the charge that he is stuck in the relentless (and highly profitable) production of visual niceties. . . . Chihuly's voluptuous visual extravagance offers the viewer undeniable pleasure. The same sort of pleasure could be had by watching sleek, high-fashion models glide down a runway, by fingering the pelts of fur coats, or examining the fenders of Jaguars. What is roused here is often the morally dubious urge to consume rather than the desire to encounter, which ideally is associated with art. For

want of a better term, critic Clive Bell early in the century called the aesthetic experience an encounter with significant form. What makes Chihuly's beautiful bowls 'significant form'? . . . At its [sic] best, Chihuly's sculptures analyze their medium in the highest tradition of modernism, exploring the fragility of glass, its translucence and its formative passage through heat. But Chihuly's tendency to be satisfied with the merely lovely diminishes much of what he does. The reasonable person, after all, grows weary of preening models and longs, finally, to see evidence of character and intelligence." Regina Hackett, "Chihuly's New Works Are a Bit Overblown," *Seattle Post-Intelligencer,* 15 Mar. 1988, C5.

130. Chihuly, "Kitchen Sessions," 1 Mar. 1998. Chihuly also observed, "I have been lucky in that I have had good associations with what is generally considered to be fine arts institutions. I don't really care if people consider what I do a craft, an art, a decorative art. Whatever. But I do have a hang-up about wanting the work to be seen by the largest audiences possible. In one museum I was in, there were 600,000 visitors. I could not do that at my local crafts gallery." E. J. Montini, "'Hot Glass' Artists Capture Fragility, Strength in Works," *Arizona Republic,* 17 Oct. 1983, D1.

131. Henry Geldzahler, "Dale Chihuly as of 1993," in Bannard and Geldzahler, *Chihuly: Form from Fire,* 13.

132. Chihuly, "Kitchen Sessions," 15 Mar. 1998.

133. Chihuly observed, "I've been influenced by many things, including people. Certainly my closest friend, Italo Scanga, has been a strong influence. There've been different mentors. But most of the people who influenced me, I didn't know. People like Warhol, Jackson Pollock. Frank Lloyd Wright was an influence." W. A. Reed, "Dale Chihuly: Form from Fire," *Porcupine Literary Arts Magazine* (2001): 57.

134. Chihuly et al., *Chihuly: Gardens & Glass,* 106, 108.

135. In a lecture, Chihuly stated, "I want to emphasize how important the drawings came to be in determining what I wanted to make. I have the luxury of not having to blow glass, so while the team is working, I can walk over to the drawing board and begin to draw. Being able to move back and forth between the pad and the drawing table is what really allowed the [*Venetian*] series to move so quickly. . . . Drawing is a fluid process, as glassblowing is a fluid process." Dale Chihuly, lecture, Glass Art Society Conference, 29 Mar. 1990, cited in Nathan Kernan, "The Drawings of Dale Chihuly: Gesture as Image," *Chihuly Drawing* (Seattle: Portland Press, 2003), 164–165.

136. Ibid., 165.

137. Chihuly, "Kitchen Sessions," 5 Mar. 1998.

138. Chihuly has fantasized about being suspended from a harness in mid-air above his drawings and paintings. See Kernan, "The Drawings of Dale Chihuly," 174.

139. Despite their strong resonance with glass history, Chihuly perceives his own glass creations in comparable terms: "I know if I go down in the glass shop right now and work down there, I'm going to make something that has never been made before. That in itself is an inspiration, the fact that I can go down there and make something that no one's ever seen before, even though they've been making stuff out of glass for five thousand years. I don't know why that's easy for me to do, but it is." Chihuly et al., *Chihuly: Gardens & Glass,* 124, 126.

140. Chihuly, "Kitchen Sessions," 5 Mar. 1998. Chihuly and Aronson, *Fire: Dale Chihuly,* 118. Chihuly tells children, "The drawing comes from *inside*," in the film *Chihuly in Action,* produced by Michael Barnard and Portland Press (1999), cited in Kernan, "The Drawings of Dale Chihuly," 170.

141. Chihuly and Aronson, *Fire: Dale Chihuly,* 148.

142. Chihuly et al., *Chihuly: Gardens & Glass,* 154, 156.

143. Rose Slivka, "A Touch of Glass," 86. The initial impetus for this practice was articulated by Haystack Mountain School director Fran Merritt in a 1981 letter to the artist: "Where it would be almost impossible to reproduce the kind of forms you create, or the conditions in space you arrange for them, the photo record can theoretically be replicated forever and ever, extending the original energy and idea to eternal life." Fran Merritt, letter to Dale Chihuly, 1981, cited in Norden, *Chihuly: Glass,* 25.

144. Chihuly et al., *Chihuly: Gardens & Glass,* 138.

145. Beth Austin, "Glass Magician Creates Cascades of Color," *Innova* (Jan. 1992): 26.

146. Chihuly, "Kitchen Sessions," 1 Mar. 1998.

PLATES

SAFFRON TOWER

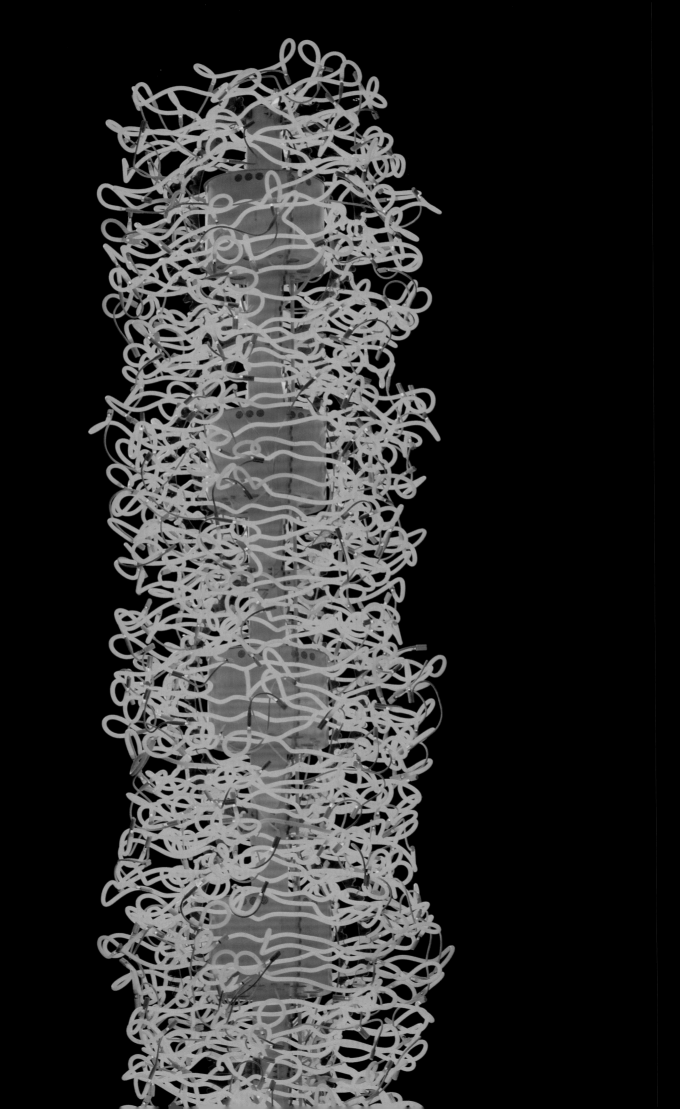

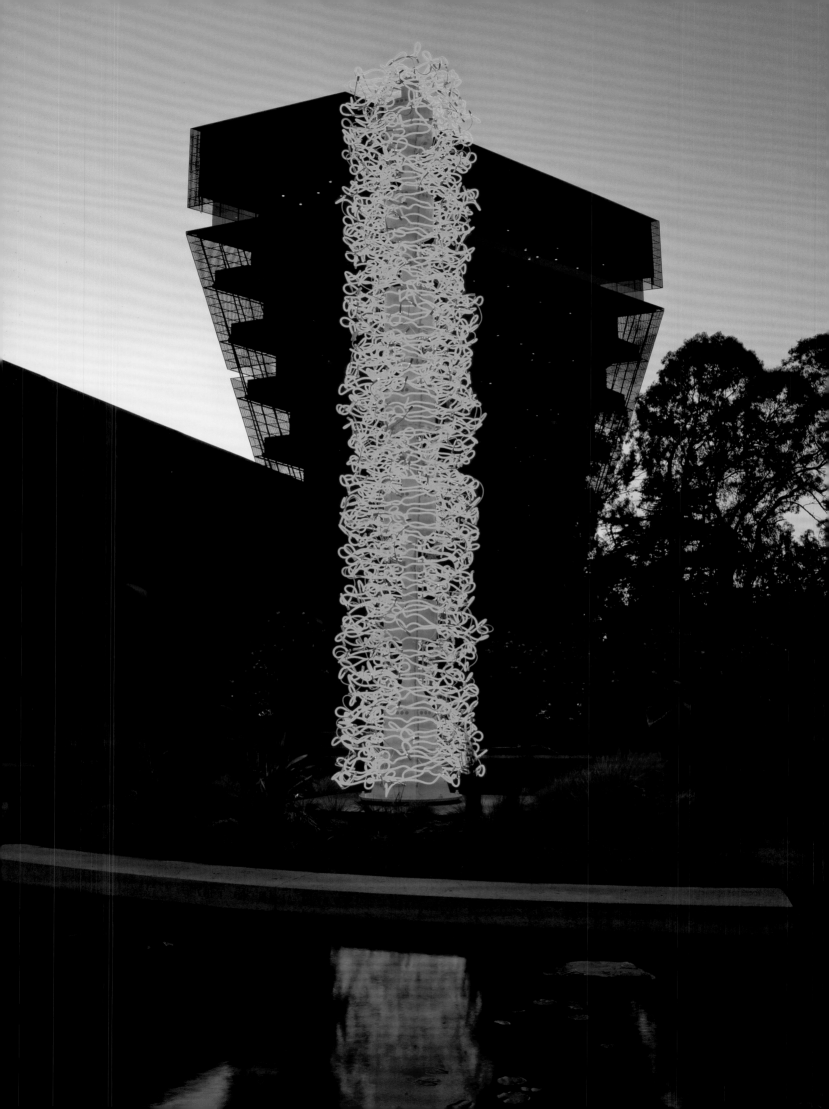

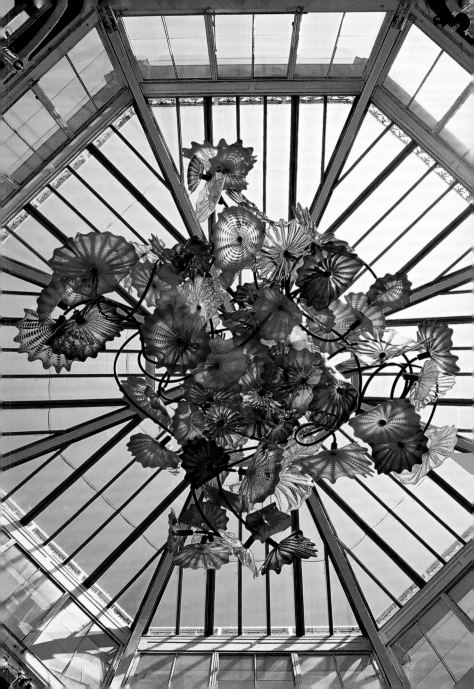

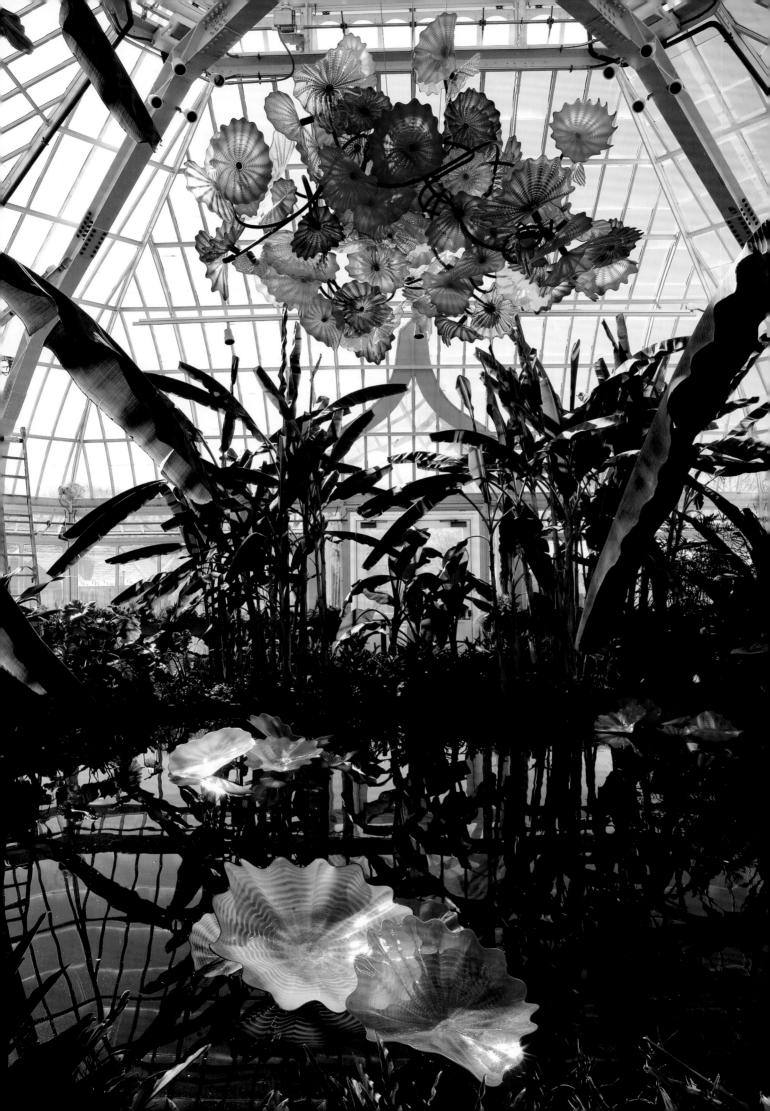

THE SUN

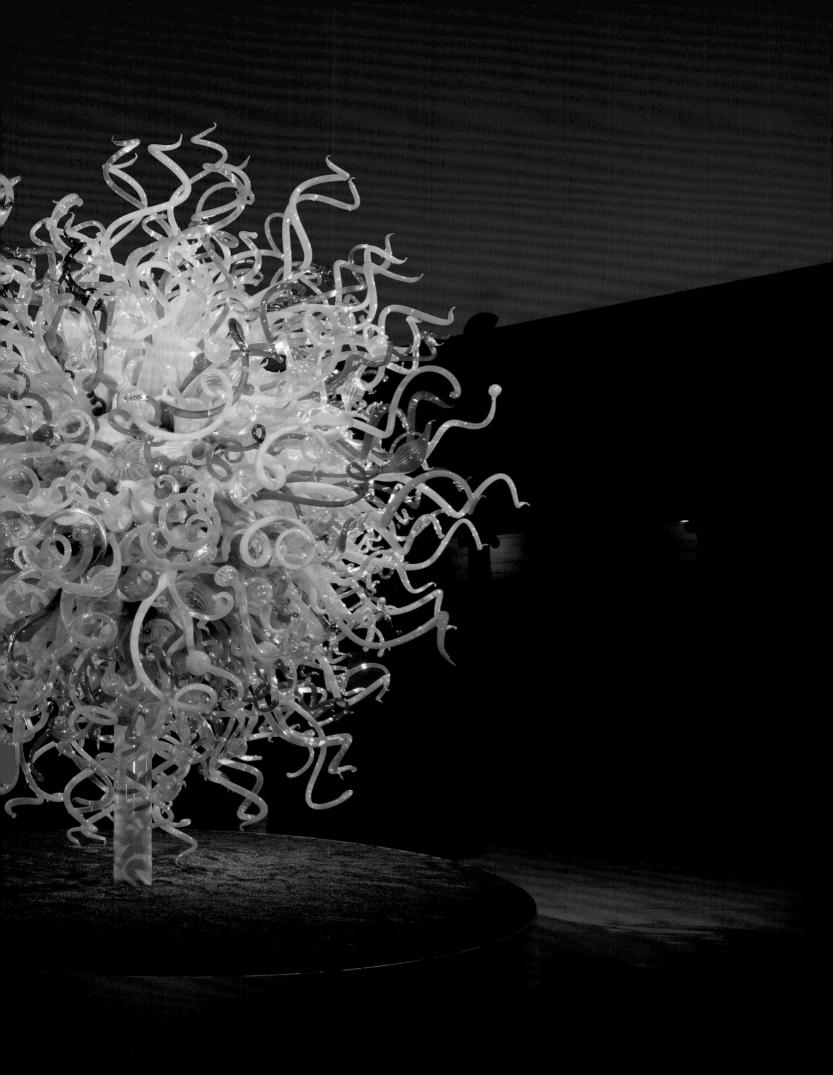

AQUAMARINE THREE-TIERED CHANDELIER

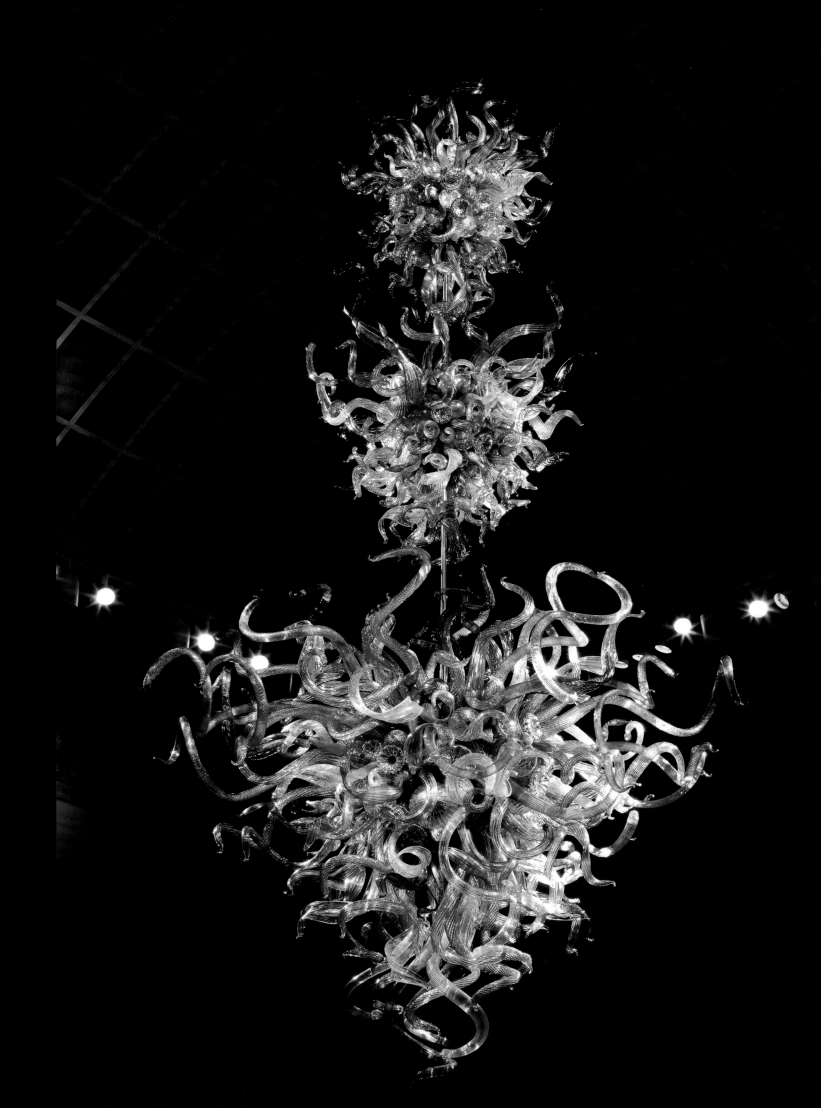

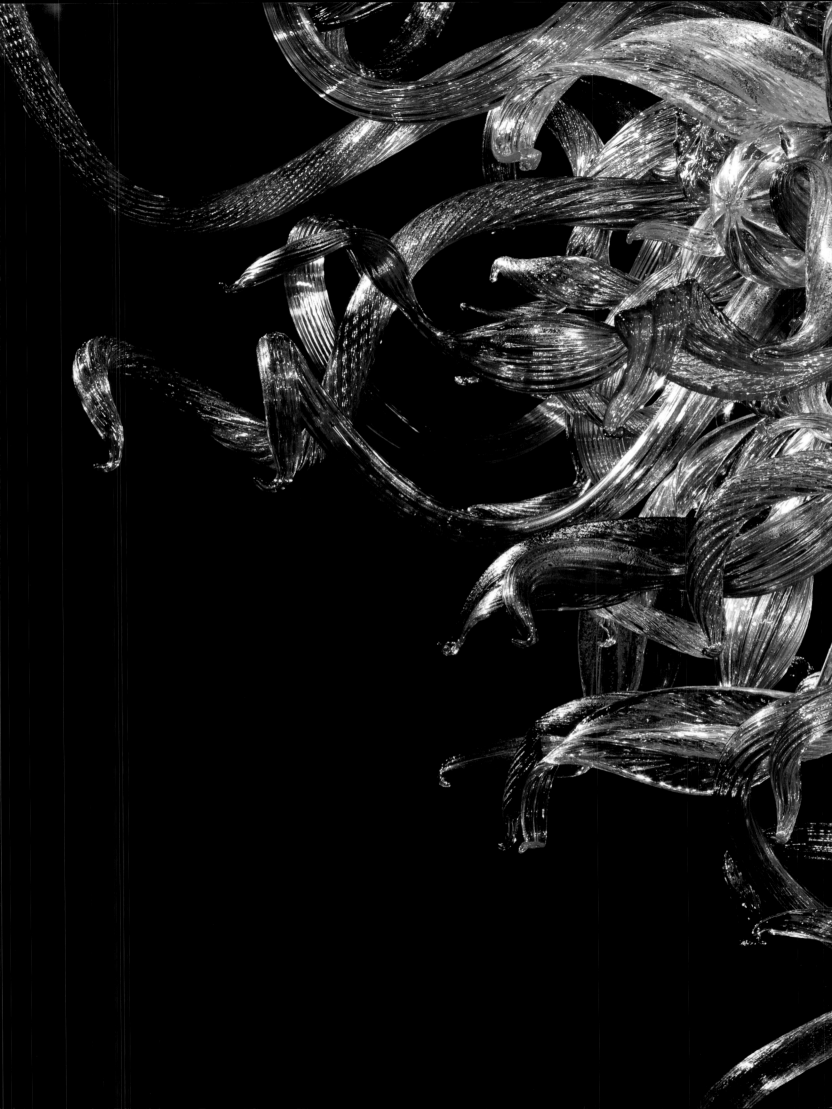

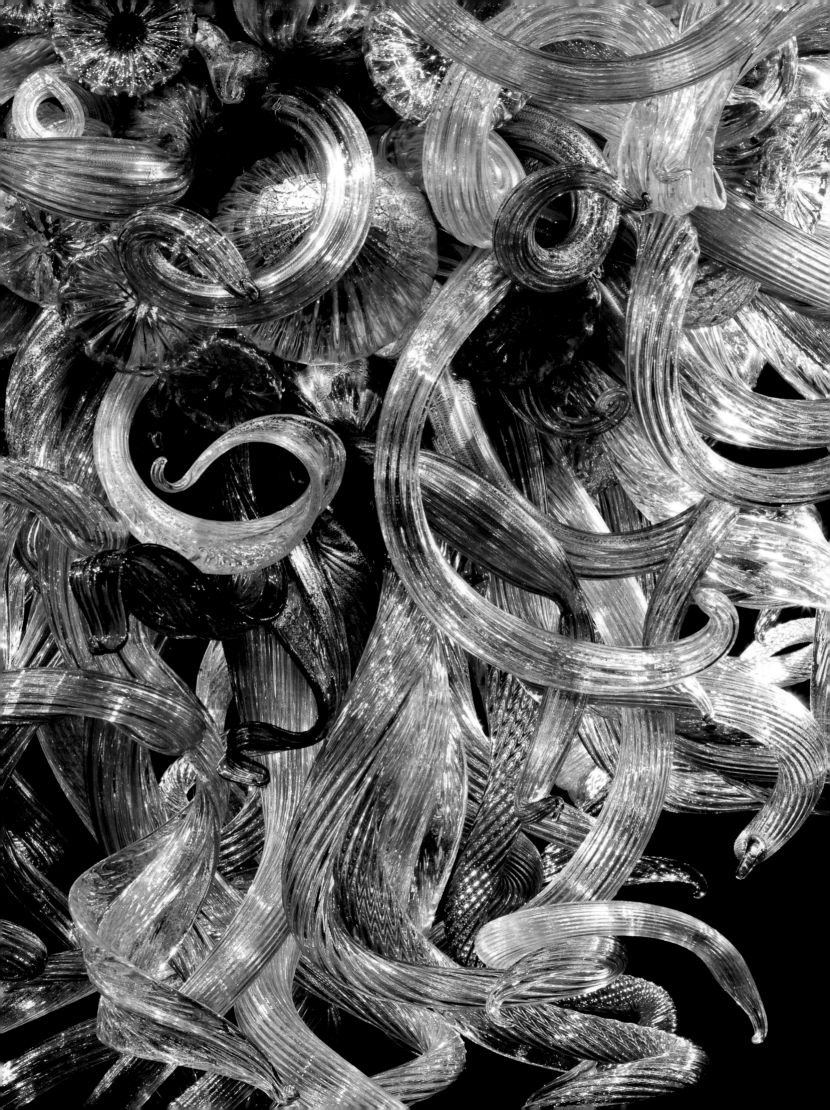

SEA BLUE AND GREEN TOWER

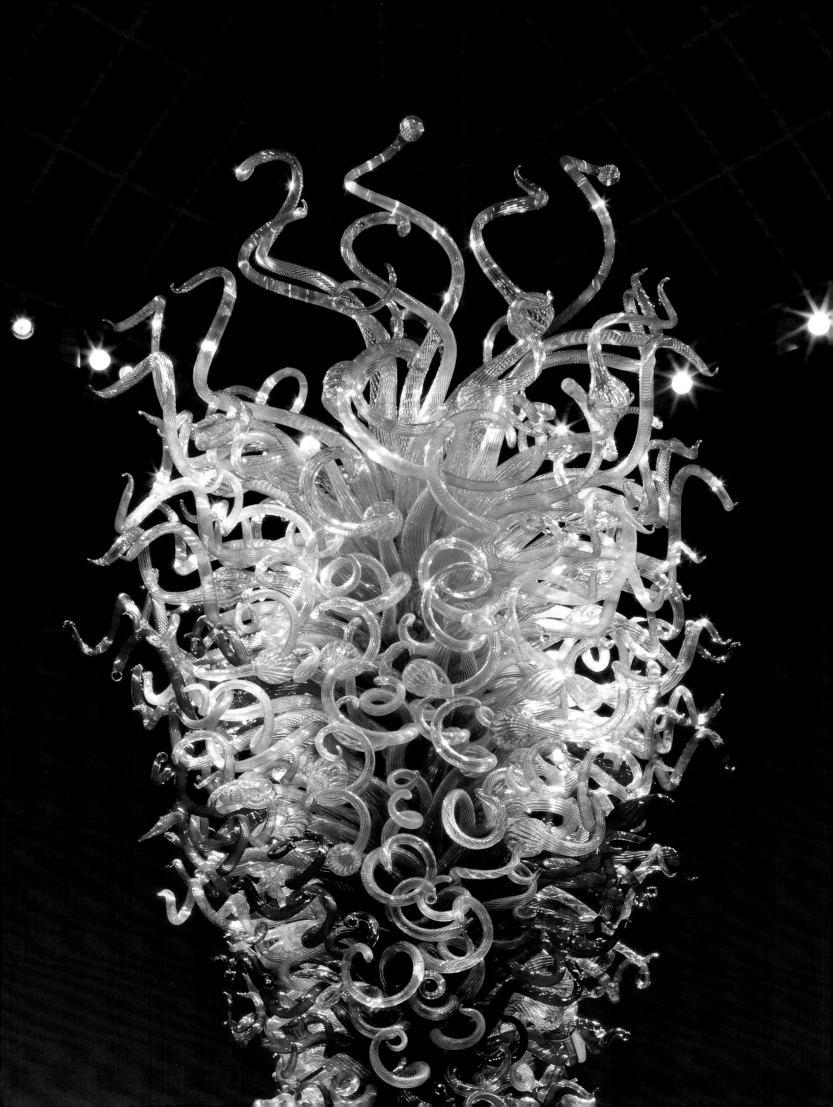

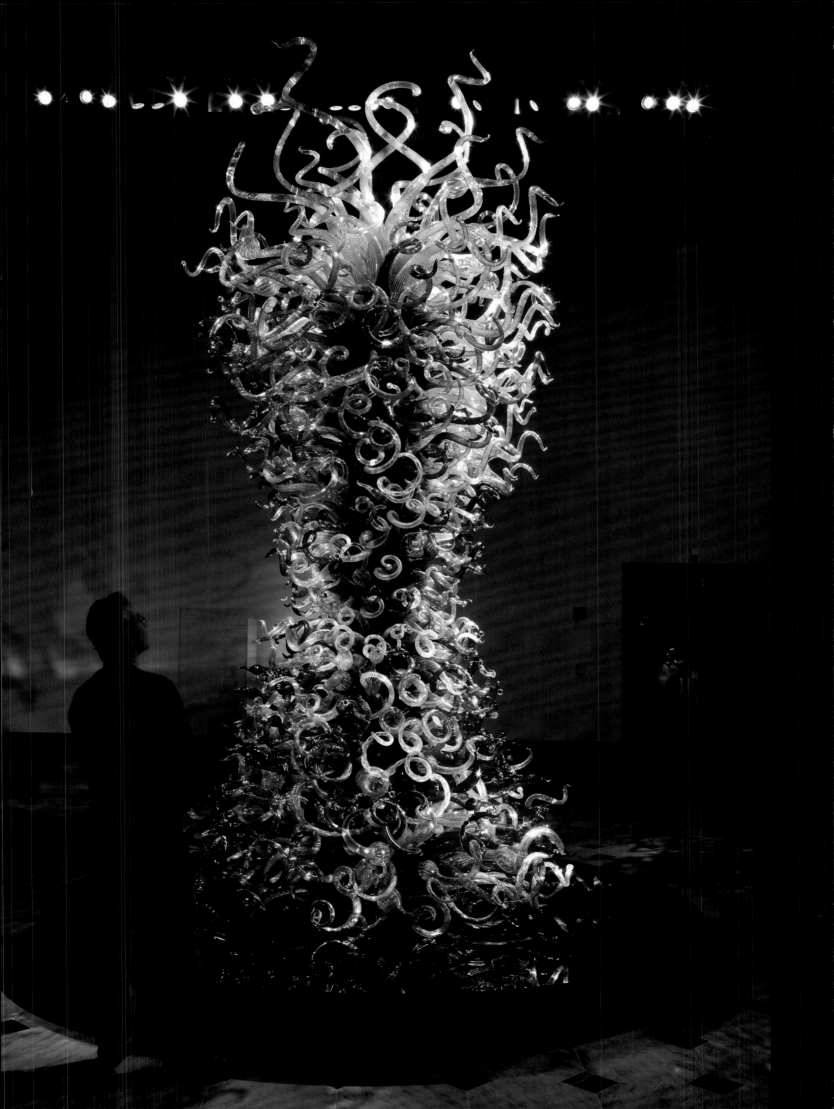

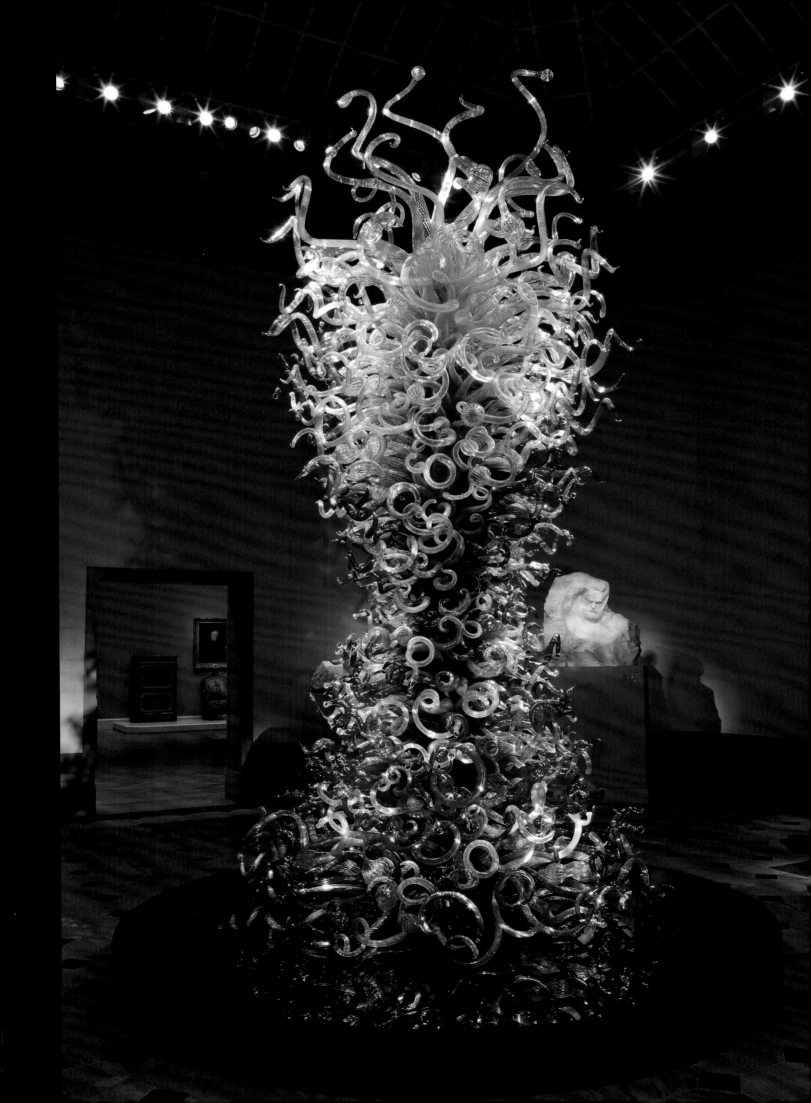

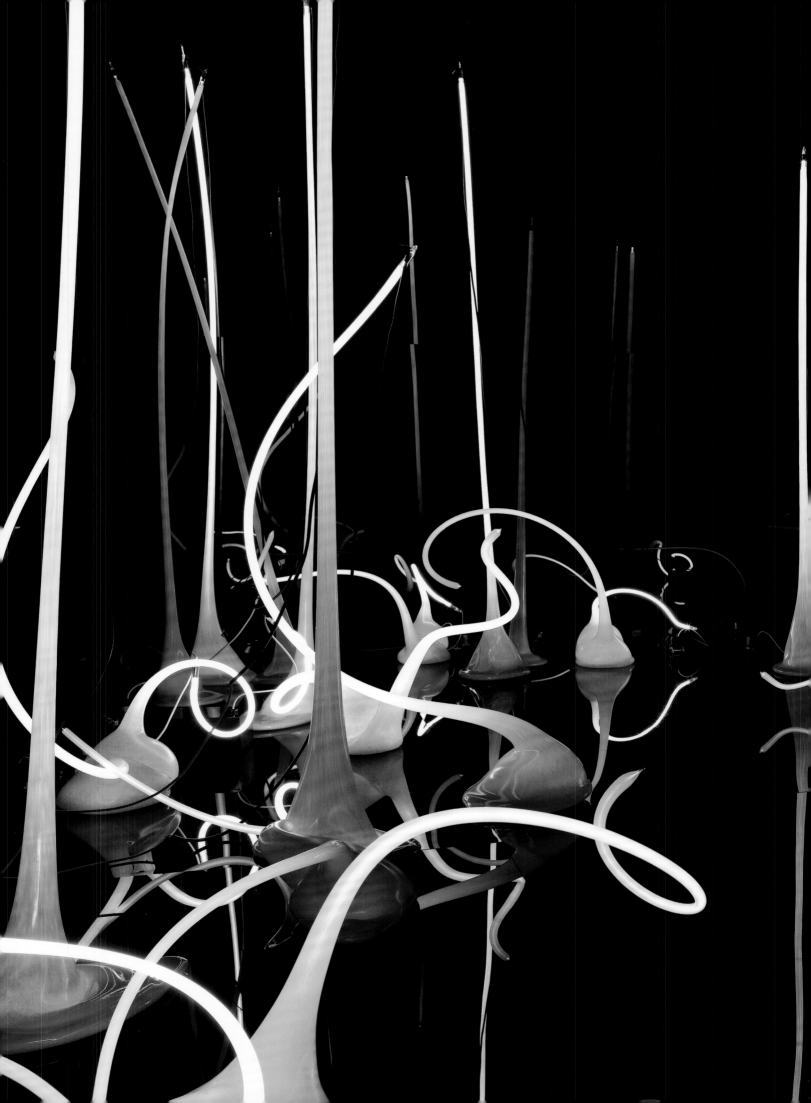

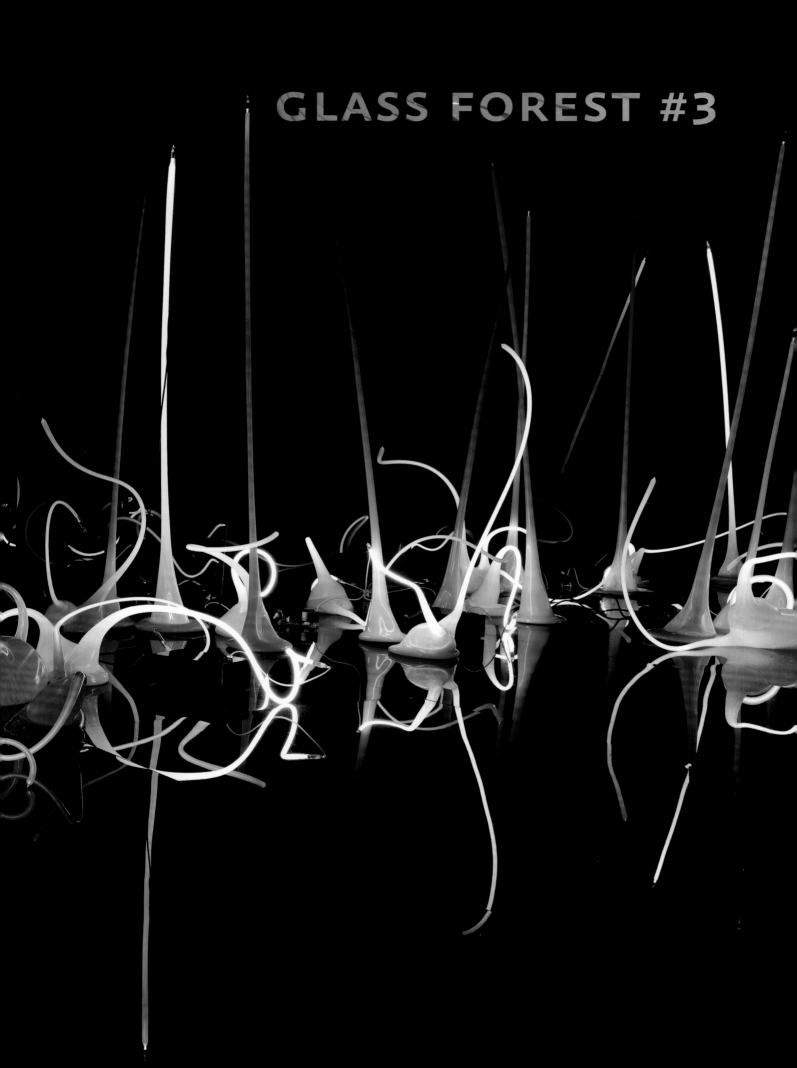

GLASS FOREST #3

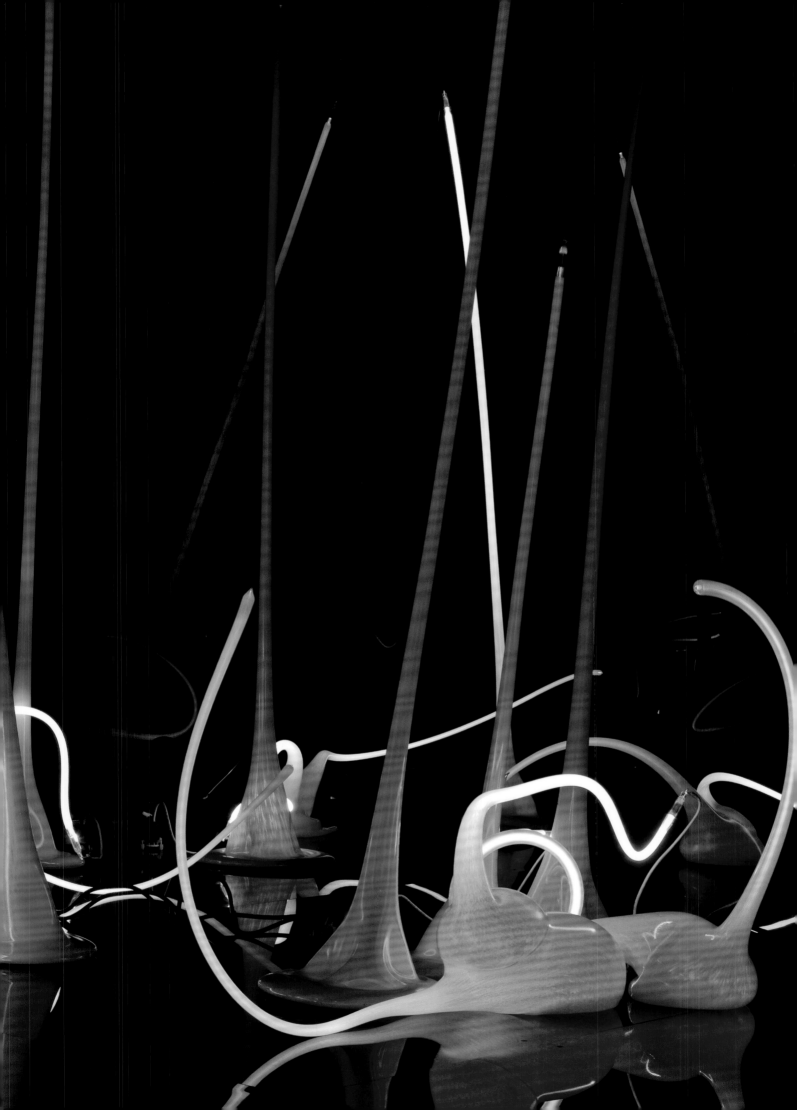

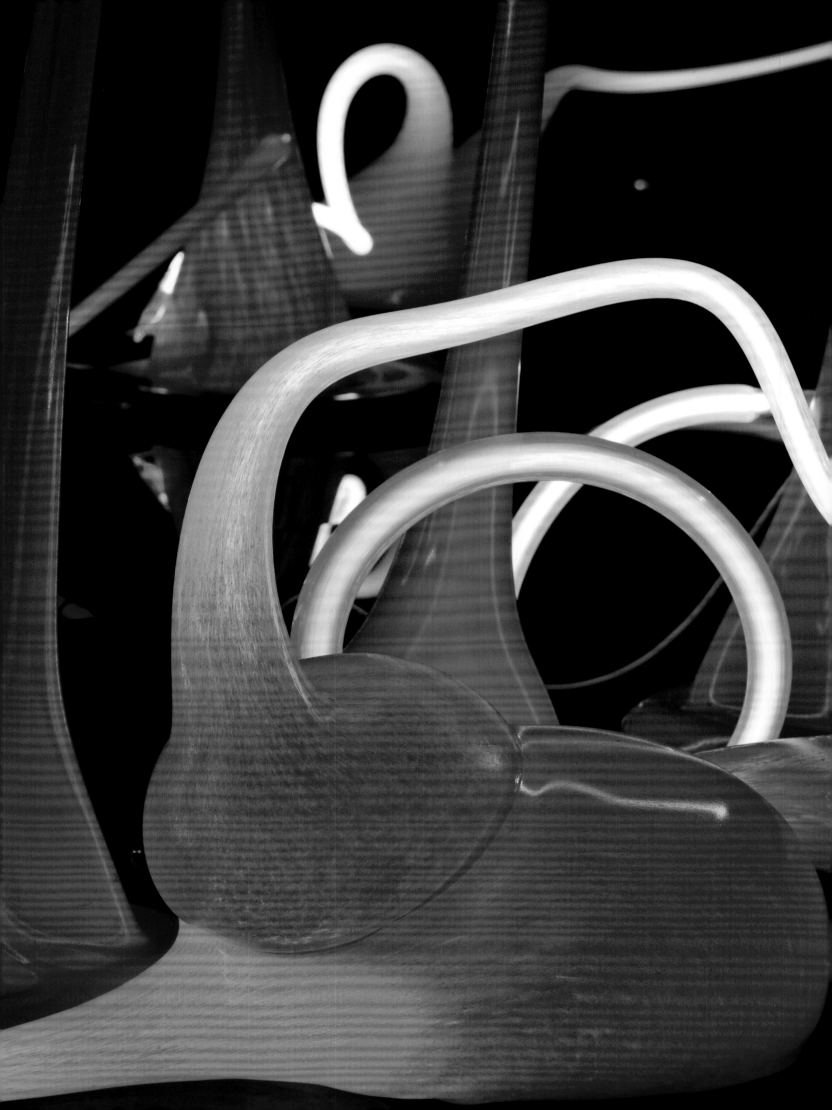

VENETIANS & IKEBANA

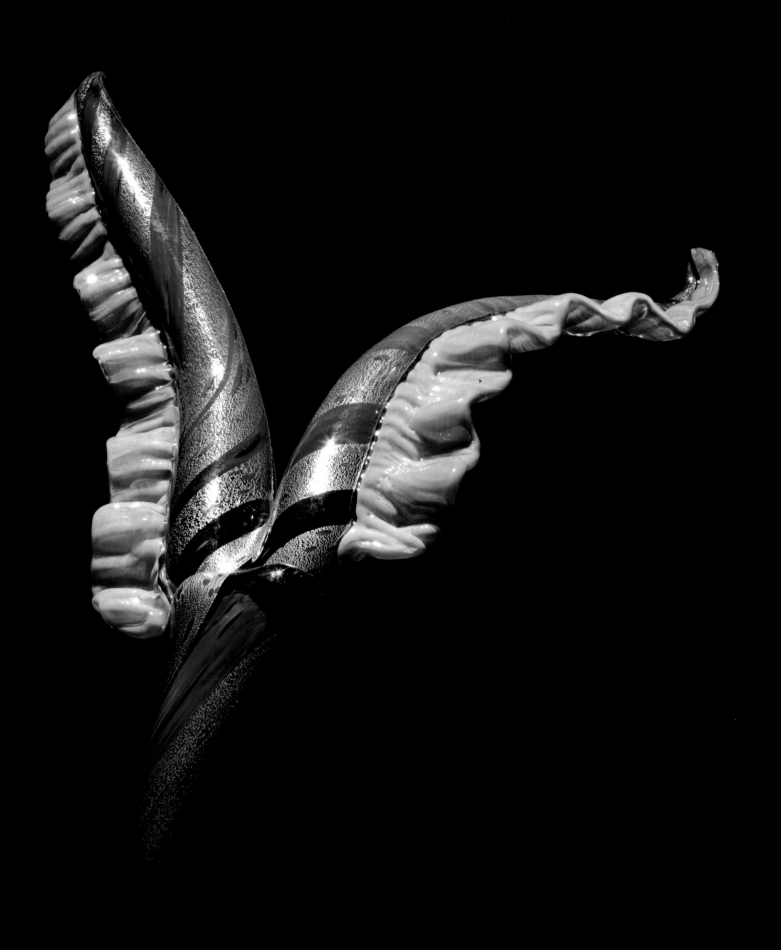

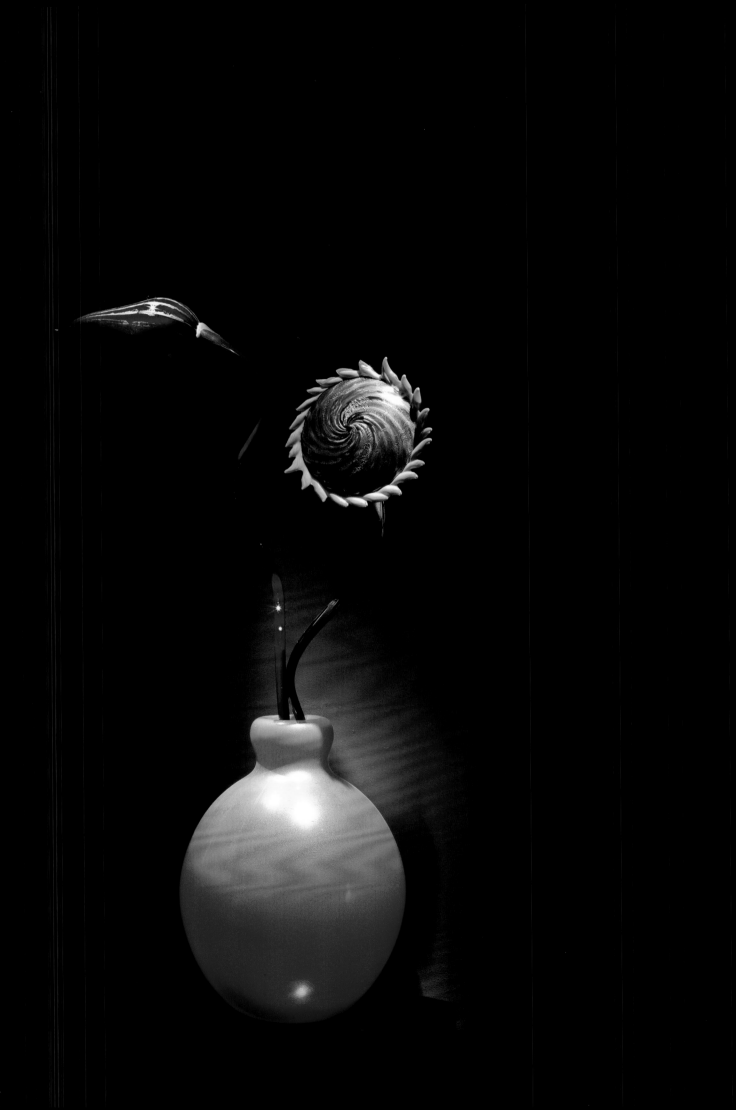

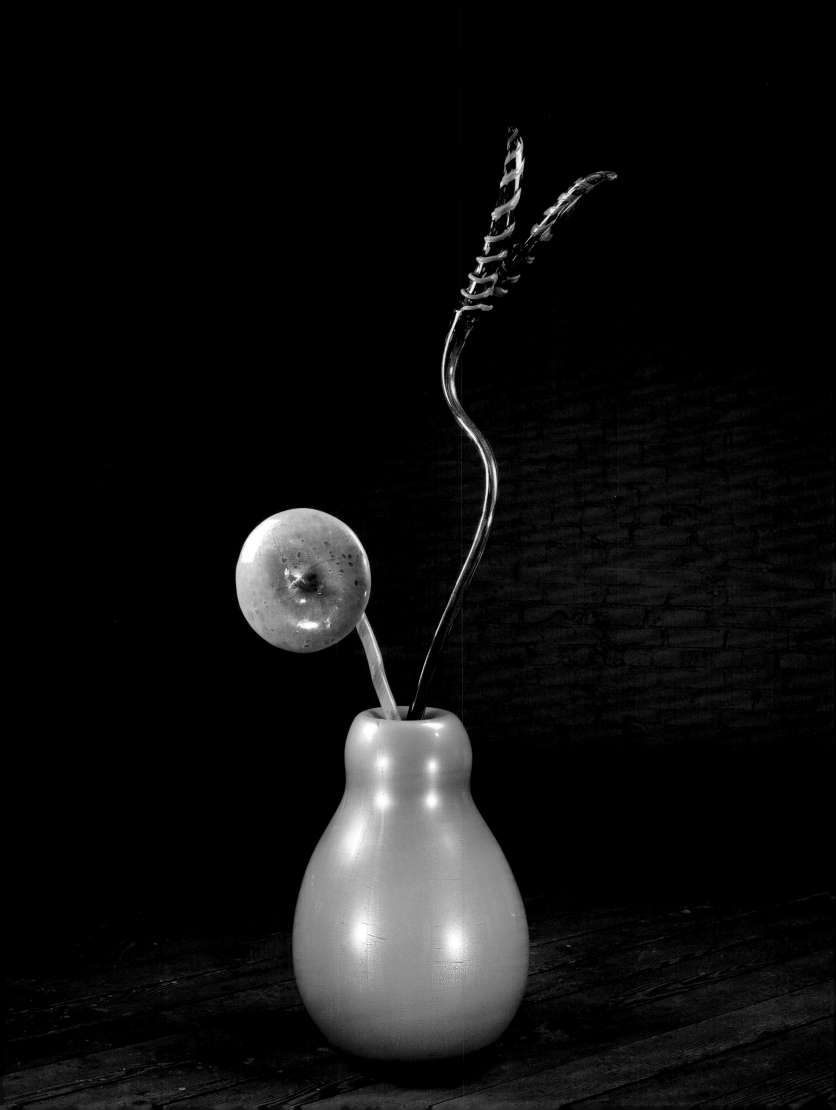

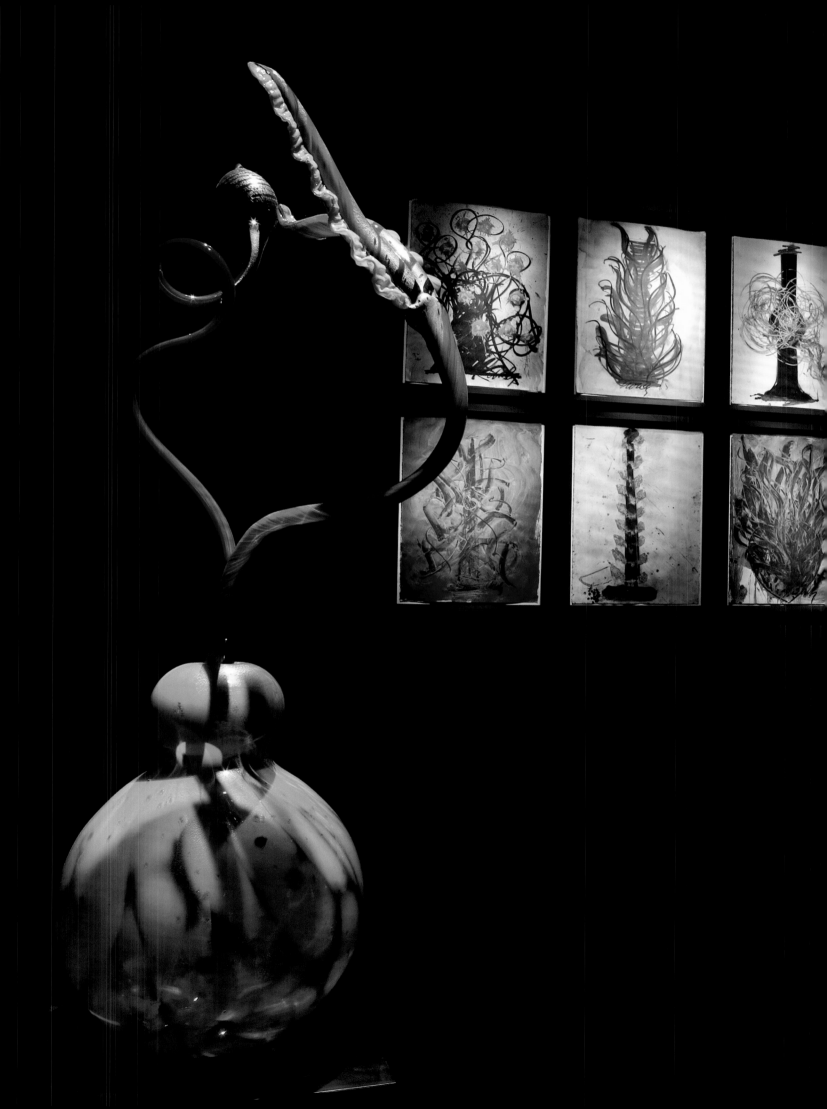

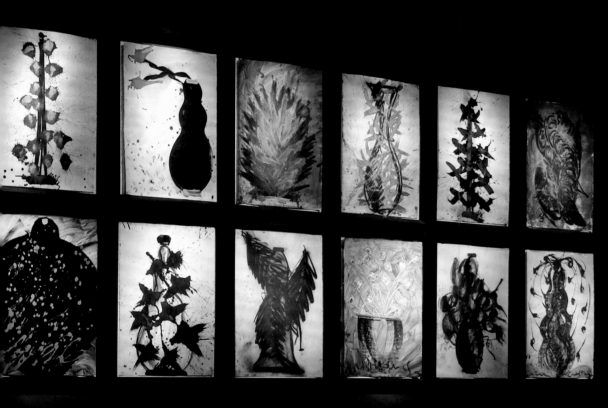

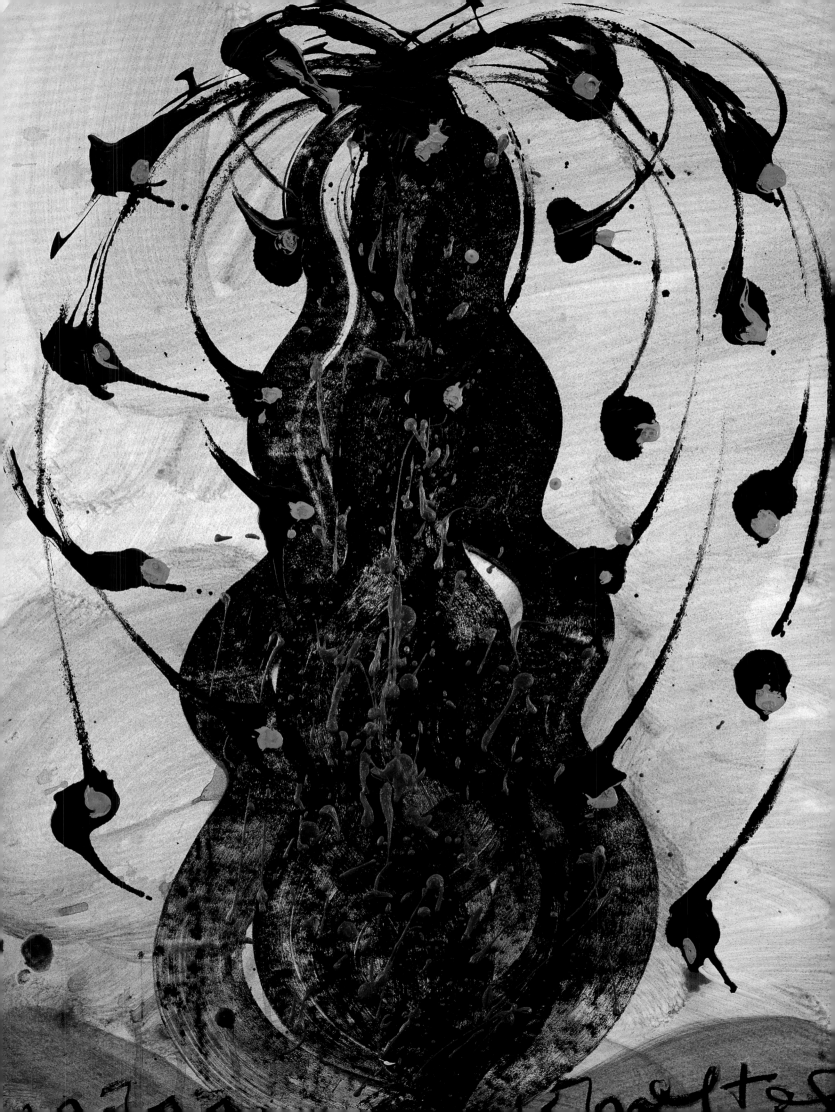

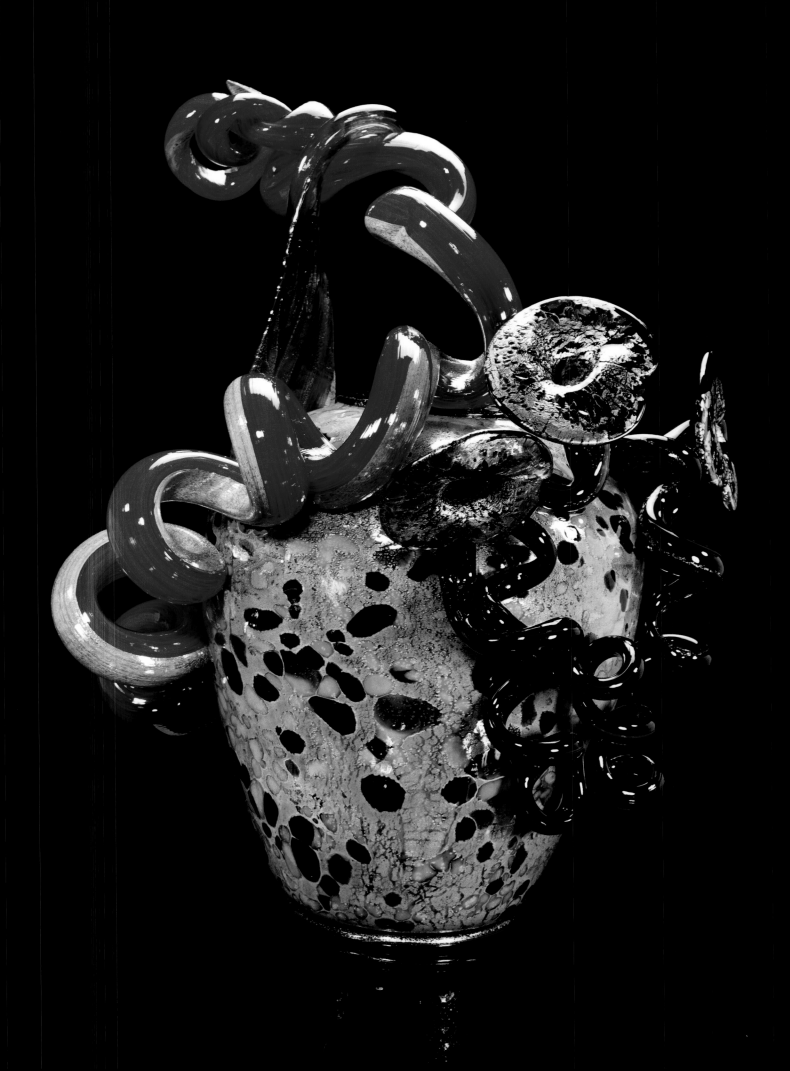

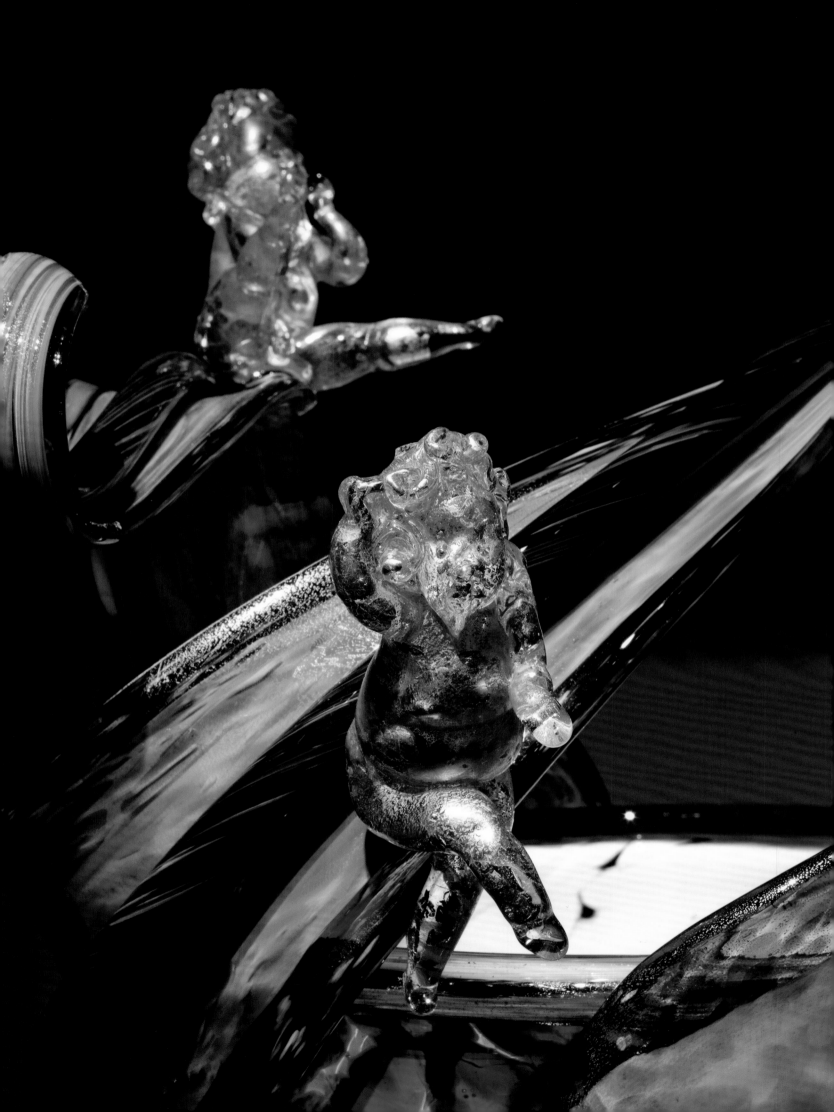

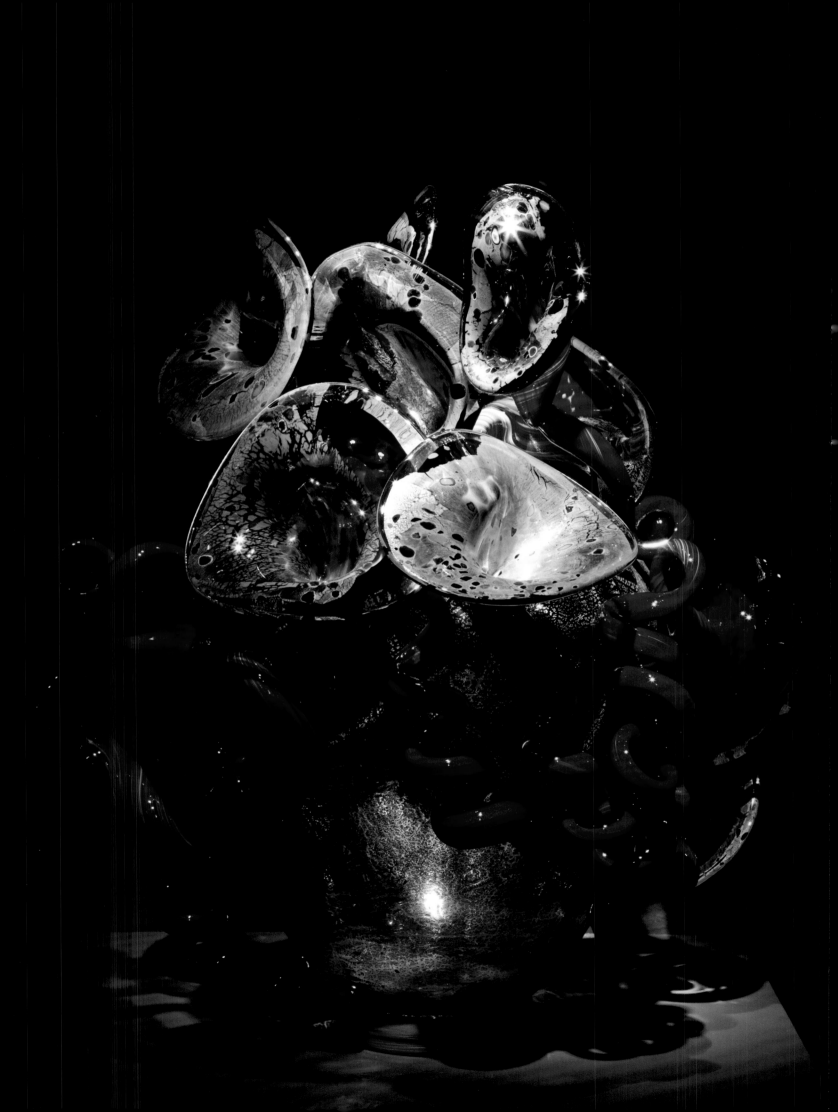

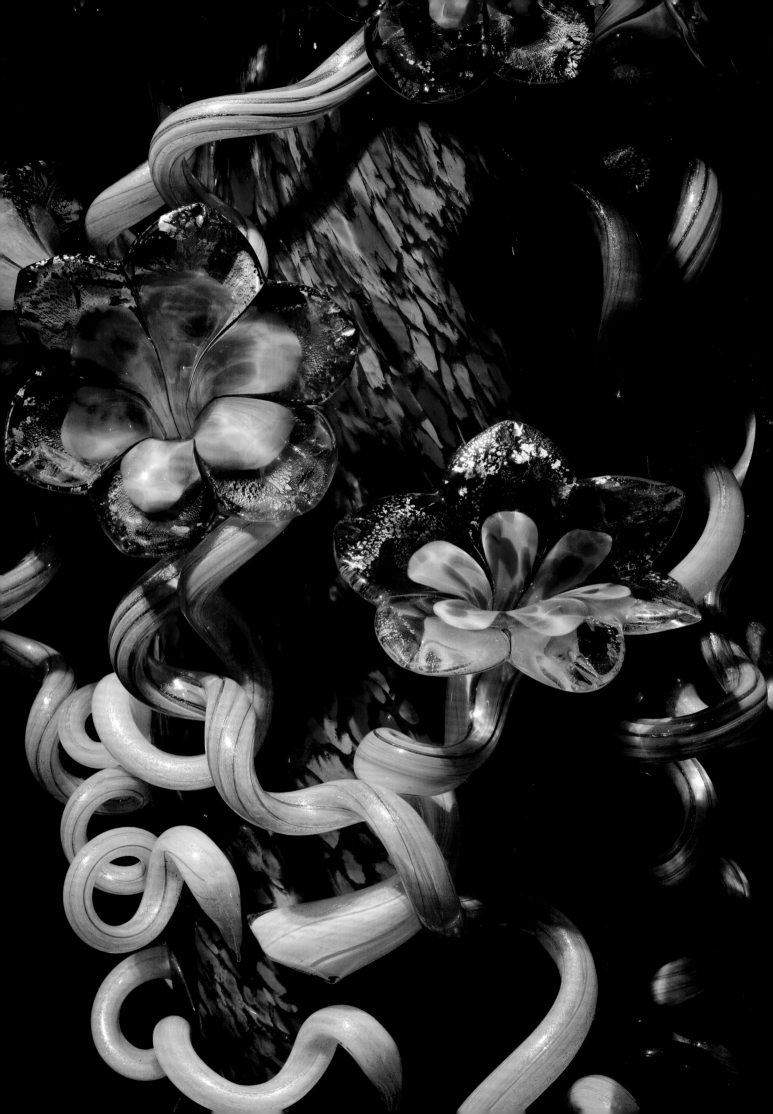

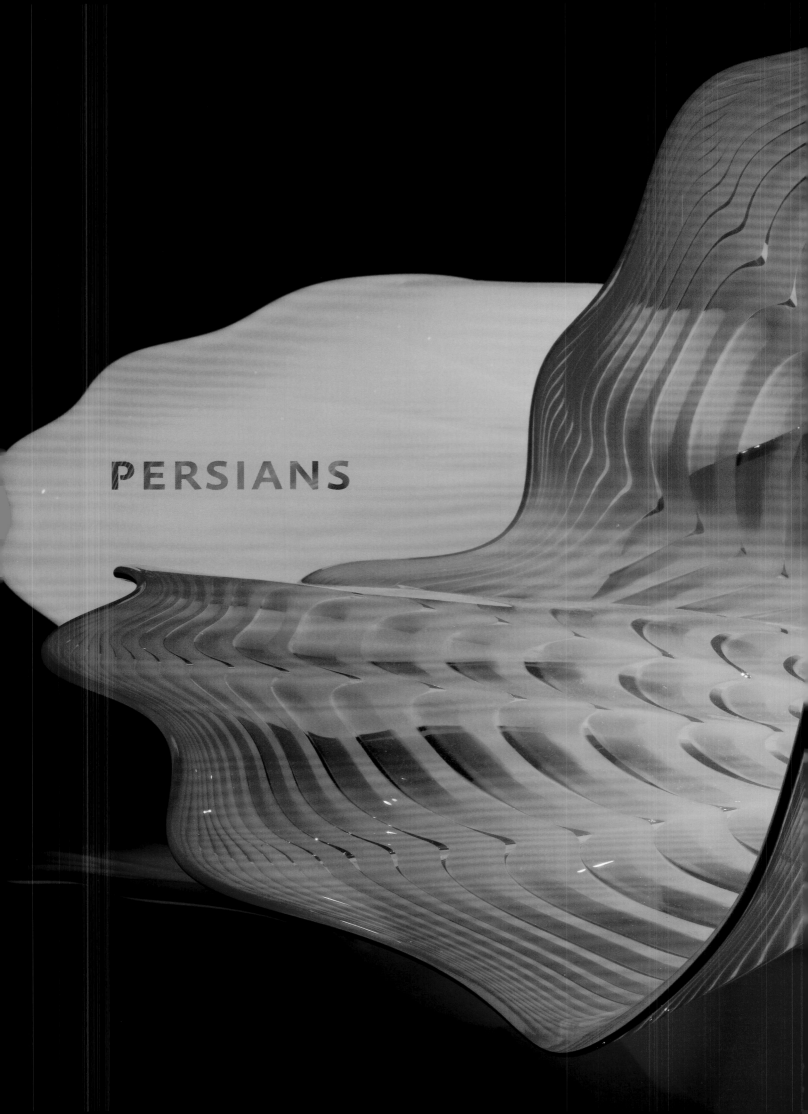

PERSIANS

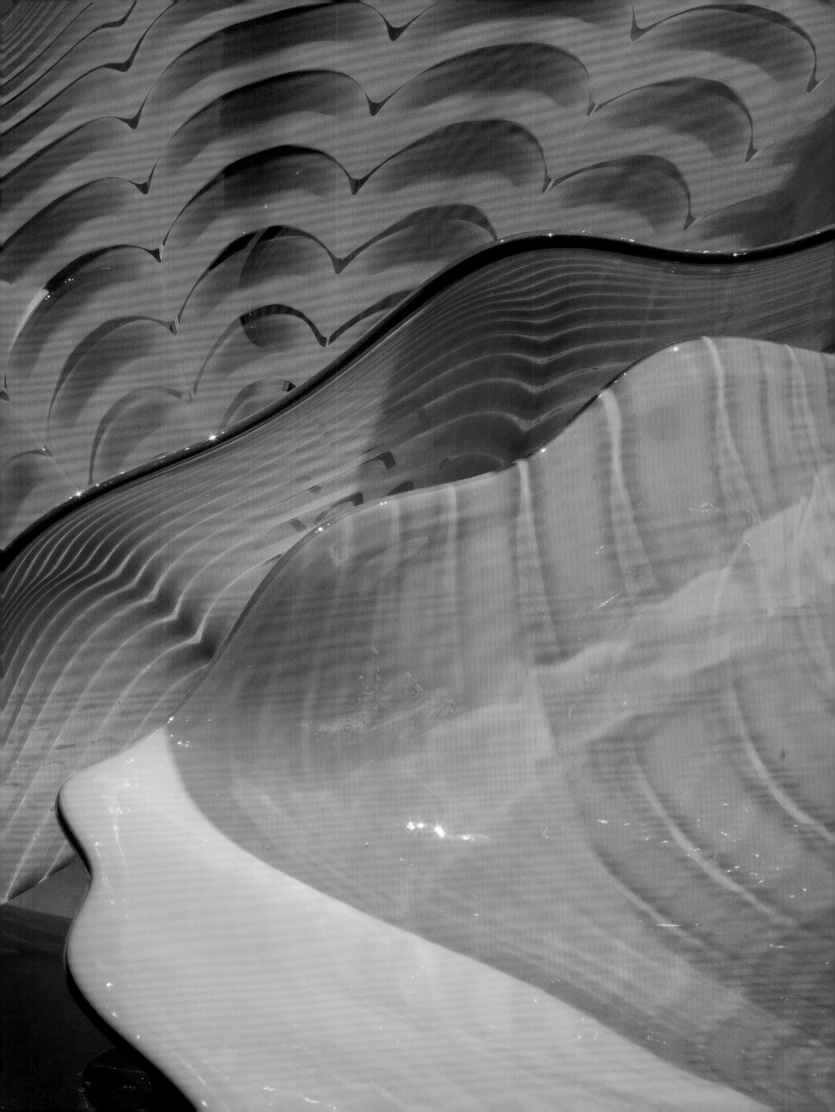

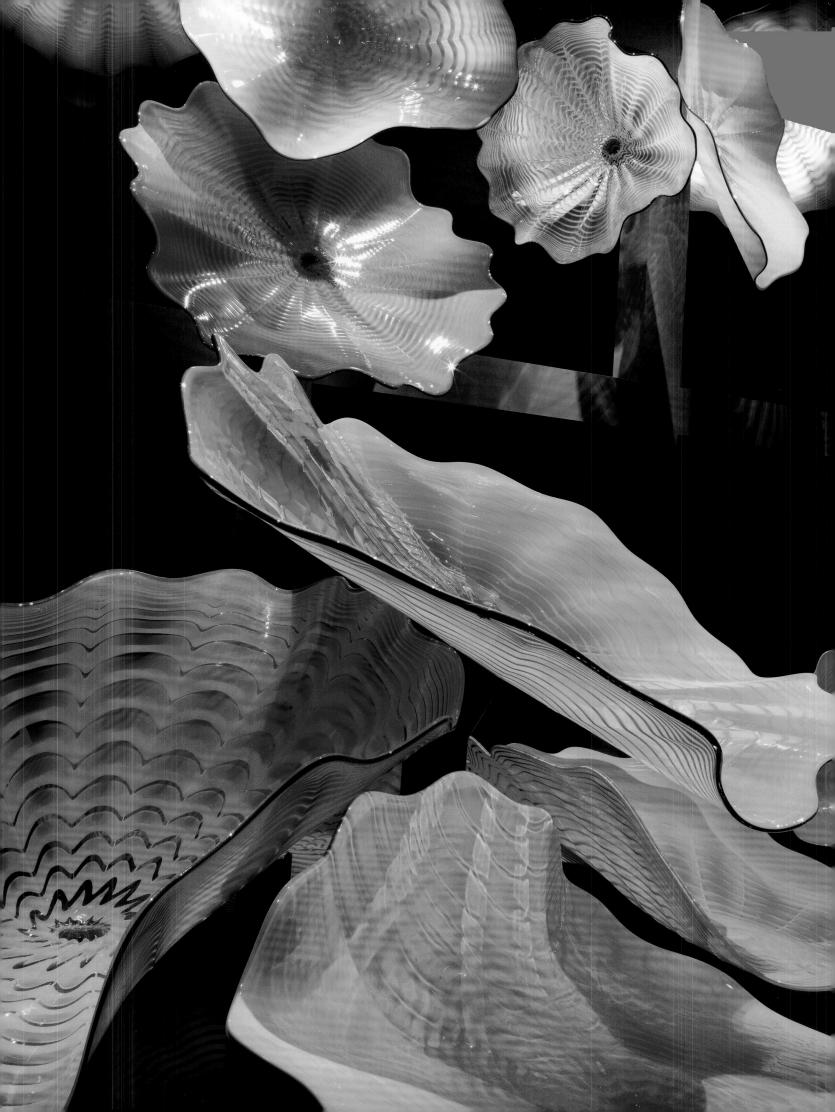

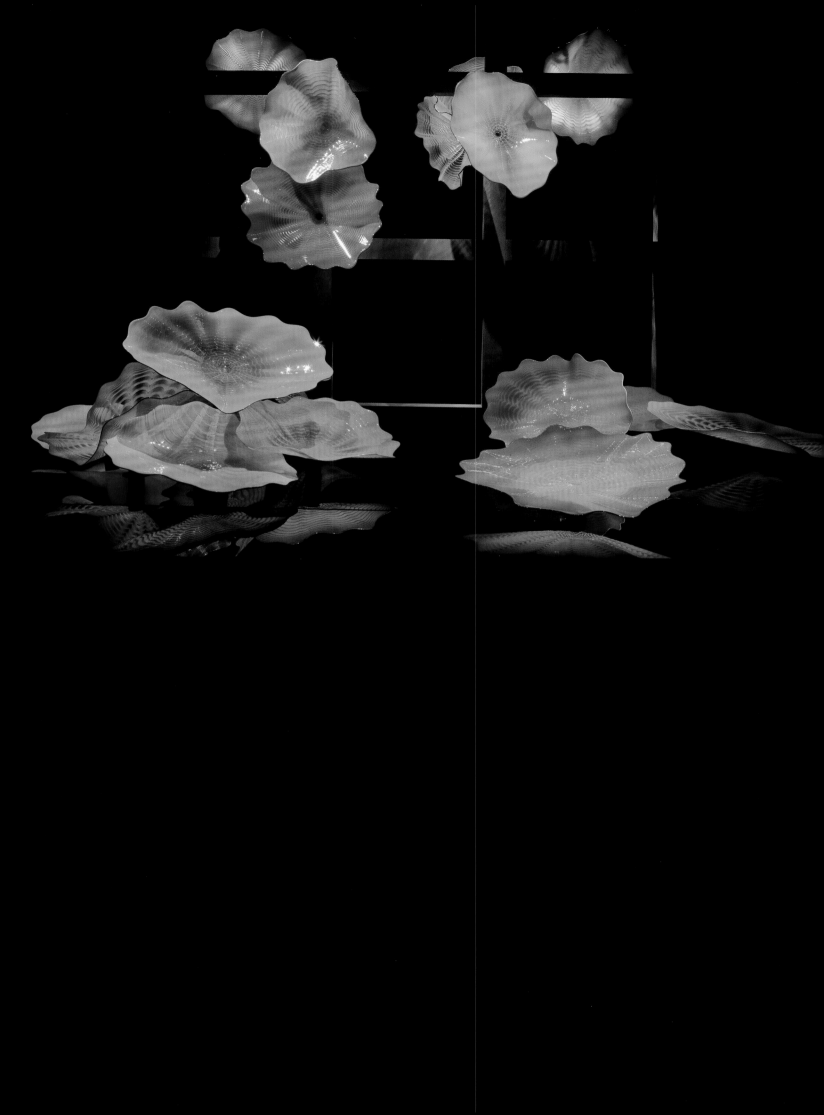

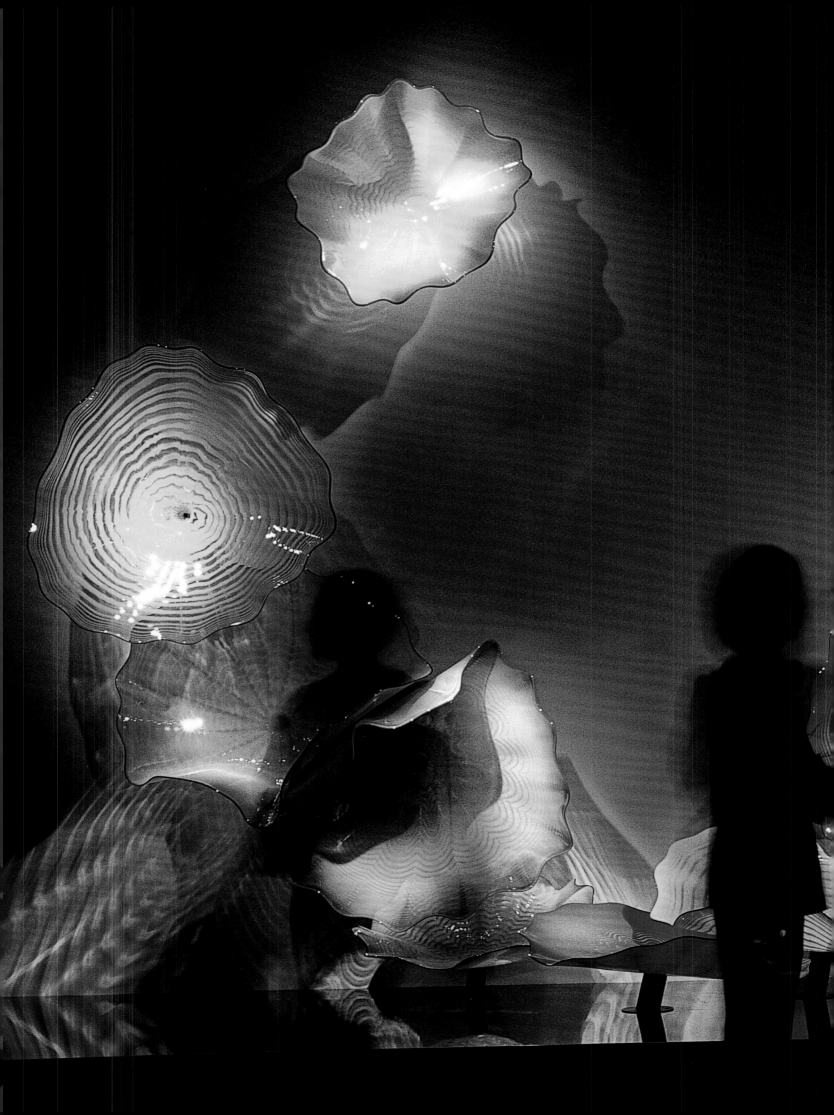

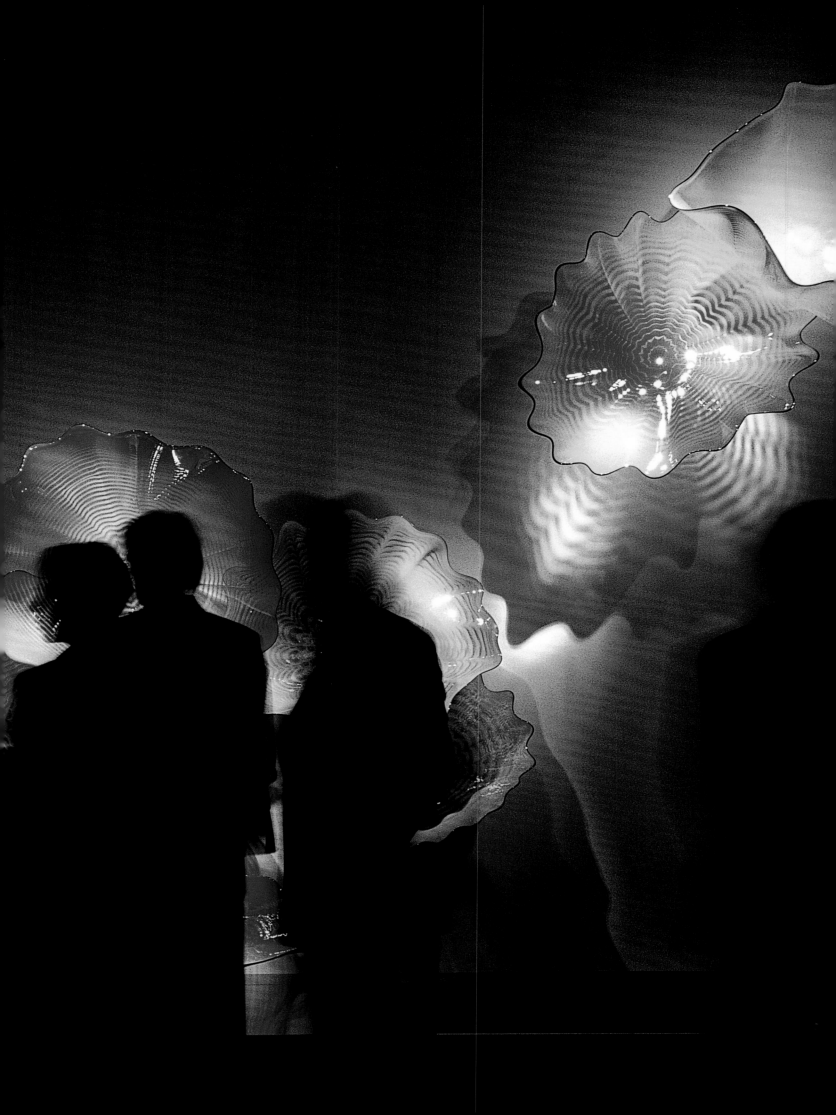

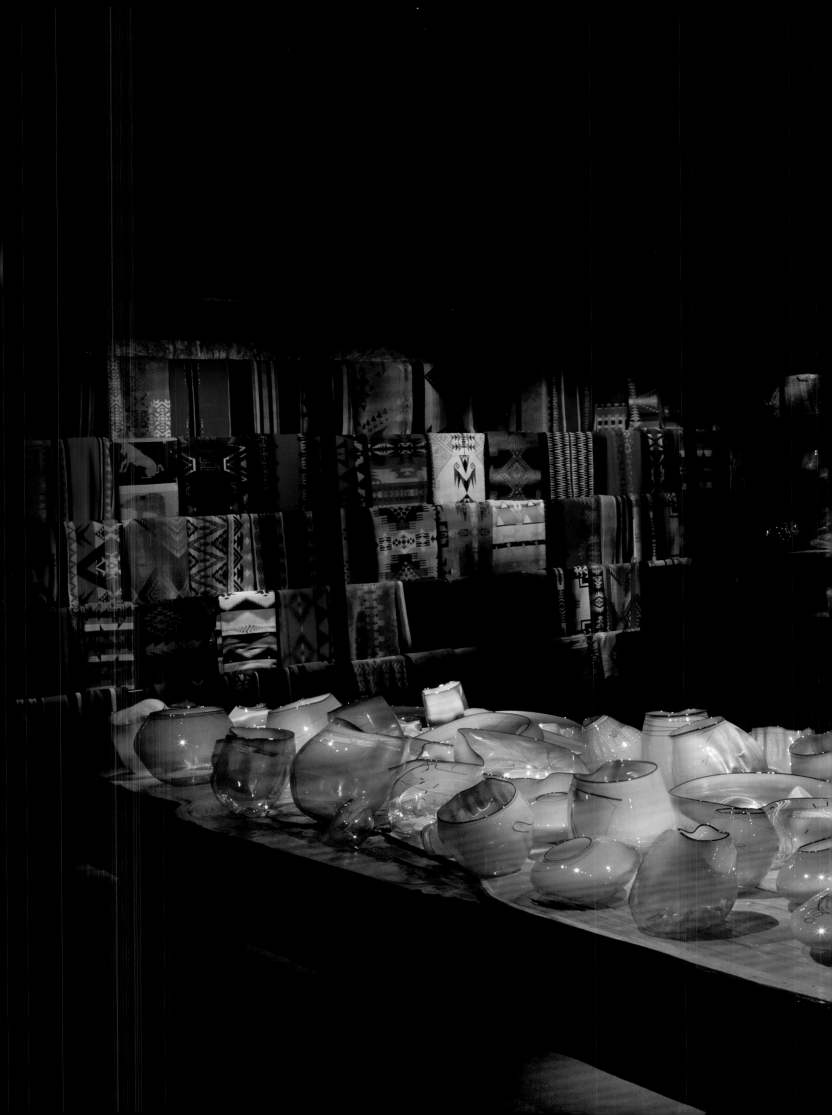

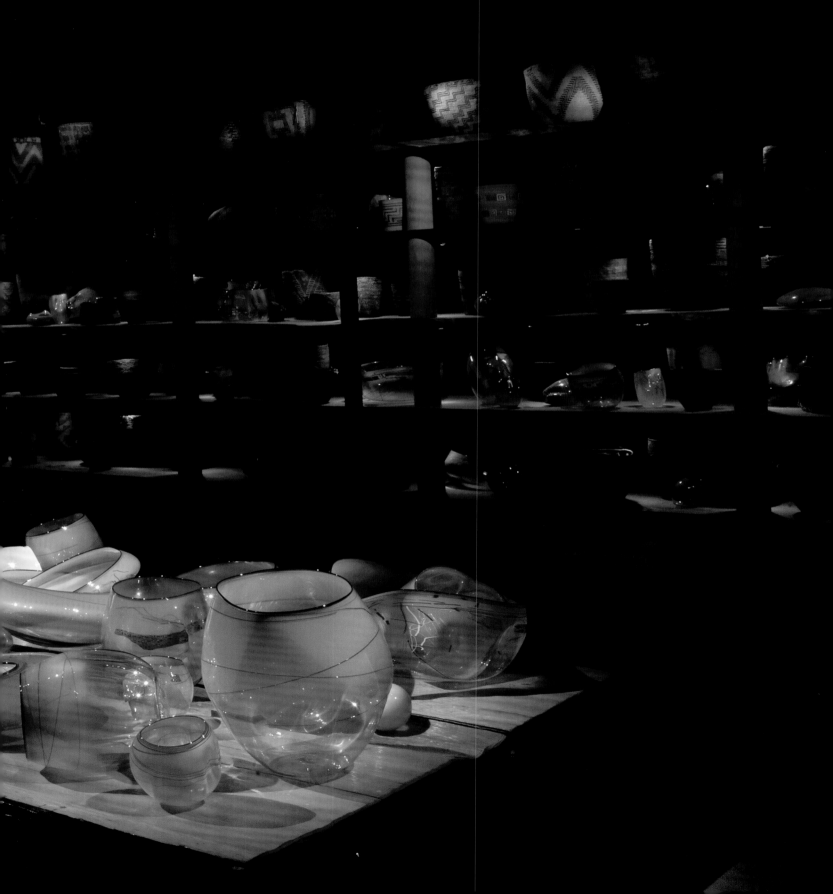

TABAC BASKETS

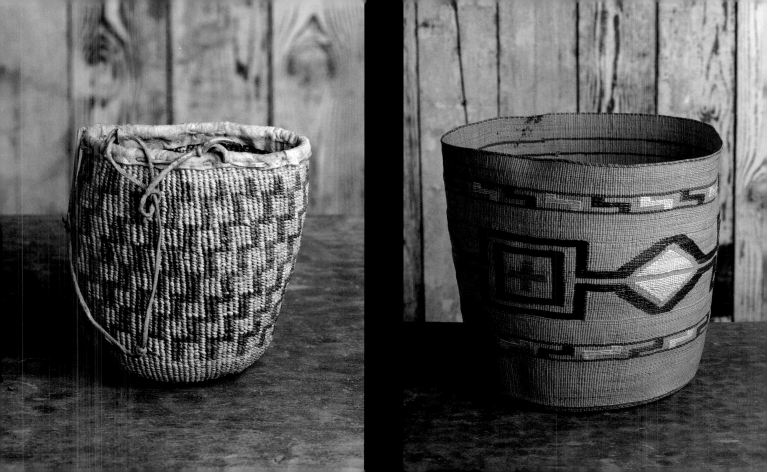

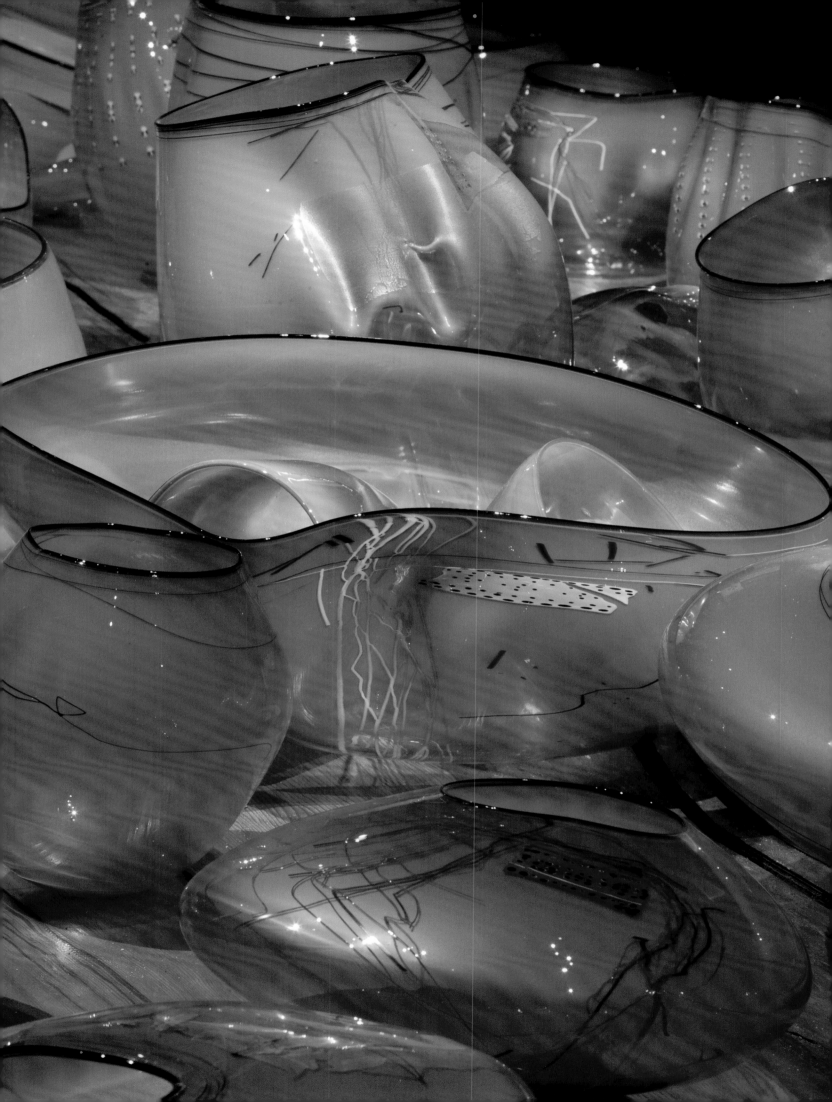

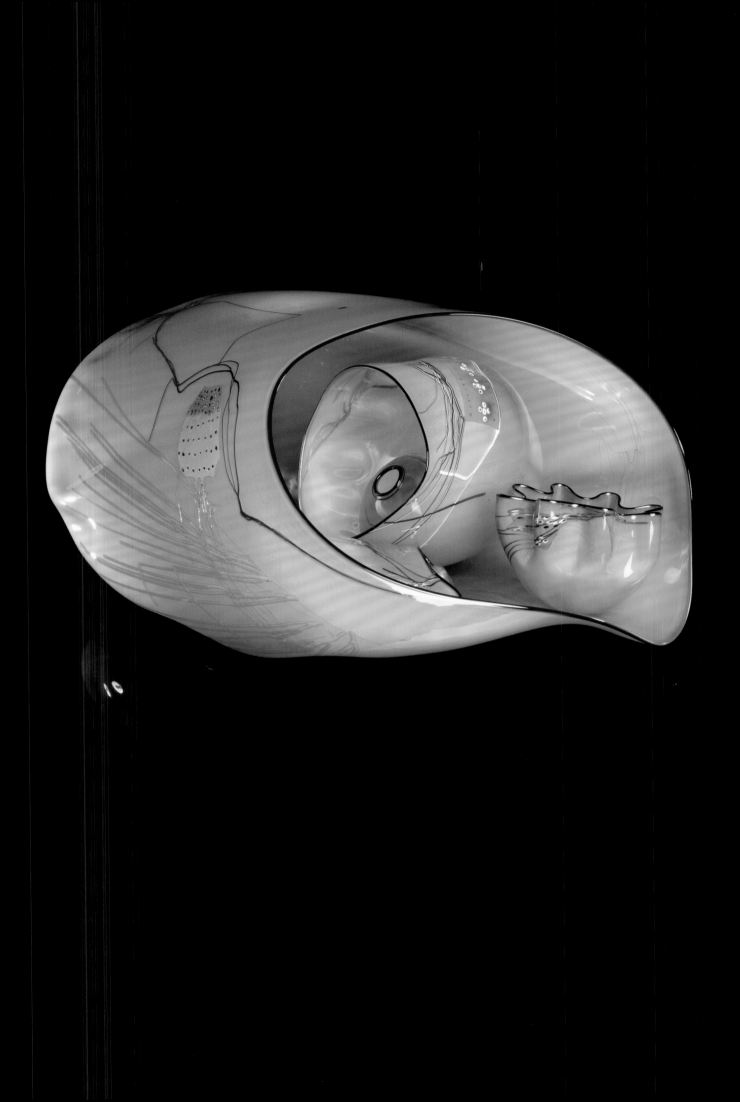

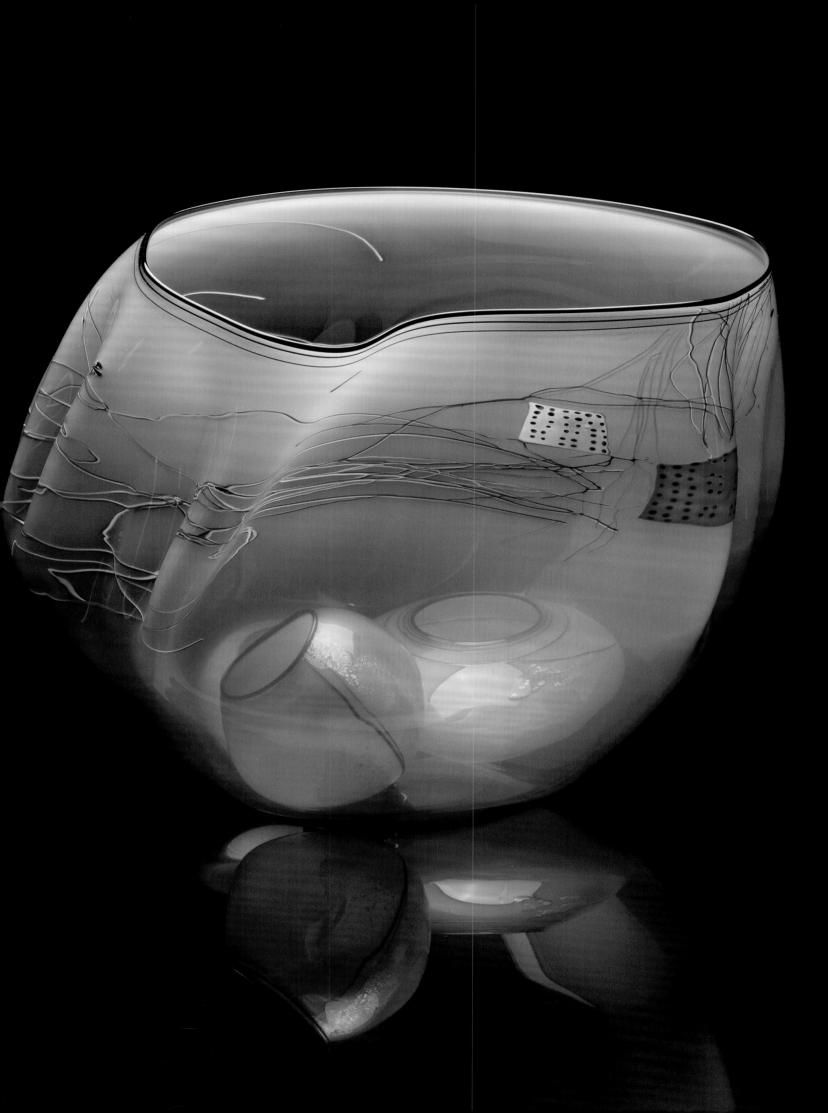

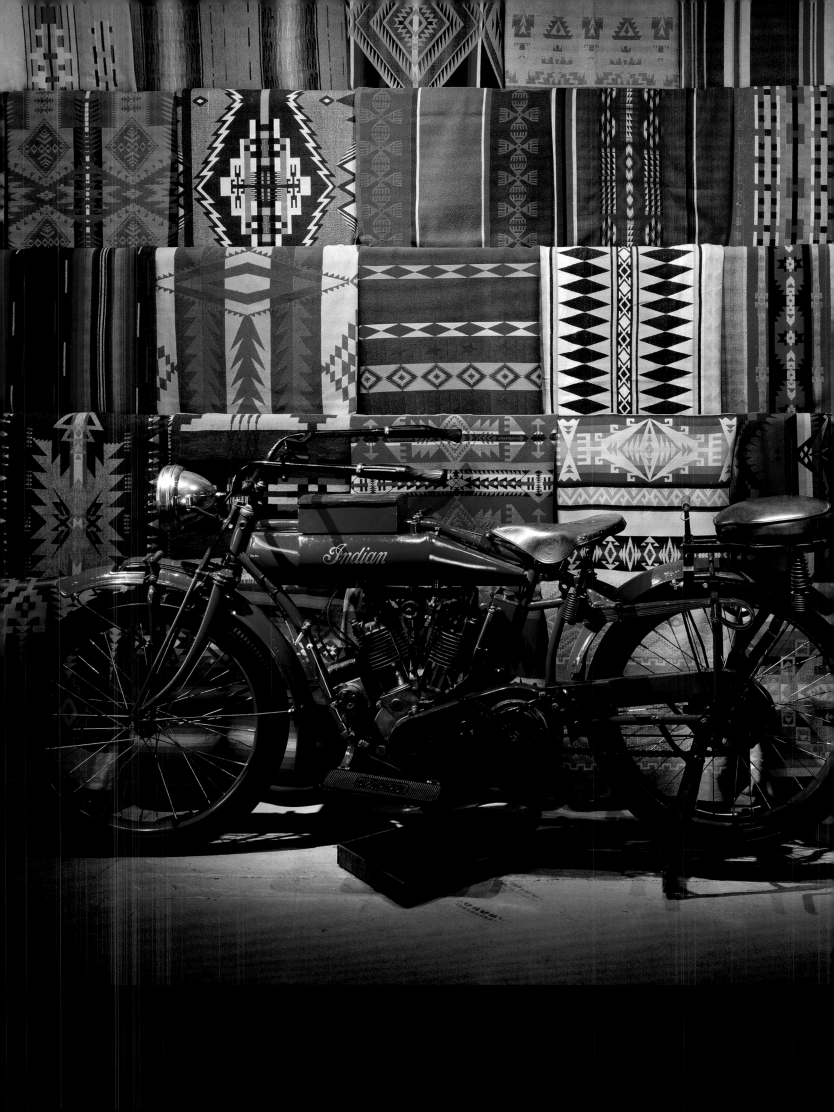

MACCHIA FOREST

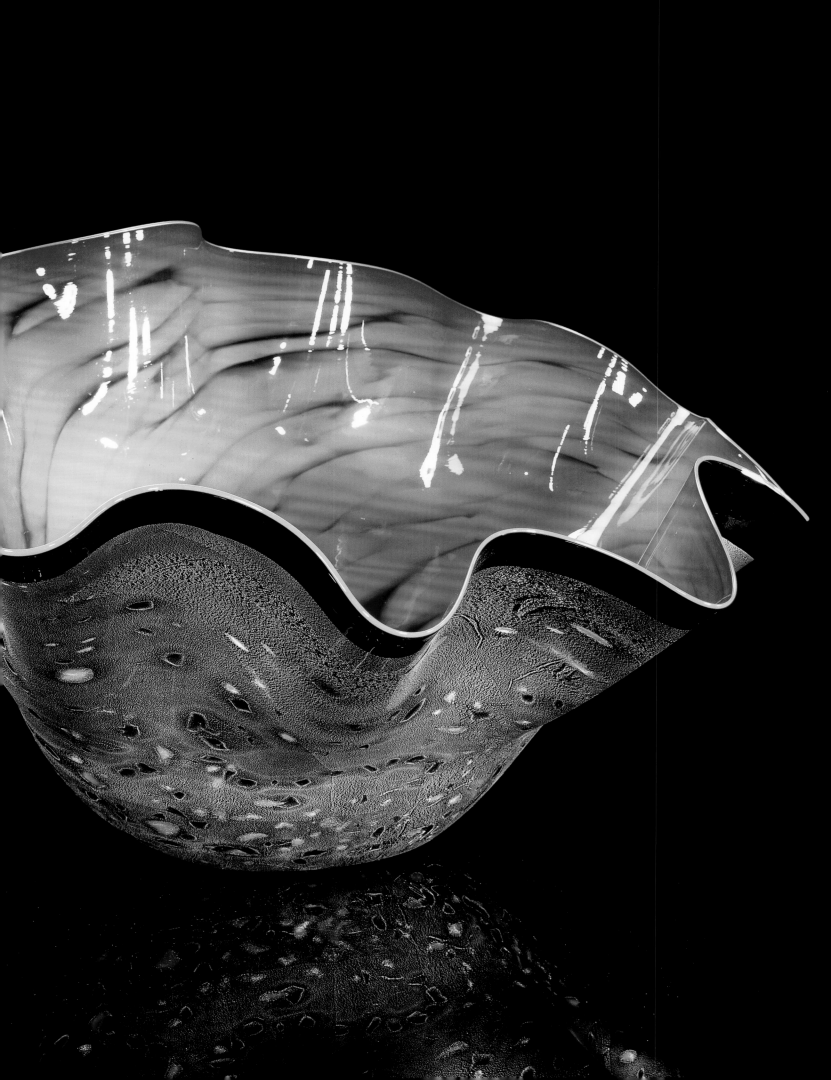

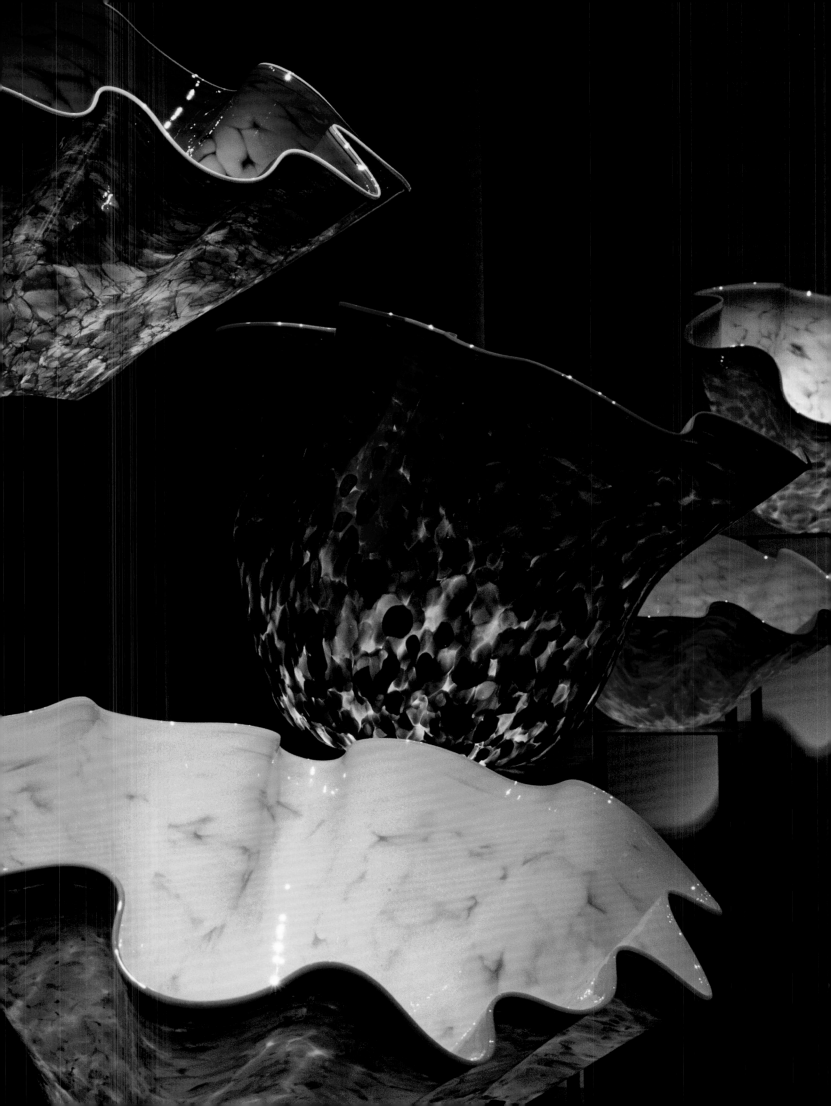

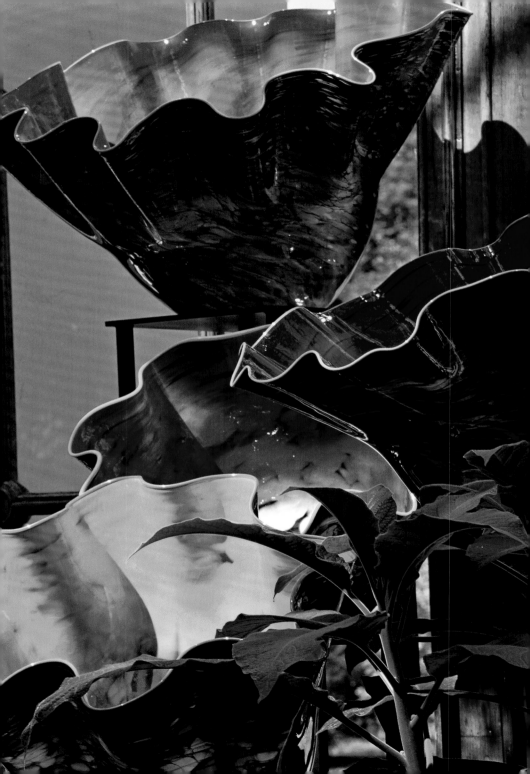

REEDS

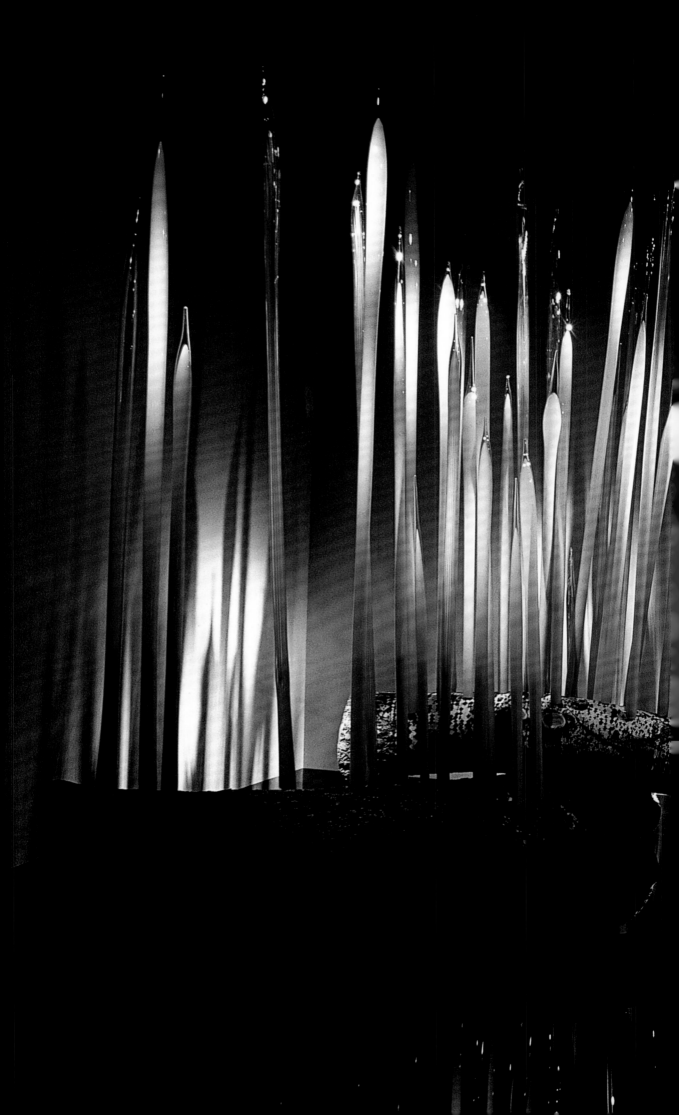

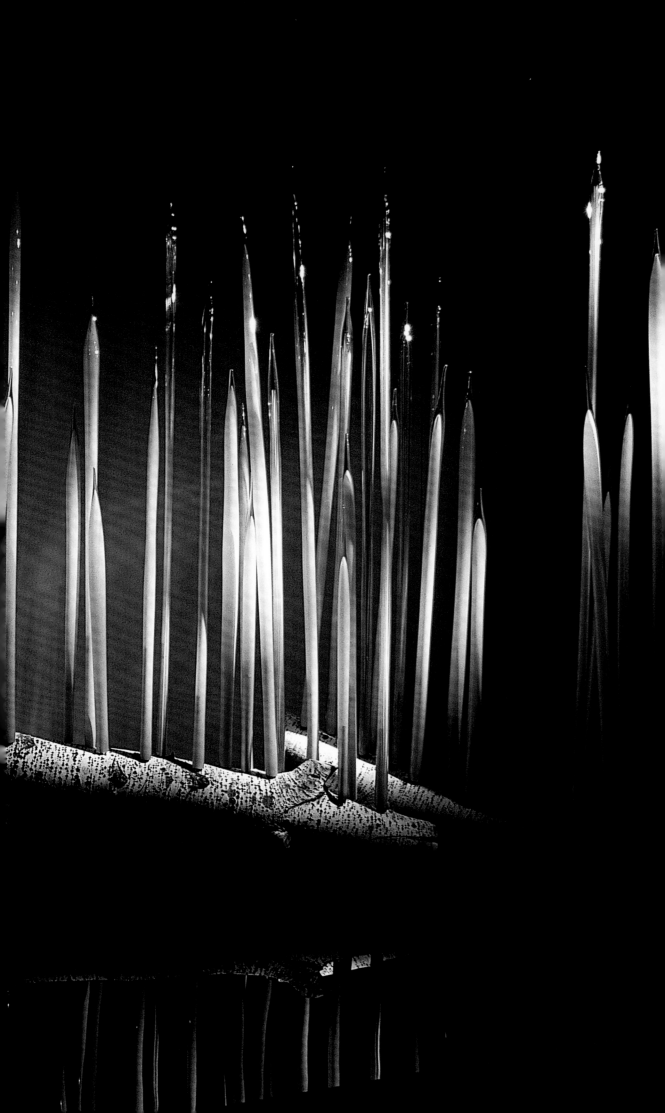

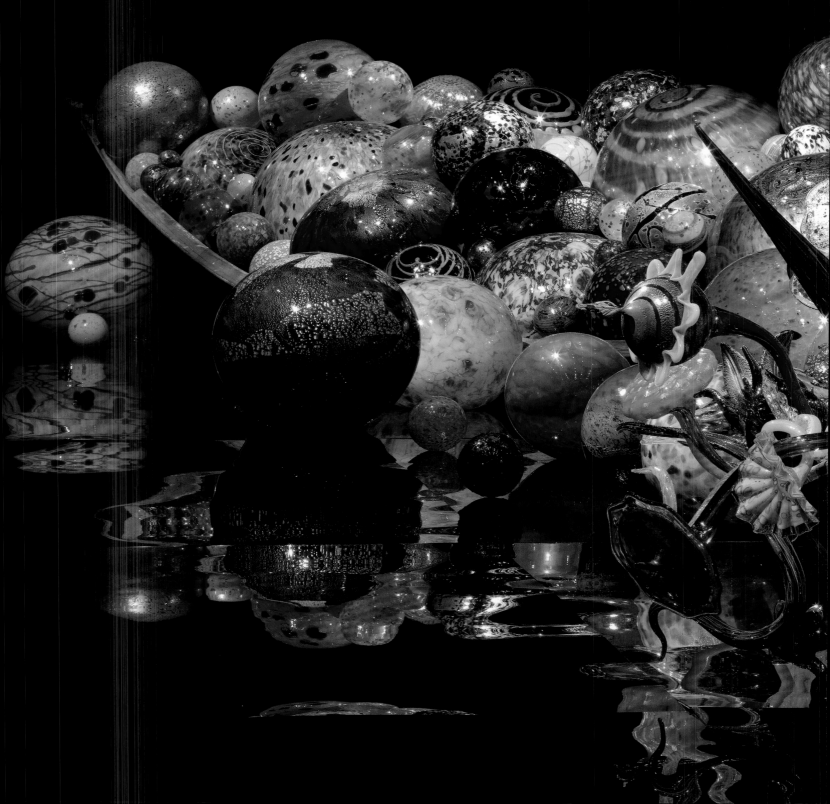

BOATS

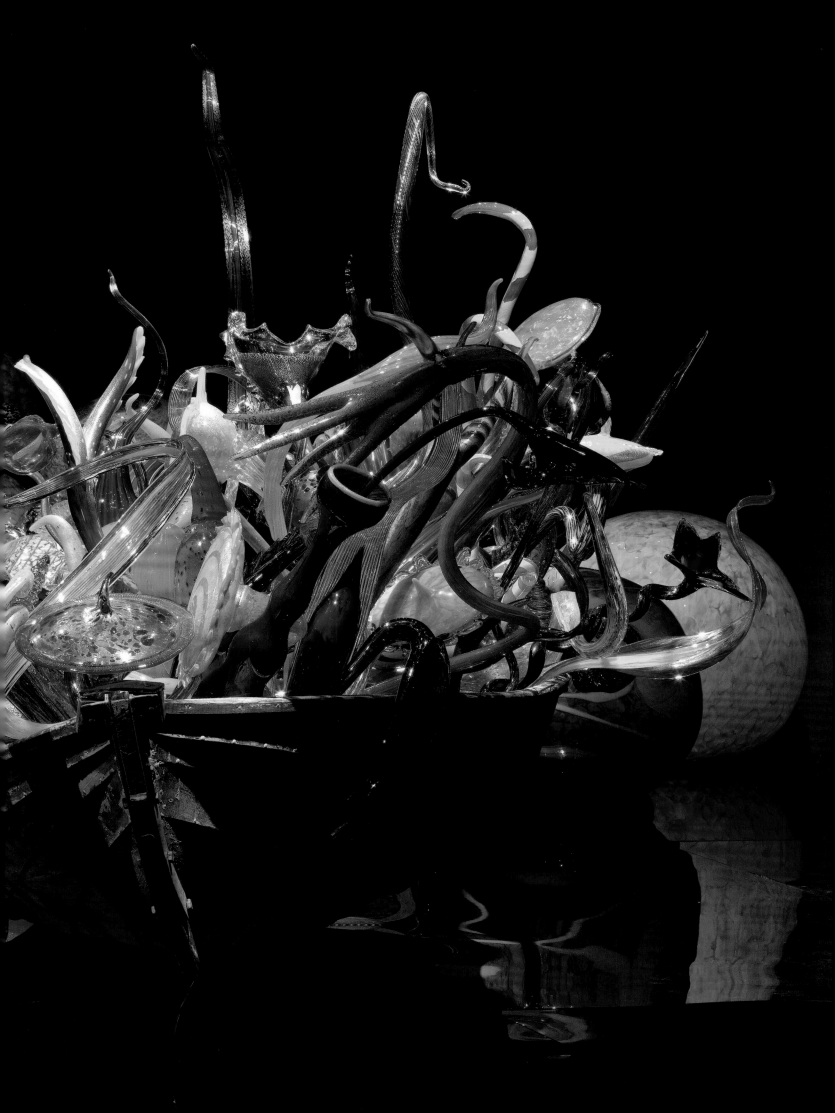

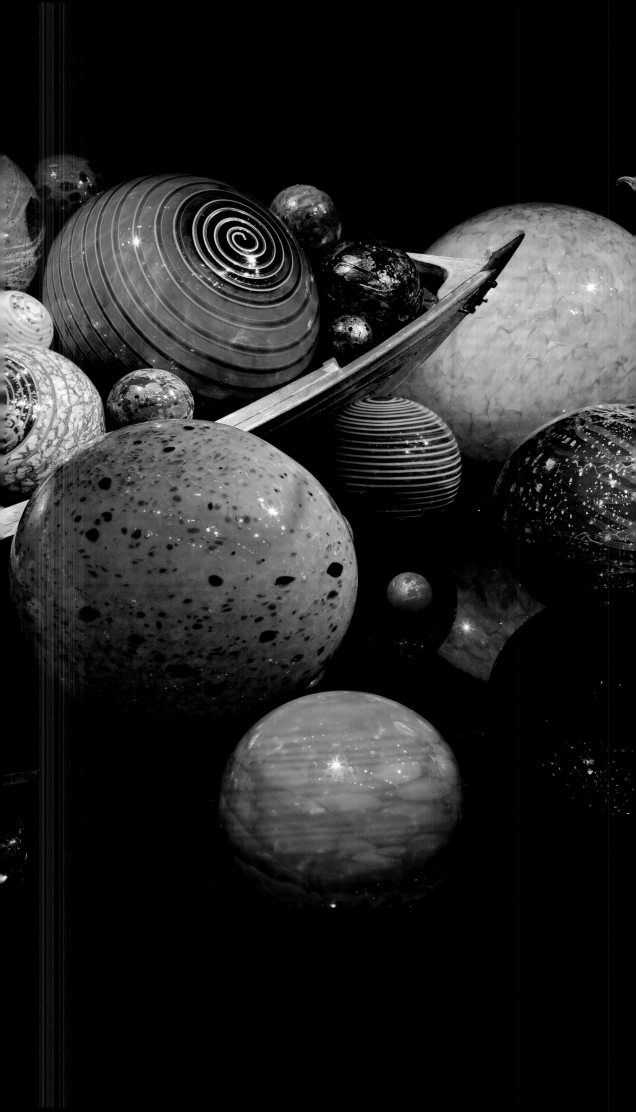

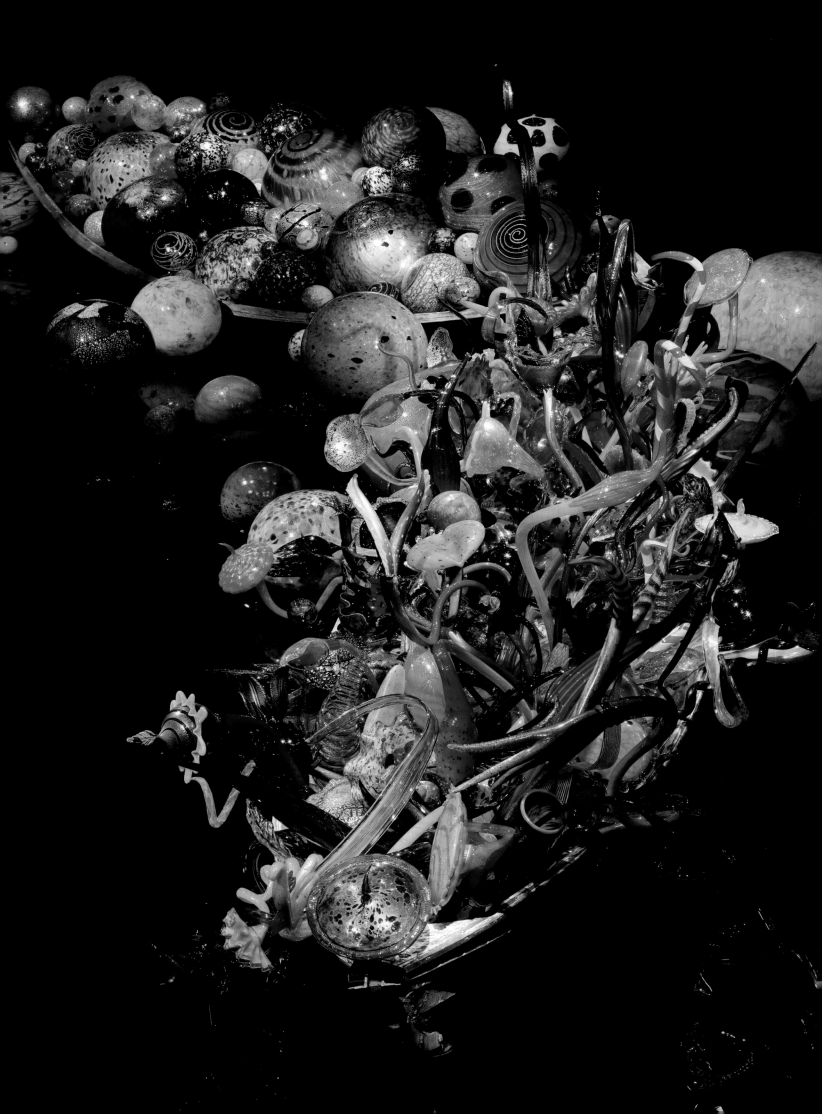

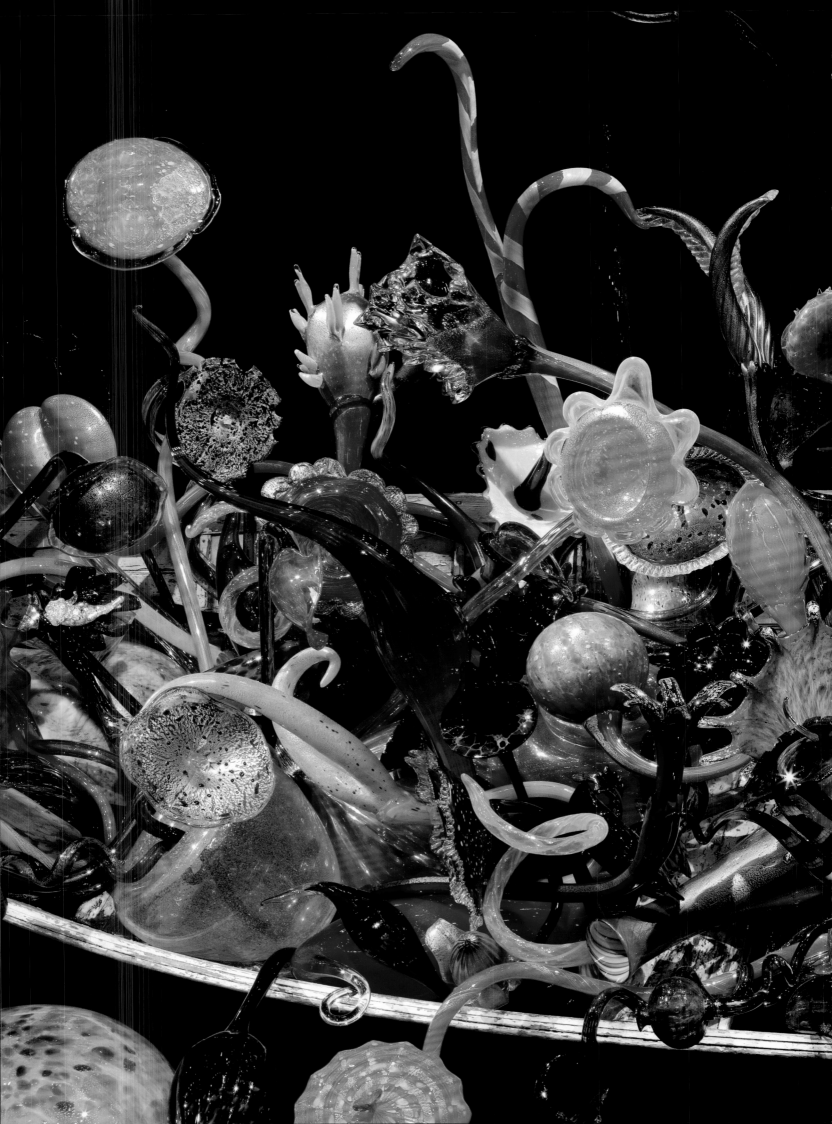

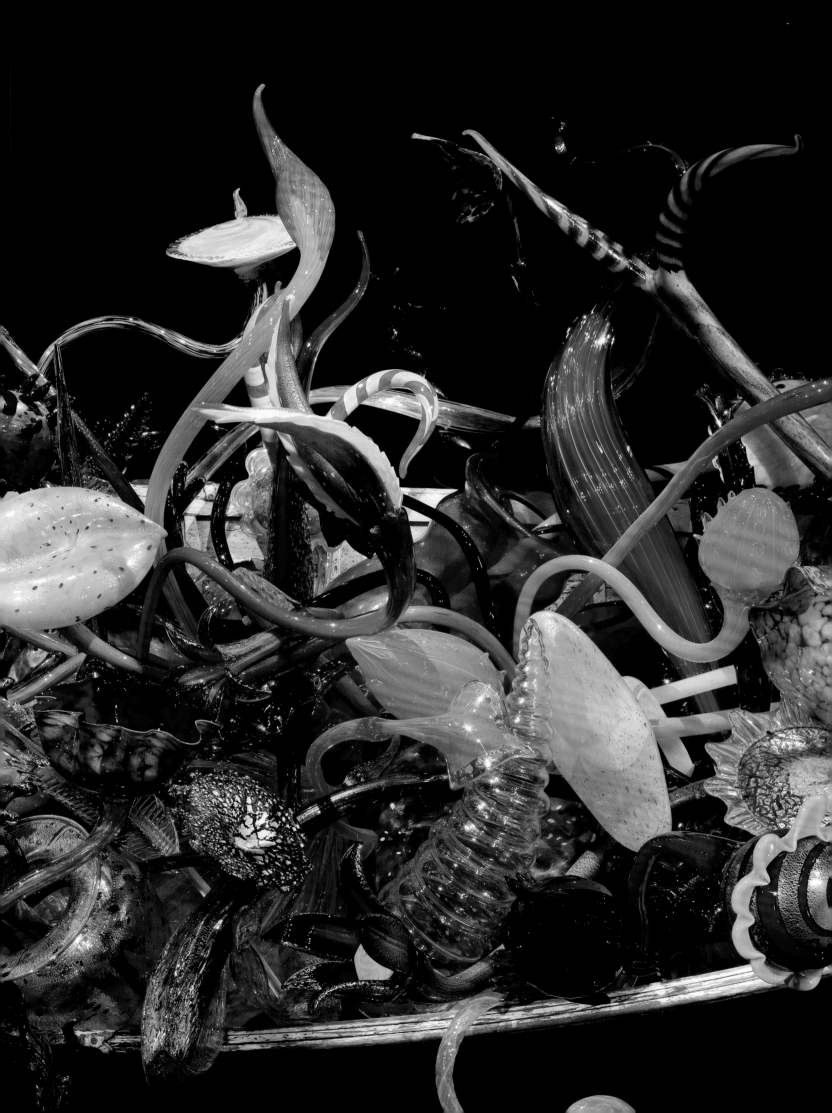

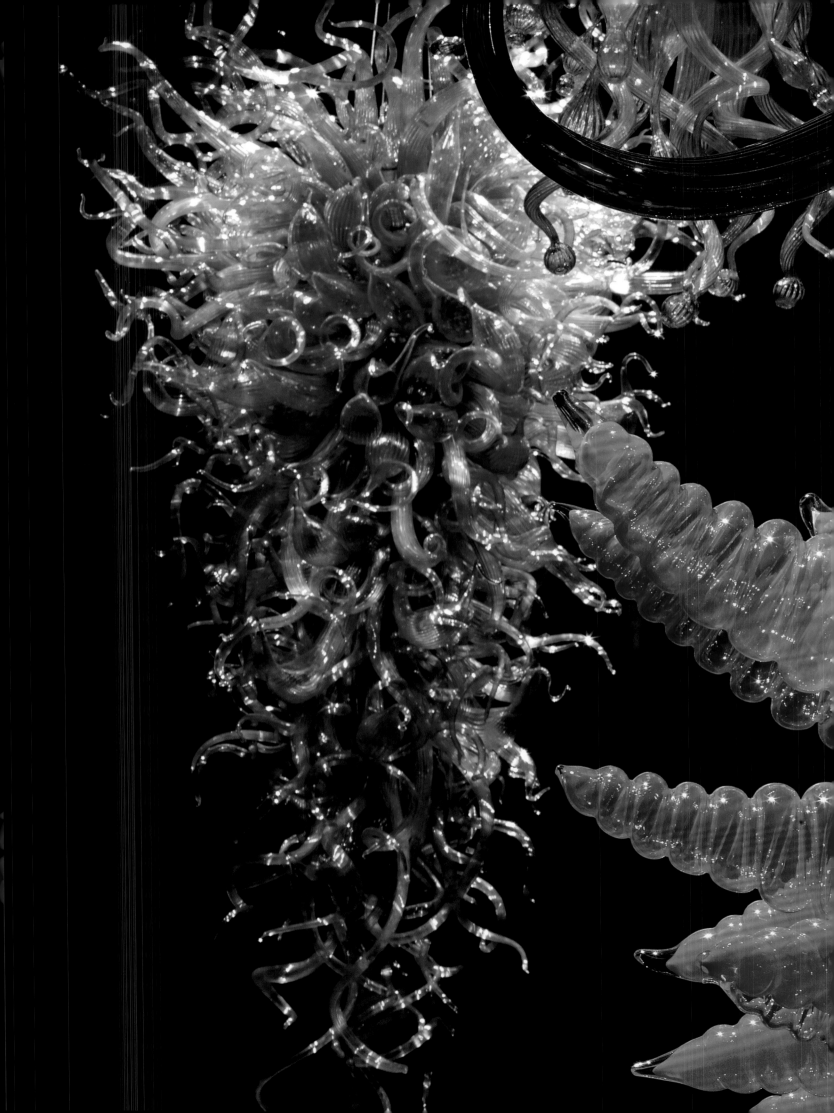

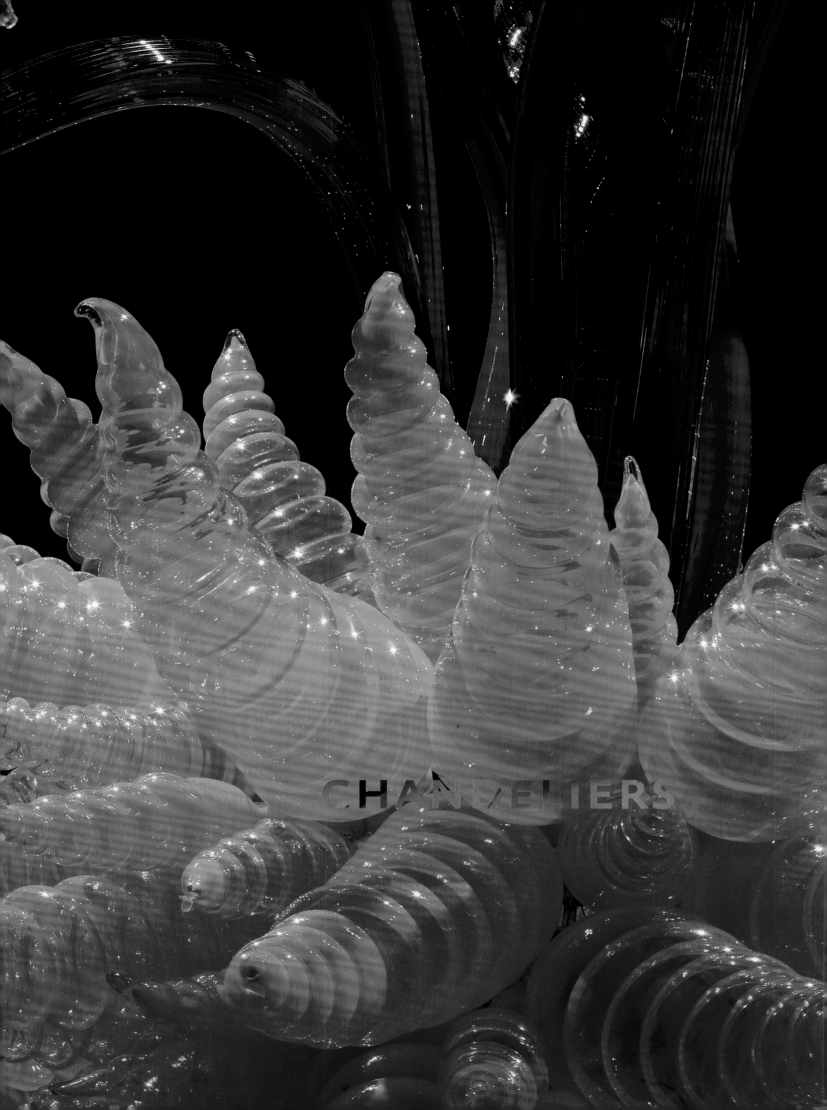

CHANDELIERS

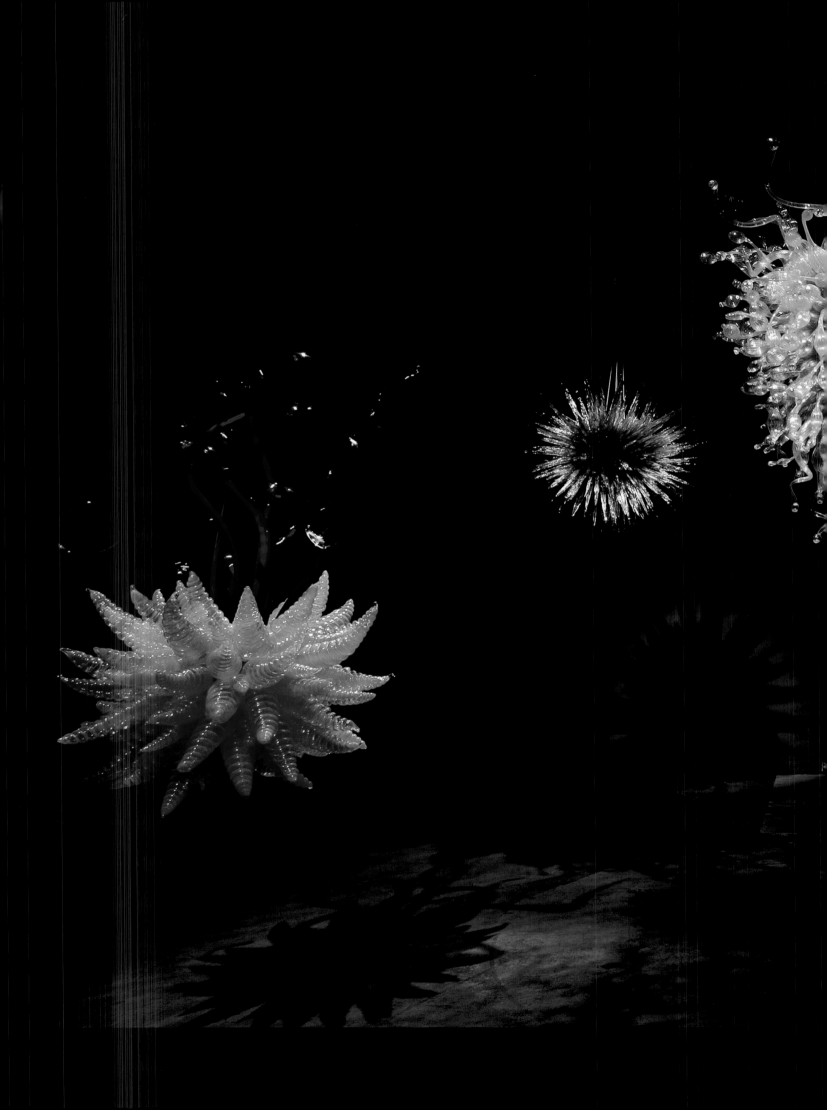

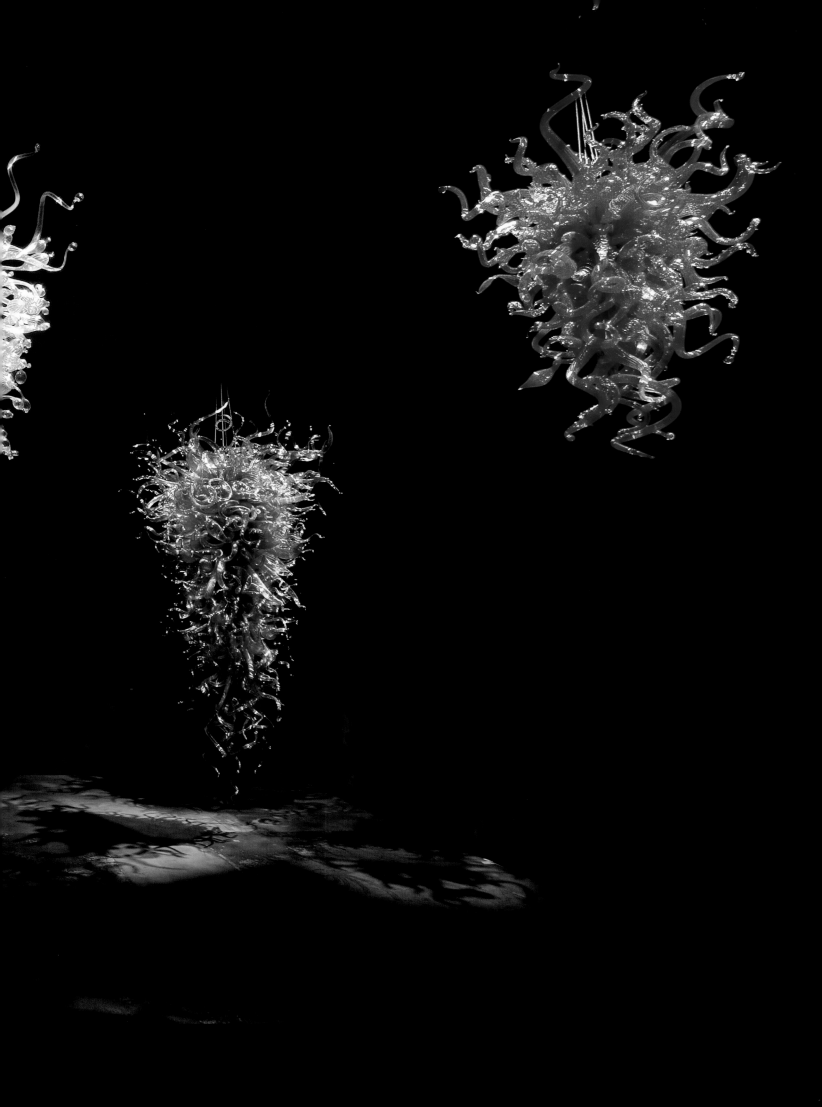

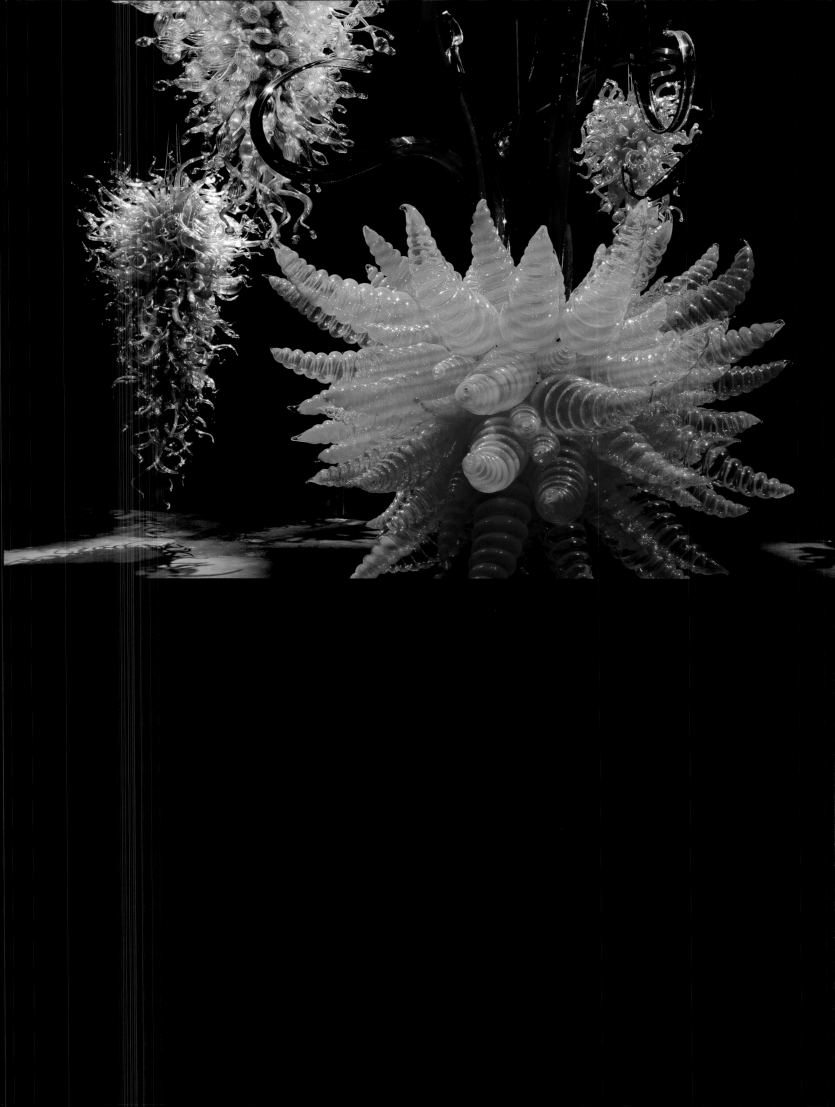

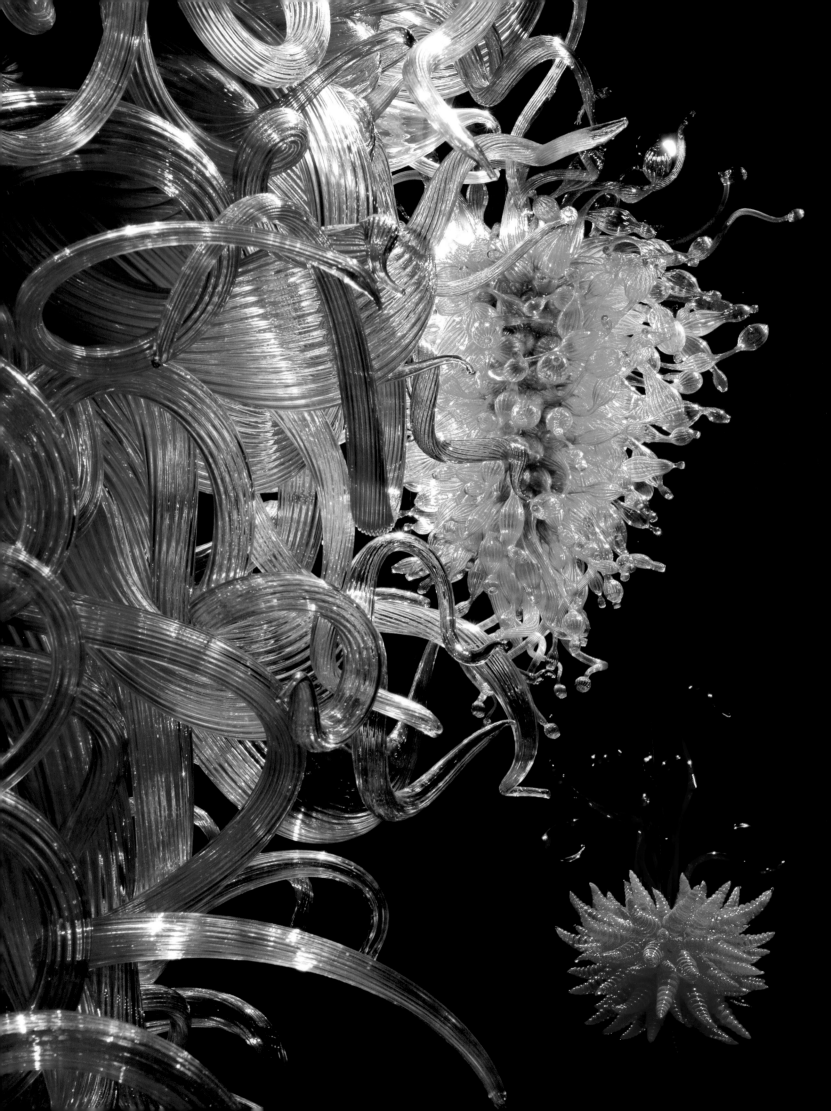

BLACK

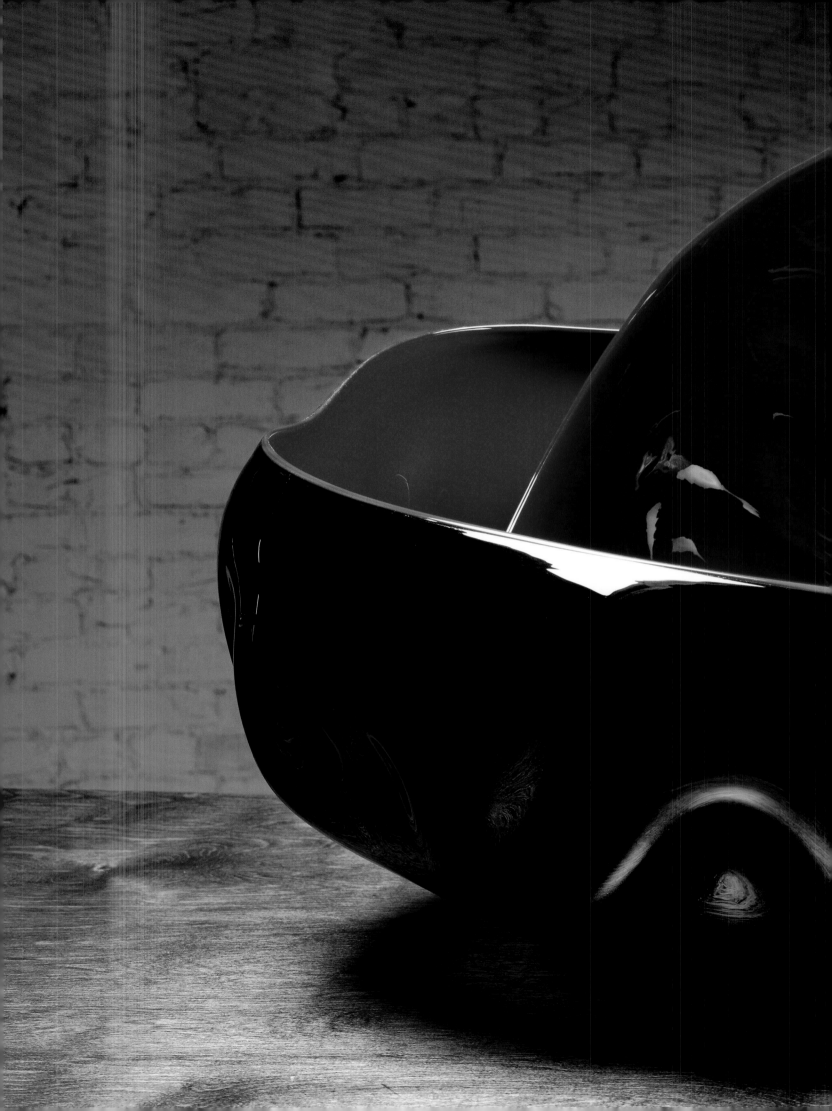

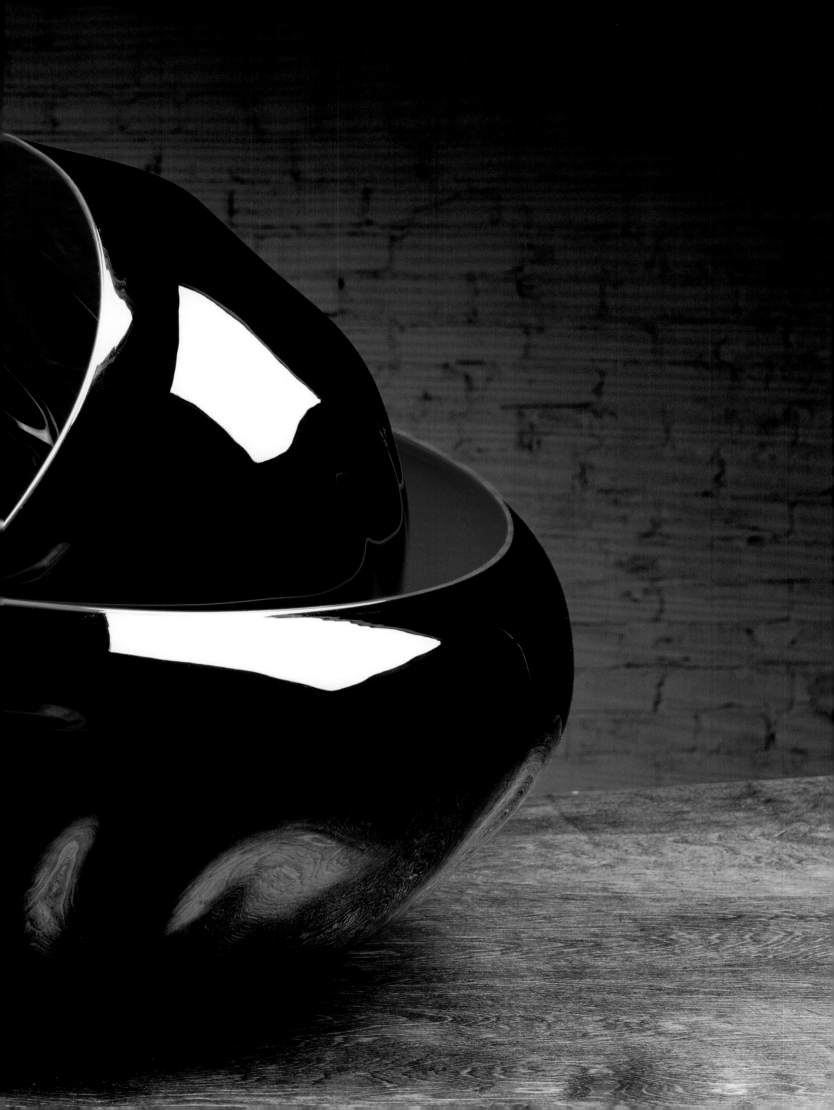

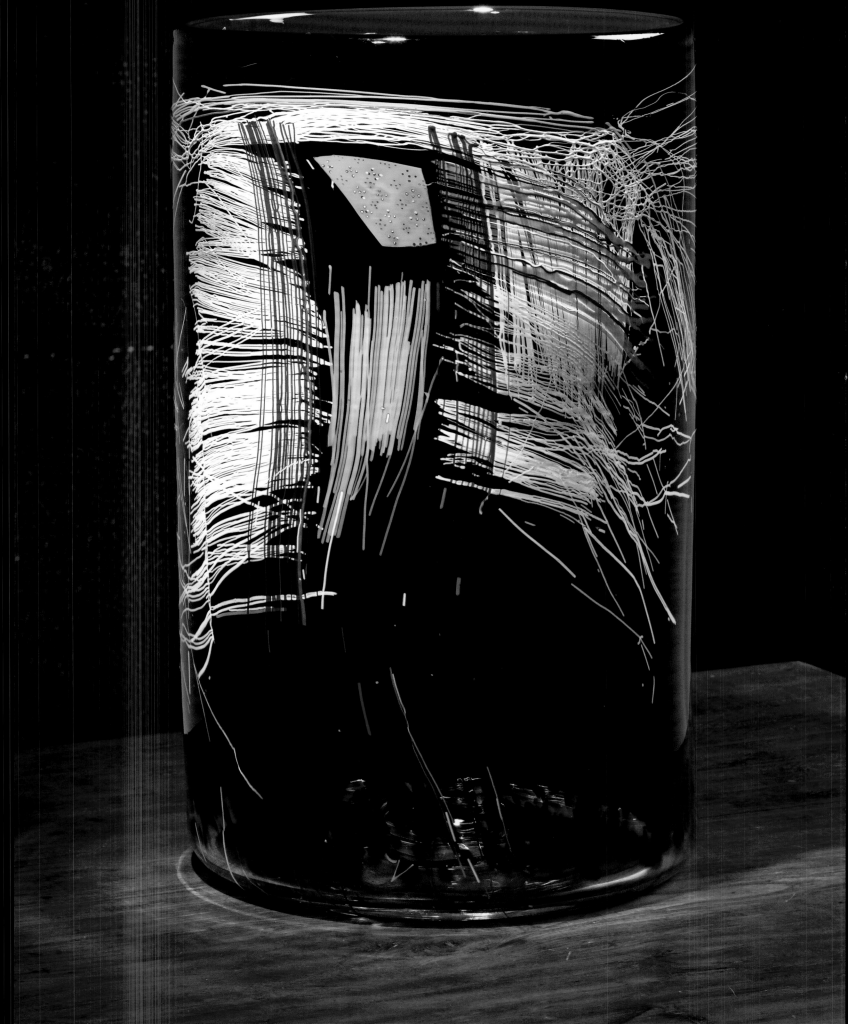

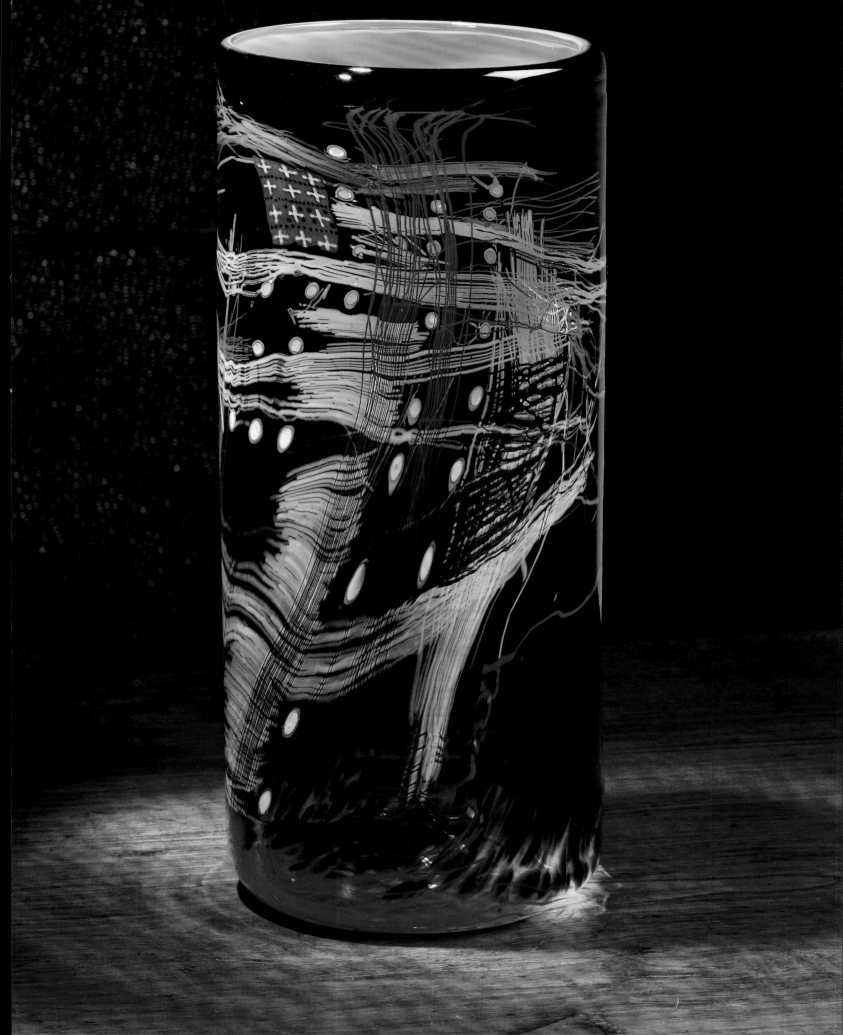

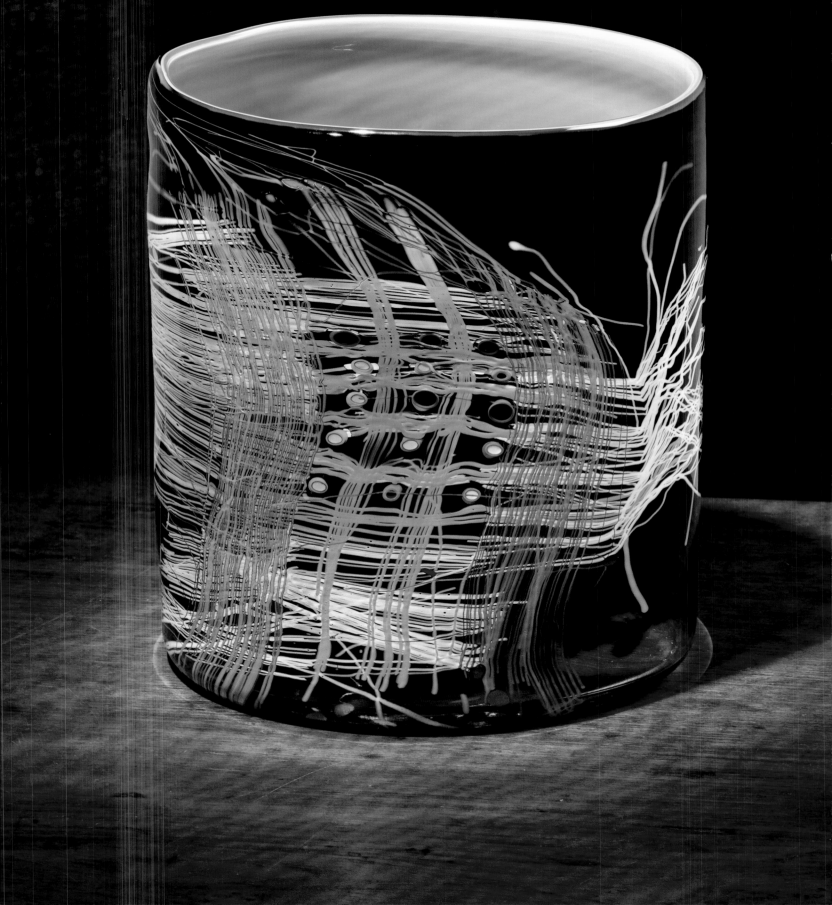

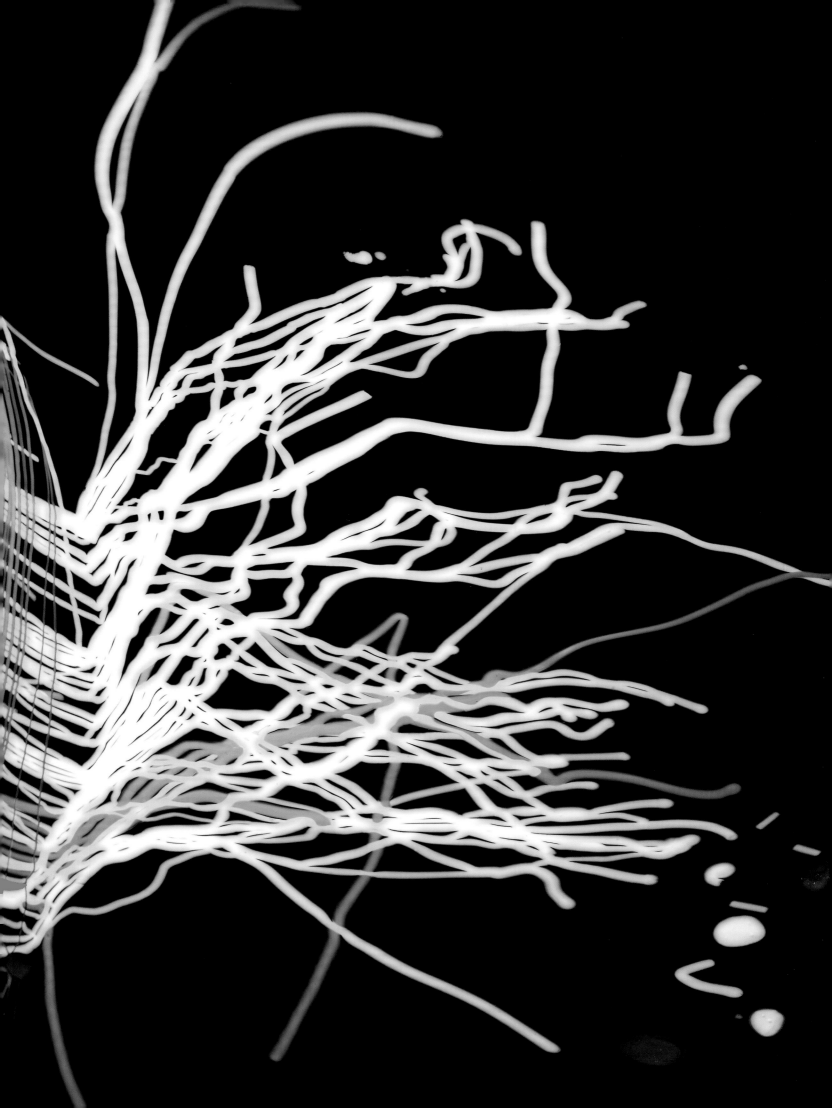

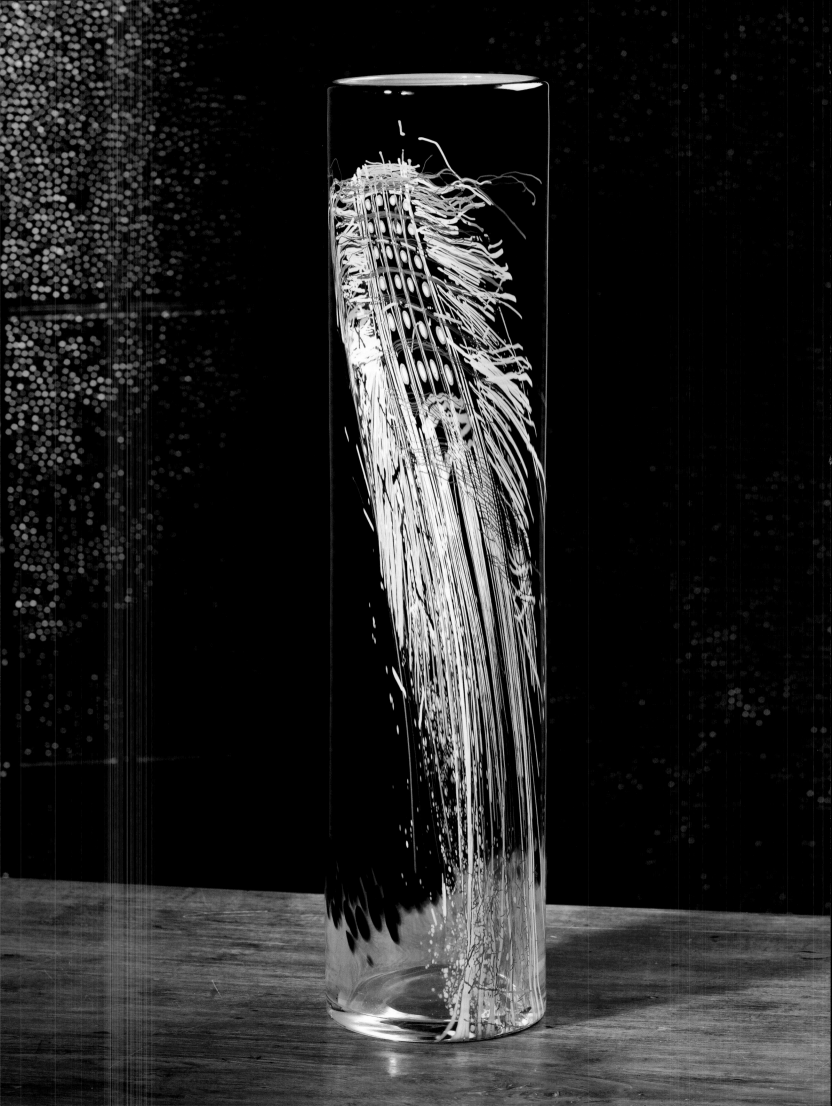

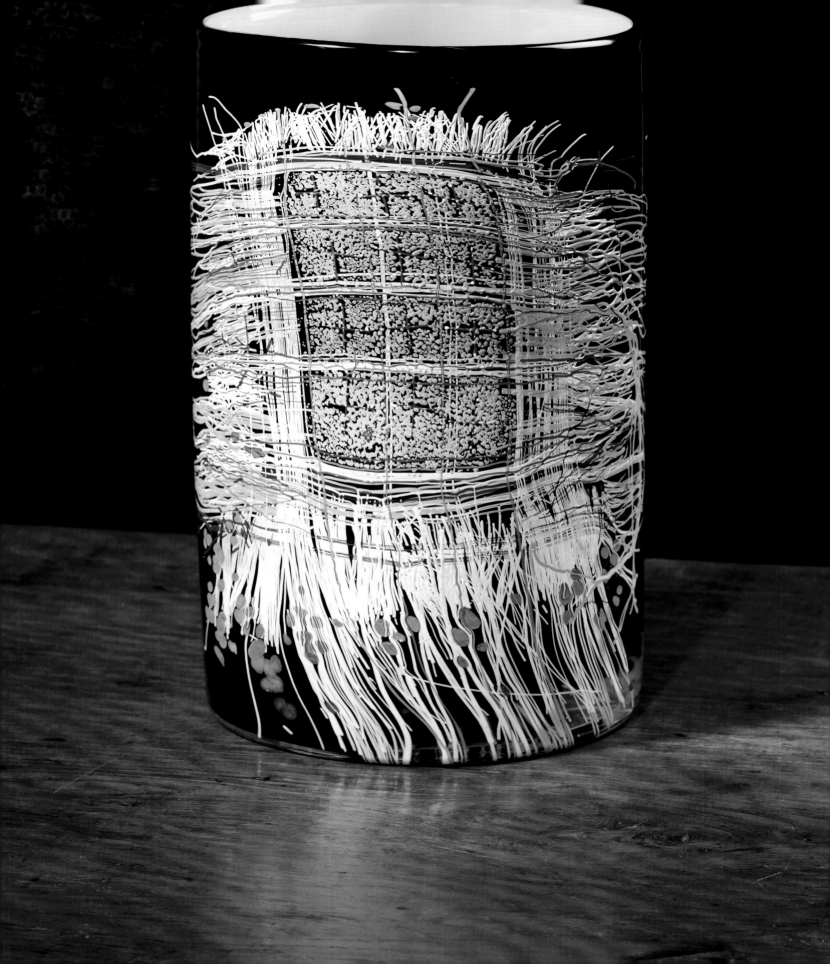

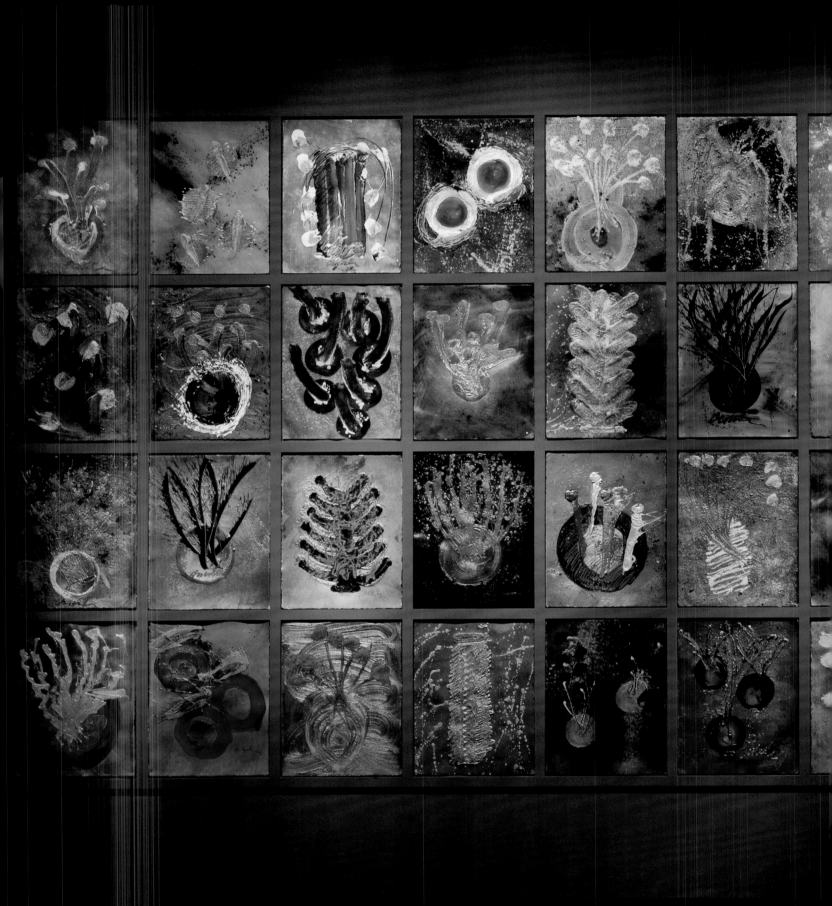

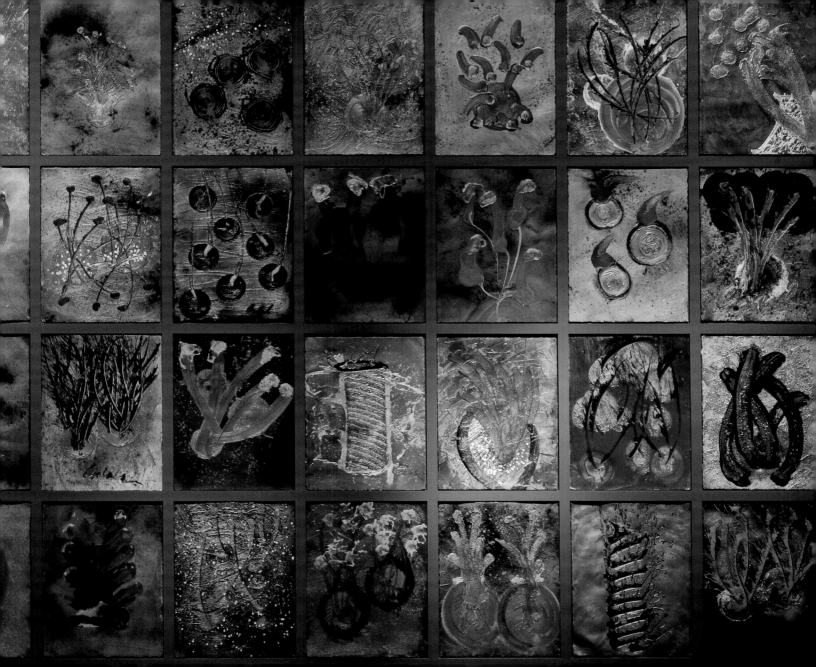

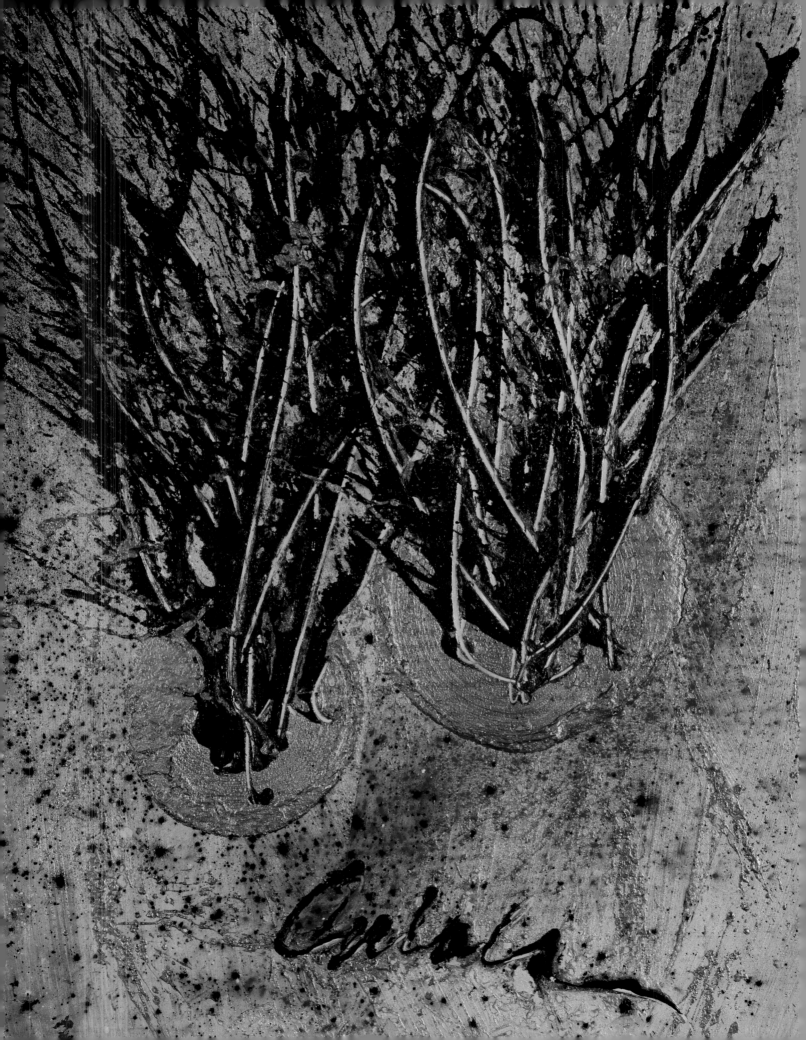

PERSIAN CEILING

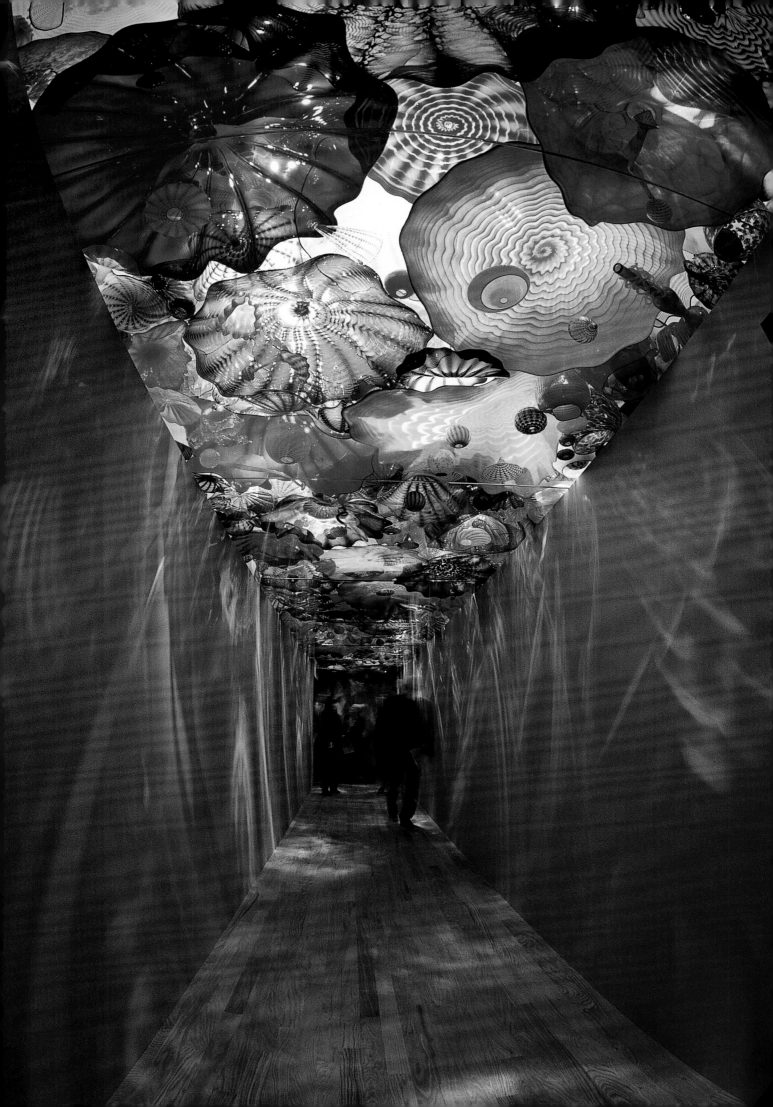

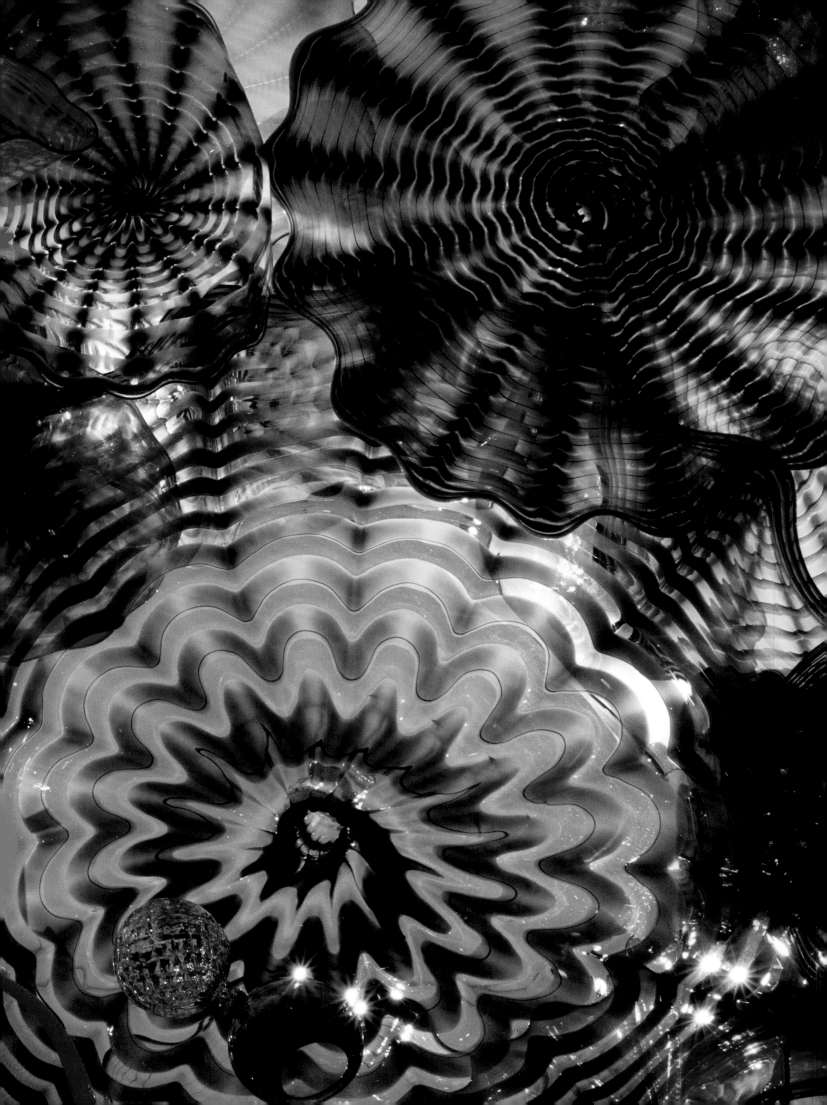

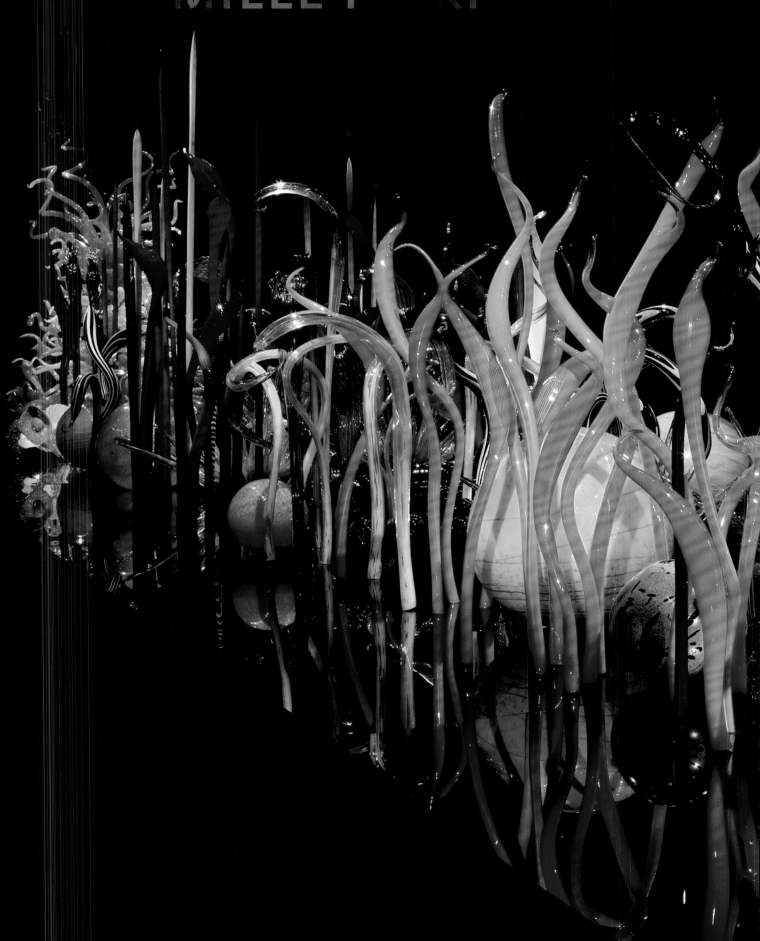

MILLE FIORI

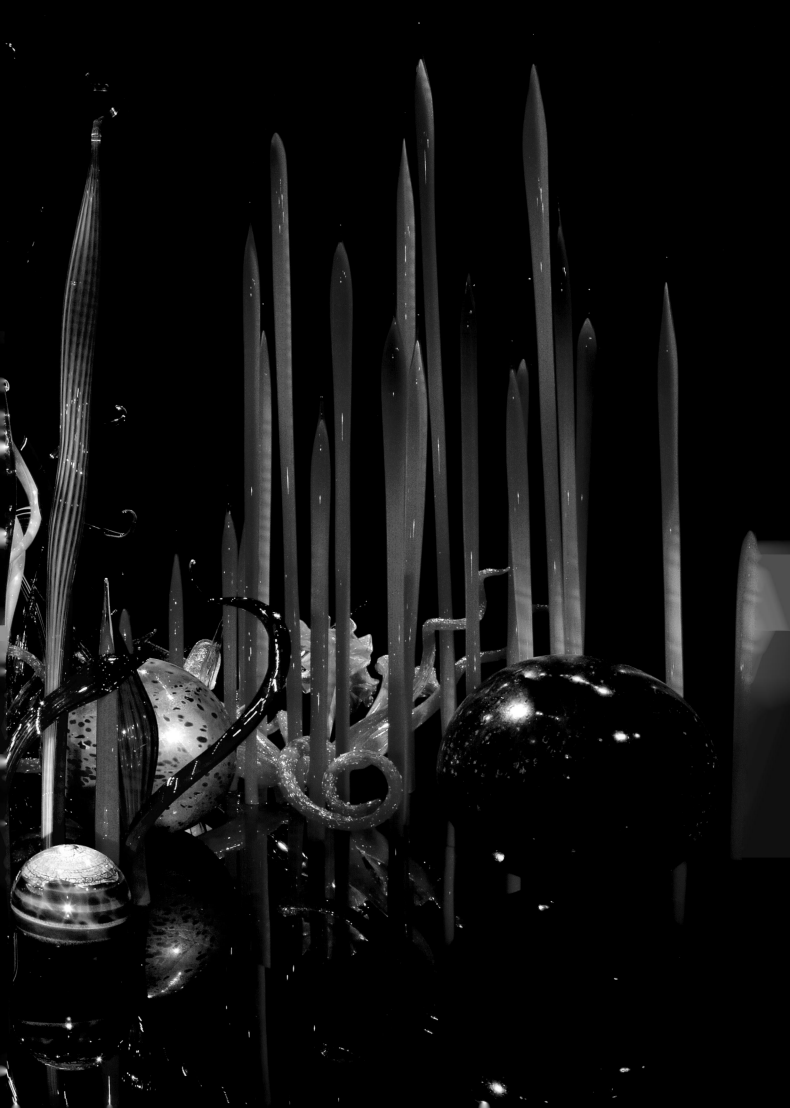

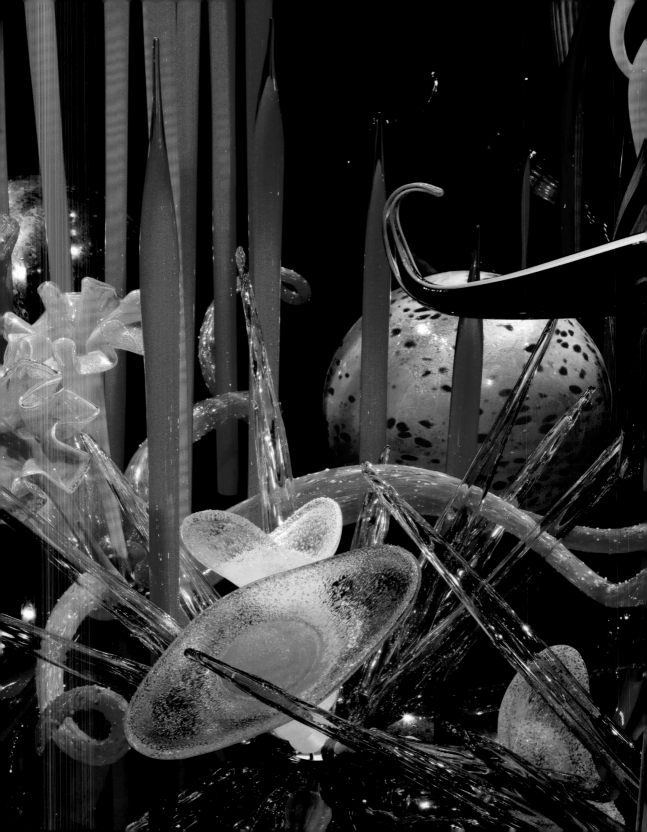

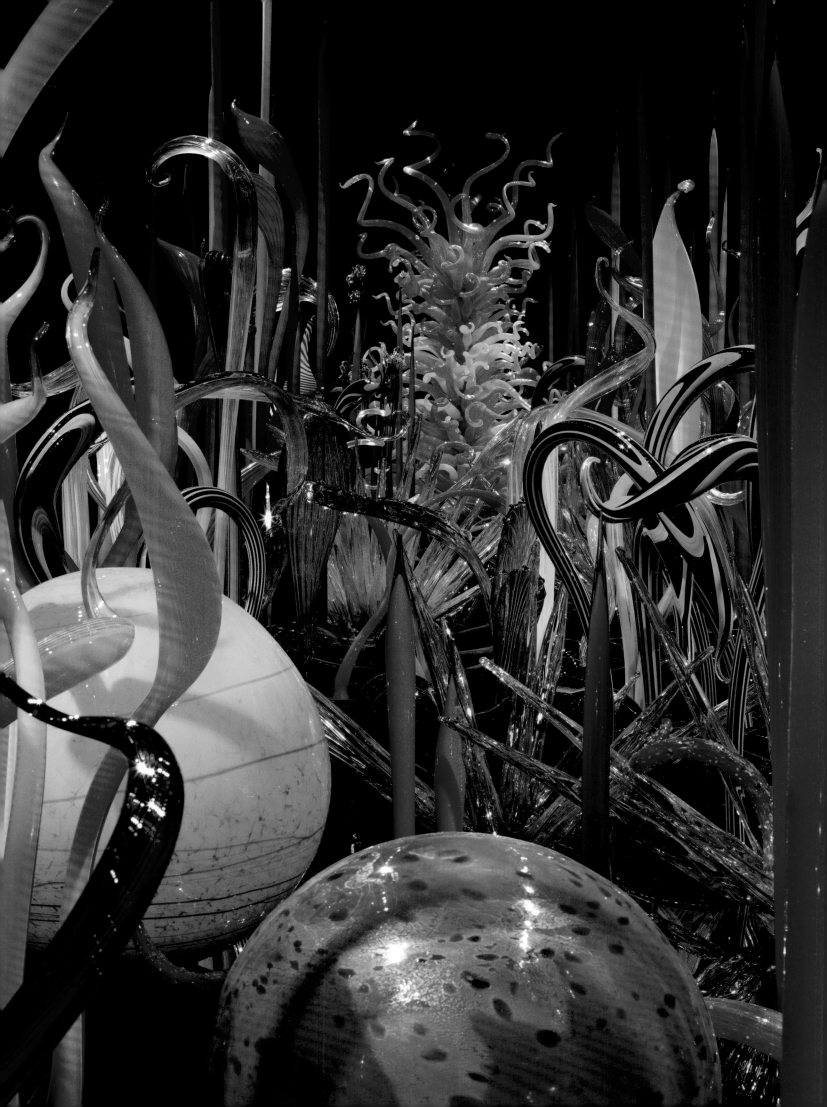

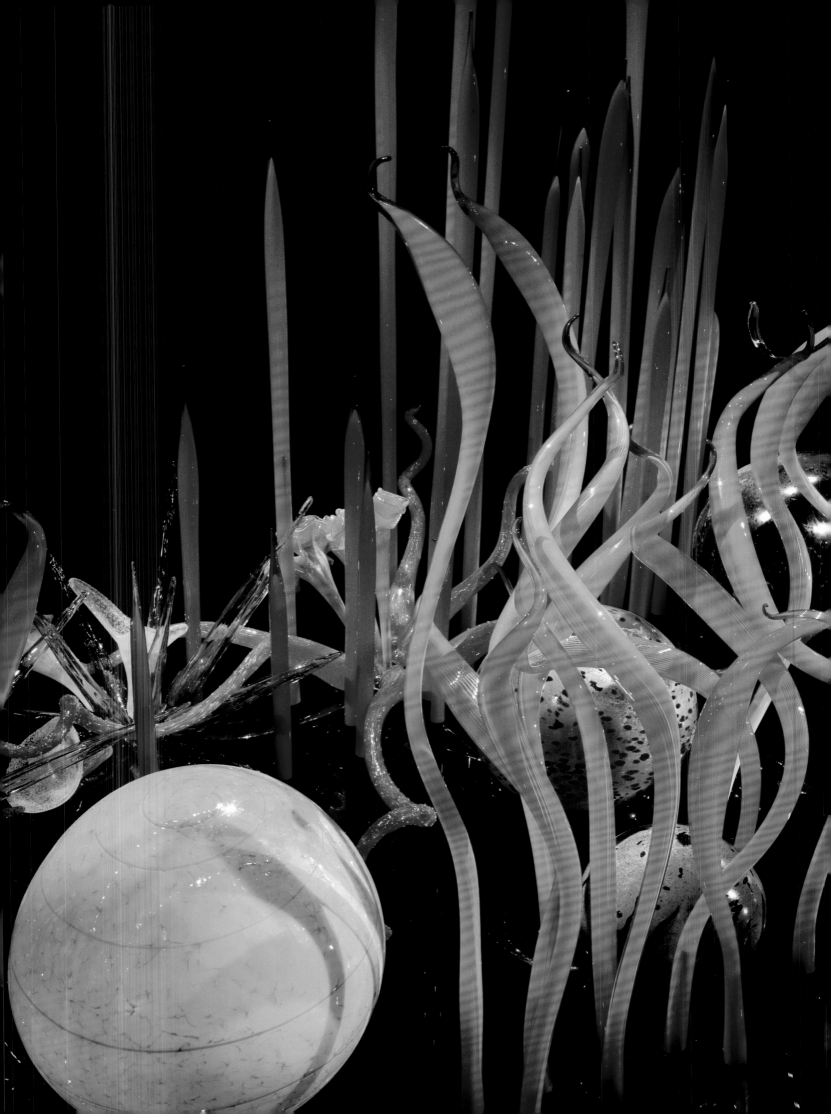

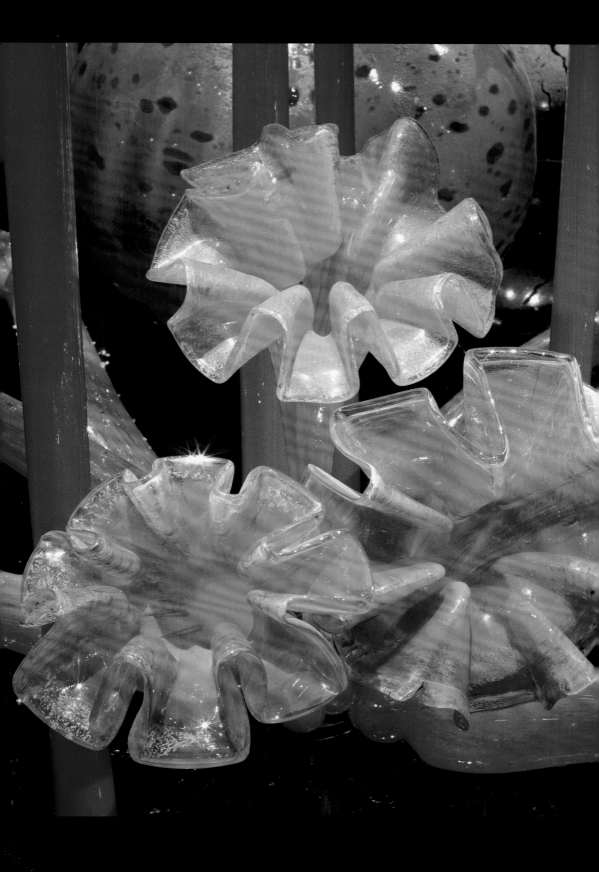

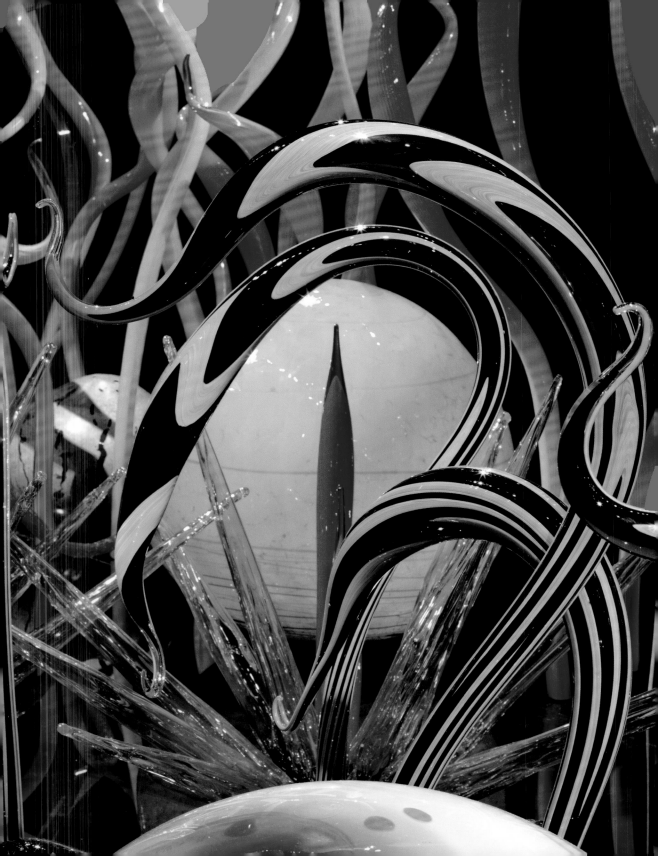

PHOTOGRAPH CREDITS

Page 1: Russell Johnson
Pages 2–3: Teresa Nouri Rishel
Pages 4–5: Terry Rishel
Pages 8–9: Terry Rishel
Pages 10–11: Russell Johnson
Pages 12–13: Ira Garber
Page 14: unknown
Page 16: Terry Rishel
Page 18 left: unknown
Page 18 right: Dale Chihuly
Page 19: Gérard Blot / Courtesy
 Réunion des Musées Nationaux /
 Art Resource, New York
Page 20: unknown
Page 22: Art Hupy
Page 24 left: Ira Garber
Page 24 right: Joseph McDonald
Page 25: unknown
Page 26 left: M. Lee Fatherree
Page 26 right: Joseph McDonald
Page 27 left: © 1988 The Metropoli-
 tan Museum of Art
Page 27 right: Claire Garoutte and
 Donna Goetsch
Page 28: Courtesy of McCormick
 Library of Special Collections,
 Northwestern University Library
Page 29: Robert Whitworth
Page 30 left: Terry Rishel
Page 30 right: © 2007 Museum
 Associates / LACMA
Page 31: Dick Busher
Page 32: Roger Schreiber
Page 33: Courtesy Cameraphoto
 Arte, Venice / Art Resource,
 New York
Page 34: Dick Busher
Page 35: Philip Amdal
Page 36: unknown
Page 37 left: Hillel Burger /
 © President & Fellows of
 Harvard College
Page 37 center: © The National
 Gallery, London

Page 37 right: Claire Garoutte
Page 38: M. Lee Fatherree
Page 39: Shaun Chappell
Page 40: Russell Johnson
Page 41: Claire Garoutte
Page 42: Russell Johnson
Page 43: Teresa Nouri Rishel
Page 45 left: Robert O. Thornton
Page 45 right: Scott Mitchell Leen
Page 47 left: Hans Namuth
Page 47 right: Russell Johnson
Page 48: Teresa Nouri Rishel

Plates
Pages 58–59: Terry Rishel

Saffron Tower
Pages 61–62: Terry Rishel

Persian Chandelier
Pages 64–65: Terry Rishel

The Sun
Pages 66–69: Terry Rishel

**Aquamarine Three-tiered
 Chandelier**
Pages 71–73: Terry Rishel

Sea Blue and Green Tower
Pages 75–77: Terry Rishel

Glass Forest #3
Cover and pages 78–79: David Emery
Pages 80–81: Terry Rishel

Venetians & Ikebana
Page 83–84: Terry Rishel
Pages 85–87: Scott M. Leen
Page 88: Teresa Nouri Rishel
Page 89: Terry Rishel
Pages 90–91: Nick Gunderson
Page 92: Teresa Nouri Rishel
Pages 93–97: Terry Rishel

Persians
Pages 98–100: David Emery
Pages 101–103: Terry Rishel

Tabac Baskets
Pages 104–105: Terry Rishel
Page 106: Claire Garoutte
Page 107: Terry Rishel
Pages 108–109: Scott M. Leen
Page 110: Jan Cook
Page 111: Teresa Nouri Rishel

Macchia Forest
Pages 112–114: Terry Rishel
Page 115: Terry Rishel

Reeds
Pages 117–119: Teresa Nouri Rishel

Boats
Pages 120–121: David Emery
Pages 122–125: Terry Rishel

Chandeliers
Pages 126–127: David Emery
Pages 128–131: Terry Rishel

Black
Pages 132–133: Scott M. Leen
Pages 134–135: Teresa Nouri Rishel
Pages 136–137: David Emery
Pages 138–139: Teresa Nouri Rishel
Pages 140–141: David Emery
Pages 142–143: Terry Rishel
Page 144–145: Teresa Nouri Rishel

Persian Ceiling
Pages 147–151: Terry Rishel

Mille Fiori
Pages 152–154: Terry Rishel
Page 155: David Emery
Page 156: Terry Rishel
Pages 157–159: David Emery